GETTYSBURG
FACES

Portraits and Personal Accounts

Ronald S. Coddington

GETTYSBURG
PUBLISHING

Published by Gettysburg Publishing, LLC
www.gettysburgpublishing.com

Front Cover Portraits:
> Brian Boeve Collection
> Charles Darden Collection
> Charles T. Joyce Collection
> Paul Russinoff Collection

Back Cover Portraits:
> Ronn Palm's Museum of Civil War Images
> Chris Foard, The Foard Collection of Civil War Nursing, The Liljenquist Family
> Collection at The Library of Congress
> Rick Brown Collection of American Photography

Cover Image: "The Battle of Gettysburg" by John Sartain, based on a painting by
> Peter Frederick Rothermel. Library of Congress

Cover Design by Ronald S. Coddington

Library of Congress Cataloging-in-Publication Data

Names: Coddington, Ronald S., 1963- author.
Title: Gettysburg faces : portraits and personal accounts / Ronald S.
 Coddington.
Description: First edition. | [Trumbull, Connecticut] : Gettysburg
 Publishing, [2022] | "All 100 images in this volume appeared in Military
 images between 2014 ... and 2021"–Page xvii. | Includes bibliographical
 references and index.
Identifiers: LCCN 2022006019 (print) | LCCN 2022006020 (ebook) | ISBN
 9781734627640 (paperback) | ISBN 9781734627657 (ebook)
Subjects: LCSH: Gettysburg, Battle of, Gettysburg, Pa., 1863. |
 Soldiers–United States–Biography. | United States–History–Civil War,
 1861-1865.
Classification: LCC E475.53 .C723 2022 (print) | LCC E475.53 (ebook) |
 DDC 973.7/349–dc23/eng/20220310
LC record available at https://lccn.loc.gov/2022006019
LC ebook record available at https://lccn.loc.gov/2022006020

Printed and bound in the United States of America

First Edition

To Harry Roach, founding editor and publisher of *Military Images*, who understood the value of Civil War portrait photographs and created a publication to showcase, interpret, and preserve them. And to the caretakers of these photographs who have, for more than a half century, generously shared their passion and knowledge to help us appreciate the stories behind the faces, especially two pioneers who have left us: Henry Deeks and Mike McAfee.

CONTENTS

———

PREFACE

Gettysburg is a soldier's story.

On one side marched an army of Northern men burdened by the weight of losses in the recent engagements of Fredericksburg and Chancellorsville yet unshaken in the belief that they would ultimately put down the rebellion.

Opposing them, an army of sons of the South, flush with victory and brimming with *esprit de corps* after decisive wins on these same battlegrounds—and now invading the North in a bold bid to bring the war to a conclusion and secure a Confederate nation.

In July 1863, the two forces clashed at a crossroads community in south-central Pennsylvania. For three days, they grappled with musket and cannon and saber and fist to determine the fate of a divided nation and the future of representative and constitutional democracy in the world.

Portraits of these individuals, the first generation to grow up with photography, are a distinct visual record of service and sacrifice. The persons peering back at us hailed from all walks of life and shared a common experience of stepping into the photographer's studio and posing for a likeness to be given to family, friends, and comrades. Their portraits are personal and intimate, and never intended for public consumption. Over time, Americans embraced their intrinsic value as part of our collective memory of a tragic and brutal war.

The personal narratives of these individuals are as unique as their portraits.

Meet the Pennsylvania color corporal who inspired his comrades during the fight at McPherson Farm, suffering three bullet wounds and receiving the Medal of Honor.

Meet the Virginia lieutenant whose wounding and capture during Pickett's Charge resulted in an unexpected reunion with his college professor.

Meet the Union army nurse who preferred tending patients in makeshift field hospitals and, inspired by her wartime service, became a physician.

Representative portraits and accounts of these participants in the Gettysburg Campaign are included here. Through words and images, they become alive again, if only for a fleeting moment.

About this book

My memories of a family day trip to Gettysburg in the early 1970s are fragmentary. Zigzagging worm fences. Meandering stone walls. Blinking lights choreographed to the disembodied voice of the Electric Map's stentorian narrator. The bronze figure of aquiline-nosed Warren holding binoculars. A souvenir picture guidebook with a photograph inside of the late President Kennedy touring the battlefield. A vague awareness of the fishhook defense. A persistent hope that I might find a bullet that escaped the attention of the other visitors.

Though the memories may be in parts, the outcome of that trip is certain. Somewhere along the three-hour drive in the family station wagon to our home in New Jersey, the power of the place permeated my psyche. The experience grabbed me with an immediacy and urgency that seemed impossibly at odds with an event so distant in time. I've long since given up trying to understand why. I accept it as my reality.

During the days, weeks, months, and years that followed, my fascination deepened and matured. Gettysburg opened a door that started my lifelong Civil War journey.

I did not realize that other visitors to Gettysburg had similar experiences for more than a century. Moreover, that the hilly,

rock-strewn landscape in and about the town did not own a monopoly in its ability to attract and hold one's attention. Other battlefields had the same power: The Sunken Road at Antietam. The Hornet's Nest at Shiloh. The Crater at Petersburg.

A few years later, in 1977, another experience with Civil War history touched me. This time, it occurred at an outdoor flea market in Warrenville, N.J. I recall a thick table painted forest green with photograph album pages haphazardly piled in a large mound. The bindings that once held the pages had disintegrated, making it impossible to know which pages belonged together, or how many broken albums were present.

I dug into the pile, transfixed by the sepia-toned faces of men, women, and children. One of the photos captured my attention: A man standing in uniform, one hand slipped into his double-breasted frock coat a la Napoleon, the other grasping the handle of a sword.

What happened next is family lore. I balked at the four-dollar price and walked away from the table without purchasing it. As I opened the passenger door on the driver's side of the family wagon and slid into the back seat of the family wagon, my brother Mike cast a glance my way and said, "You're not gonna get it?"

I slid back out, walk-ran to the table, pulled out four wrinkled greenbacks from my pocket and purchased the photo.

The educational value derived from this single image far exceeded the cost. Back home, I dug into my Civil War books, desperate to learn more about the soldier. I studied the markings on his uniform and came to understand that he was not a soldier, but a master's mate in the Union navy. And, thanks to helpful dealers at other flea markets we visited in subsequent weeks, I learned that the photograph was a postwar copy print in a cabinet card format. The back of the cardstock mount included an imprint of a photographer's studio in Chicago.

All these visual clues helped paint a picture of the man in the picture.

I discovered one more clue. A name inscribed on the album page: "Uncle George Garlick." Armed with a possible identification, and obsessed with a desire to confirm it, I discovered the National Archives in Washington, D.C., kept records of Civil

War veterans. I sent a letter to the Archives and soon received a reply with copies of documents from the pension file of George Washington Garlick. Born in New York, Garlick relocated to Illinois and worked in the railroad industry prior to the war. He began his military service in the ranks of his adopted state's 12th Infantry and 2nd Cavalry before joining the Navy's Mississippi River fleet as an acting master's mate and acting ensign on the ironclad gunboat *Pittsburgh* and the hospital ship *Red Rover*. He survived the war, lived in Chicago and St. Louis, and died in 1928 at age 91.

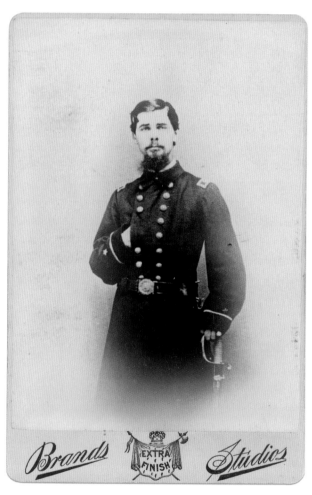

Acting Master's Mate George Washington Garlick, U.S. Navy
Cabinet card by Brand of Chicago, Ill. Author's collection.

Meanwhile, I bought more old photos at flea markets in New Jersey and Pennsylvania. I looked forward to weekend family outings to Neshanic Station, Lambertville, Chester, New Hope, and other antique meccas with unbridled enthusiasm.

When I encountered other curious flea marketers sorting through boxes and trays of old photos, I viewed them as competition—for hunting these rare treasures bordered on blood sport in my teenaged mind.

I did not realize until some years later that we were kindred spirits linked by our passion. Moreover, that men and women of all ages across the country were on the same voyage of discovery as photo collectors.

The origins of collecting Civil War portrait photos

The modern movement to collect Civil War portrait photos began a quarter century before I showed up at the Warrenville flea market. Several events fueled a fascination with these artifacts.

In the 1950s, the last living veterans of the Civil War passed, each receiving media coverage in newspapers across the nation. Meanwhile, the ancestral links that connected American families to their Civil War soldiers had weakened. In a growing number of cases, great-grandchildren and other descendants no longer recognized the faces of the soldiers and sailors staring back at them from worn photo albums banished to attics and basements.

Historian and journalist Bruce Catton wrote his masterful Army of the Potomac trilogy. His writings, produced in the wake of World War II and the rising tide of the Civil Rights movement, reflected the romance and Lost Cause narratives that had emerged after the surrender at Appomattox and were firmly rooted in our culture by his birth in 1899. David Blight, acclaimed professor of history at Yale, observed "Catton's works became a kind of national siren call into the past, to the scenes of a distant but deeply resonant war."

The commemoration of the Civil War at 100 began in earnest in 1957 with a congressional act creating the United States Civil War Centennial Commission. The ambitions of the Commission were not fully realized due to the ongoing Civil Rights movement, which stirred sectional discord around race and other factors. But it did succeed in raising awareness of the brutal war that came so very close to obliterating the Constitution.

These intertwined events spurred a movement to collect relics from the Civil War years. One of these collectors, Ross J. Kelbaugh, author of *Introduction to Civil War Photography* and other books, put a name to these pioneers: the Centennial Generation.

These collectors were not the first to attach value to wartime portrait photographs. The first collectors were the soldiers, sailors, and civilians who filled photograph albums with *cartes de visite* portraits, battlefield views, and other scenes during the conflict. In the postwar period, some of these portraits were reproduced in regimental histories and other memorials.

Some of the old soldiers elevated photo collecting to new heights. Massachusetts veterans Arnold A. Rand and Albert Ordway amassed a huge collection of images, including many portraits, for the Military Order of the Loyal Legion of the United States (MOLLUS). The bulk of the albums can be found at the U.S. Army Heritage and Education Center in Carlisle, Pa. Another Massachusetts soldier, Col. Samuel Crocker Lawrence, held a large private collection that resides in the Medford Historical Society & Museum in Medford, Mass.

In the earlier part of the century, evidence exists of original wartime portraits sold by veterans or their families to the curious, including one 1902 case of a veteran in need of money. Such events appear to be isolated incidents rather than part of an active collecting network.

By the 1950s, Civil War portrait collecting began to take hold. It was a separate and distinct genre from photographs of battlefields and other scenes produced by Mathew B. Brady, Alexander Gardner, and others. Their work had captivated Americans since the war itself, when the images were publicly displayed, reproduced as woodcut engravings in newsmagazines and books, and mass-produced as *cartes de visite*.

Collector Rich Jahn of Paramus, N.J., became interested in portrait collecting in the 1950s. "There was a kid in my neighborhood, and he had a big tray of Civil War photos. That must have been the late 50s, maybe 1960," Jahn recounted in a 2016 interview. His story is one of many from this period of those who perceived the historical importance of these portraits.

Not everyone viewed soldier and sailor portraits as collectible on their own during these early days. William A. "Bill" Turner, a Civil War militaria dealer, noted in a 2006 interview, "Hell, we used to give 'em away for free. Buy a gun and we'd give them a picture of a soldier with the gun they just bought." Turner's comment referenced the already established community of collectors focused on uniforms, guns, swords, and related equipment. These collectors shared a common ancestor with portrait photograph collectors—Civil War veterans. However, the marketplace for cloth, metal, wood, and leather items traces its roots to earlier in the 20th century, due in part to Francis Bannerman's establishment of the army-navy surplus empire that bears his name.

Though Turner gave away images early on as evidence, he soon realized they had their own collecting and monetary value. He amassed one of the largest and most important collections of Confederate portraits and actively bought, sold, and traded until his death in 2012.

Turner is also representative of many who started collecting Civil War artifacts before turning to images.

The 1963 publication of Francis A. Lord's *Civil War Collector's Encyclopedia* included a section about portrait photography. Though modest in comparison to other entries, it proved the existence of soldier and sailor images as a separate and distinct field of collecting.

A community of image collectors emerged in the 1960s and 1970s. They established collecting criteria based on individual interests. Some placed a premium value on geography, notably specific regiments and other organizations formed in local and state jurisdictions. Others focused on specific branches of service. The study of uniforms, equipment, and weapons inspired another subset of collectors. Identified soldiers drew in other enthusiasts.

Collectors typically made first contact with images at garage sales, flea markets, thrift stores, and antique shops. Direct and easy access to images provided budding collectors with an opportunity to raise awareness and educate themselves through physical examination.

Serious collectors soon discovered the existence of mail order catalogs, which ranged from black and white with text-only descriptions printed on letter-sized paper, folded in half, and stapled or taped to glossy, full-color illustrated catalogs in a letter-sized format.

Physical shows emerged as influential centers to buy, sell, trade, make friends, and network. The majority of those who set up tables began as collectors and became dealers to support their hobby. Pre-show meet-ups, formalized as dealer set-up days, witnessed a frenzy of activity as dealer/collectors bought, sold, and traded images. Some of these photos ended up on the dealer's table, and others in the personal collection of the dealer-collector.

As the community grew, the appetite to share images and stories about them increased.

In 1975, one collector took the need to a new level. Collector Harry Roach added a large-format albumen portrait of four brothers, all Union soldiers, to his holdings. He meticulously researched their military service and conceived of writing a story. About 1977, he recalled in a 2018 interview, "I sent an article on the brothers to a major magazine, or perhaps just a query, which received a rejection along the lines of 'we do not cover this sort of material.'"

The same year Roach came into possession of the albumen, William Frassanito's landmark volume, *Gettysburg: A Journey in Time*, generated new interest in battlefield photography by meticulously placing these historic images in context to specific locations on the battleground. Frassanito's landmark book, and a subsequent 1978 volume set at Antietam, inspired Roach, a Vietnam veteran trained as a photo analyst in air intelligence.

Roach determined to do for military portrait photography what Frassanito did for battlefield photographs. In the summer of 1979, he launched *Military Images* magazine. He selected the

story behind the albumen of the four Union army brothers as the cover and included an interview with Frassanito.

Roach initially set an expectation in the magazine to document military photography during a 100-year period from 1839, when the first commercially successful daguerreotype process was announced, to 1939, the beginning of World War II. Civil War images, however, dominated the pages of *Military Images* and still do today.

Roach collaborated with influential collectors in the emerging field of Civil War portrait photography studies. They include Ronn Palm, who later established Ronn Palm's Museum of Civil War Images in Gettysburg, West Point Curator of History Michael J. McAfee, Bill Gladstone, Brian Pohanka, and others.

In 1986, a second magazine dedicated to the hobby emerged. *Incidents of the War,* edited by D. Mark Katz, catered to "the discriminating collector and student of Civil War Photography." Issued quarterly, the magazine ceased publication in 1988.

Civil War portrait photograph collectors are not alone in having a representative publication. In 1973, William S. Mussenden founded *North South Trader* magazine. In 1985, its original editor, Stephen W. Sylvia, purchased it. Now known as *North South Trader's Civil War,* the magazine's target audience is "Civil War collectors, relic hunters, researchers, and historians."

Civil War battlefield photography enthusiasts also have a representative journal. *Battlefield Photography* made its debut in 2002 in connection with the Center for Civil War Photography, an organization founded by Bob Zeller. An authority in stereoview photography, Zeller's 1997 volume, *The Civil War in Depth: History in 3D,* is an important contribution to battlefield photography and the stereo format.

By the 1990s, the military images community flourished, fueled by a vibrant marketplace of dealers and networks of collectors, the flow of information, and the rise of authoritative voices representing relevant aspects of the hobby. The community also experienced a wave of growth flowing from the 1989 Edward Zwick dramatic film *Glory* and the 1990 Ken Burns documentary series *The Civil War.* These productions ignited interested in Civil

War artifacts much in the same way as Catton's trilogy inspired the Centennial Generation of the 1950s.

The identification by many community members as caretakers of images became firmly established by this time. This point of view places the image at the center of the community and the collector as a temporary keeper responsible for the preservation and protection of the artifact until some future point when it is transferred to the next caretaker. The chain of caretakers is linked to the provenance of the image itself.

The advent of the commercial Internet in the 1990s disrupted the community much in the same way as it affected other groups. Forums and blogs injected new ideas and scholarship, and surfaced previously unknown, unpublished photographs. Dealers and auction houses established websites. In 1997, the birth of eBay connected sellers and buyers of images, enabling easy transactions and open access to photographs without the established networks and personal interactions at physical shows.

The rise of social media platforms in the early 2000s further impacted the community. Facebook has enabled image and information sharing and business transactions online, and the social media giant's private groups are centers of activity for image enthusiasts of all ages and levels of knowledge. Among them are Civil War Faces and Civil War Faces Market Place, founded in 2011 by Doug York, and The Image Collector, founded in 2017 by Dale Niesen.

Community is also at the core of Civil War Photo Sleuth (CWPS). Founded by Kurt Luther, an associate professor of computer science and (by courtesy) history at Virginia Tech, and the author of the column Photo Sleuth for *Military Images* since 2015, CWPS launched in 2018. (Note: I am a co-founder of CWPS.) The site combines community and technology, including artificial intelligence-based face recognition software, to aid in the identification of those pictured in Civil War-era photographs.

Today, the greater community of image caretakers flourish in the physical and digital worlds, a testament to passion, dedication, and devotion to the study of Civil War portrait photography.

Acknowledgements and methodology

Representative members of the photo collecting community form the backbone of this volume. This project could not have come to fruition without them. I am forever grateful for their generosity in sharing relevant images and research.

They are Dave Batalo, Brian Boeve, Bruce Bonfield, Rick Brown, Rick Carlile, Chad Carlson, Charles Darden, Guy DiMasi, Mark H. Dunkelman, Chris Foard, John Fuller, Seth McCormick-Goodhart, Francis Guber, Thomas Harris, Rusty Hicks, Britt C. Isenberg, Carolyn Ivanoff, Charles T. Joyce, Jeff Kowalis, John Kuhl, C. Paul Loane, Faye and Ed Max, Dave Morin, Seward Osborne, Ronn Palm, Ben Pauley, Paul Russinoff, Mark Savolis, Dan Schwab, Joseph Stickelmyer, Karl Sundstrom, Daniel Taylor, Brian White, David Wynn Vaughan, and Buck Zaidel.

Two pioneer collectors are no longer with us: Mike McAfee and Bill Turner.

All 100 images in this volume appeared in *Military Images* between 2014, when I became editor and publisher, and 2021. During this seven-year period, 130 portraits of individuals with unique Gettysburg experiences appeared in the magazine. A unique experience is defined as suffering death, a mortal wound, a wound, or capture; an event in which the individual is mentioned by name in a primary source such as an after-action report or a news story; a story documented by the individual in a wartime letter, journal, or other document; or a postwar reminiscence in a regimental history book or other publication. After careful review of the images and stories, I selected 100 for inclusion. Of the 30 eliminated, six had been sold or traded by the collector and the new owner could not be traced. Two dozen other images, all portraits of Union infantrymen, were eliminated to make room for other branches of the service, caregivers, and Confederates.

Of the 100 individuals included, 75 served the Union and 25 fought for the Confederacy. This ratio does not reflect the actual balance of forces in the battle: The Army of the Potomac mustered 85,000 soldiers and the Army of Northern Virginia 75,000.

To accurately represent those engaged, the ratio needed to be 53 percent Union and 47 percent Confederate, not the 75/25 percent split here.

Two major factors account for the lack of Confederate photography: The comparative overall sizes of the wartime armies and the lack of access to photography.

The number of total enlistments for all the armies of the Union and Confederacy favor the North by about a two-to-one margin: 2.1 million to 1.1 million.

Also, and especially relevant, photographic supplies largely disappeared in the Confederate states. The naval blockade of Southern ports along the Atlantic coast and Gulf of Mexico deprived photographers of essential chemicals and equipment. The success of Union armies in capturing and occupying Southern territory shut off access to photography galleries for Confederate soldiers. Economic instability, especially inflation, put the price of a photograph out of reach for the few operating galleries available to Jeff Davis' soldiers. By 1863, even the galleries in the Confederate capital of Richmond, Va., had fallen into steep decline.

The overwhelming majority of surviving Confederate photographs date from two distinct periods. The first and longest timeframe is the first two years of the war, when the South had ample supplies and before the blockade took full effect. The second lasted for a few months in 1865 between the surrender of the Confederate armies in April and May and orders directing former Confederate soldiers to remove military insignia from their uniforms.

When the 100 portraits were originally published in *Military Images,* most were accompanied by capsule biographies describing the individual's Gettysburg experience plus other military service and personal information. These mini-profiles averaged between 150 and 300 words. A small number of images were accompanied by feature-length profiles exceeding 1,000 words. I expanded each capsule biography into stylistically consistent short story and wrote entirely new stories based upon the full-length features. In some cases, I added new research not available at the time of first publication.

I opted not to include formal endnotes and a bibliography in favor of a references section. It can be found at the end of this volume with contextual notes.

Notes on Civil War portrait photography

Behind every portrait photograph taken during the Civil War years lies a question that each sitter had to consider. Which format do I choose?

Two primary formats were available: plate or paper. Both are featured in this volume.

Hard plates came in three varieties: iron (tintypes), glass (ambrotypes), or copper coated with silver (daguerreotypes). Effectively a unique negative developed on a plate, the subject is pictured in reverse. They came in a variety of sizes, the largest being a full plate measuring about 8 by 10 inches. The most popular sizes were a sixth or a quarter plate—easy to carry in a pocket or display on a fireplace mantel. These images were housed in cases that are essentially frames with covers. They were intended for family and close friends, for the giving of one's reflection was an intimate and deeply personal act.

Paper photographs are composed of albumen paper treated with light-sensitive chemicals and egg whites and mounted to card stock. They are positive prints produced from a glass negative and picture the subject as they appear rather than in reverse. The most popular format, the *carte de visite* or visiting card, measures about the size of a modern trading card. Printed by the dozen and distributed to family, friend and acquaintances, *cartes de visite* were stored in albums—the Facebook of the 1860s.

The choice of plate or paper was new to Americans in 1861. Since the announcement of the first commercially successful photograph in 1839 by Louis-Jacques-Mandé Daguerre, his daguerreotypes enjoyed a virtual monopoly until the mid-1850s, when ambrotypes and tintypes (known at this time as melainotypes or ferrotypes) arrived on the scene. These new varieties retained much of the high quality of daguerreotypes at more

affordable prices due to less expensive materials. By the start of the Civil War, ambrotypes and tintypes had replaced daguerreotypes as American's format of choice. Daguerreotypes continued to be produced early in the war, as evidenced by a small number of surviving soldier images.

Daguerre's 1839 announcement overshadowed the efforts of William Henry Fox Talbot to perfect a radically different process based on paper prints from a paper negative. He announced his calotype, or talbotype, in 1841. At first, paper prints failed to compete against the daguerreotype because of the superior quality of hard plates. Moreover, Talbot patented his invention, which limited its distribution compared to the daguerreotype process available to the world without restrictions.

Meanwhile, a group of dreamers inspired by Talbot's process envisioned the expansion of photography beyond Daguerre's one-off portraits and landscapes. They imagined a more utilitarian role for photographs, one where paper portraits might be affixed to passports and licenses or traveling merchants might replace cumbersome wagons of goods with sleek photo albums filled with product images—in effect, a catalog.

In the late 1840s and early 1850s, three major developments made paper prints competitive with hard plates—and set the stage to make the dreamer's visions a reality. Frederick Scott Archer improved Talbot's process by using a chemical cocktail that became known as collodion and replaced the paper negative with smoother glass. Louis Désiré Blanquart-Evrard invented albumen paper, a high-quality product that was soon mass-produced. In 1853, the restrictive patents on Talbot's process were lifted.

The following year, French photographer André-Adolphe-Eugène Disdéri patented his invention of a *carte de visite* camera. It deployed several lenses to make multiple exposures on a single glass plate. Two monarchs popularized the *carte de visite* and launched a phenomenon known as Cardomania when they posed for portraits in the format: Napoleon III and Empress Eugénie in 1859, and Queen Victoria and Prince Albert in 1860.

The *carte de visite* gained a foothold in the U.S. coincident with secession and civil war. By the defeat of the Confederate armies and subjugation of states in rebellion in 1865, Cardomania had

swept the country and supplanted hard plates as the dominant format for portraits, and a huge number of mass-produced views of war scenes, military, political and religious leaders, stage celebrities, and other subjects.

Cartes de visite reached the zenith of their popularity about this time. In 1866, the introduction of the 5 by 7-inch cabinet card marked the beginning of *cartes de visite*'s slow and gradual slide as the public's format of choice. Cabinet cards became all the rage in the 1870s, though *cartes de visite* continued to be produced into the 1880s and 1890s.

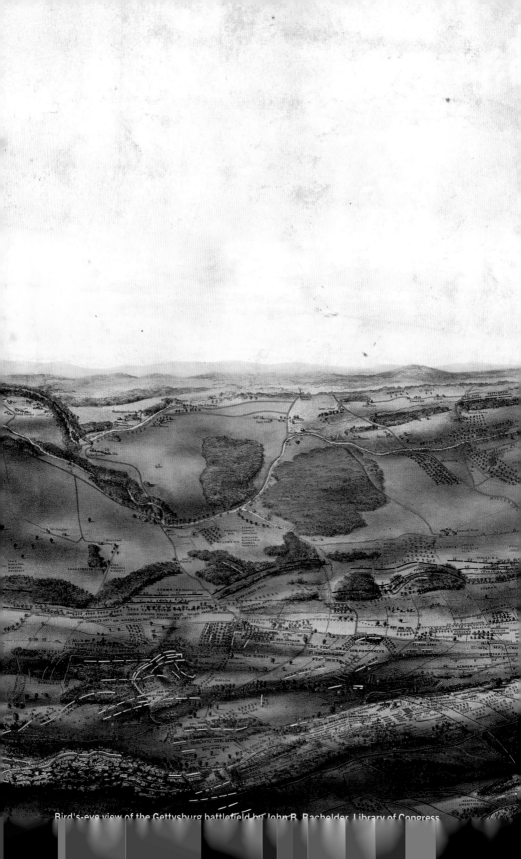

1

PRELUDE TO BATTLE

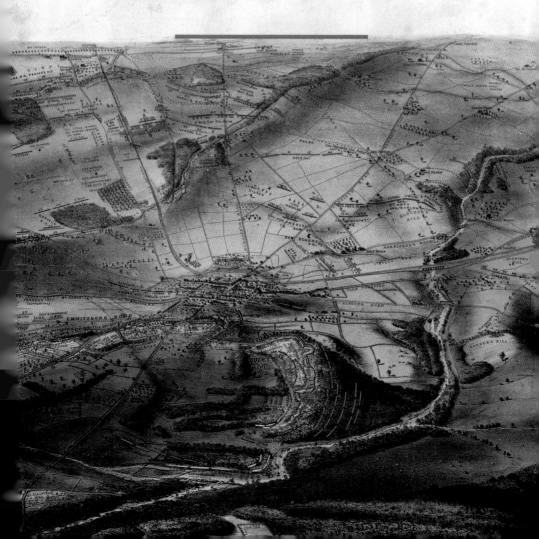

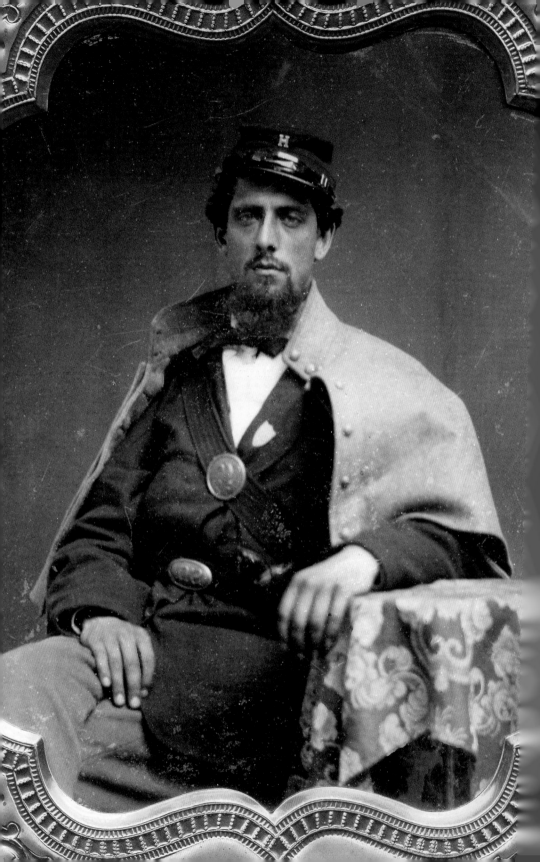

A Seminarian Answers the Call to Arms

A mass of college students crowded the street in front of Buehler's Book Store and Horner's Drug Store in downtown Gettysburg on June 16, 1863. They gathered to discuss the proclamation issued by Pennsylvania Gov. Andrew Curtin for citizens to defend the state against the invading Confederate army.

The outcome of this impromptu meeting was the formation of a military company composed of scholars attending Gettysburg College (known then as Pennsylvania College) and the Lutheran Theological Seminary. About 64 students volunteered, and locals filled out the balance of the 100-man company.

When it came time to choose a captain, the volunteers elected respected professor Frederick A. Muhlenberg. The 44-year-old teacher of ancient languages declined. The men then turned to one of their own: Frederic Wilson Klinefelter.

The son of a merchant from nearby York, Klinefelter, 26, had heard a call to the ministry in the late 1850s and embarked on a course of study to fulfill his spiritual needs.

The bombardment of Fort Sumter interrupted his plans. He set aside his books and left Gettysburg College for the ranks of the 16th Pennsylvania Infantry for a three-month enlistment. He marched off with the regiment for the Bull Run Campaign, but it

Sixth-plate tintype by an unidentified photographer. Paul Russinoff Collection.

did not participate in the culminating battle that ended in disaster for the Union army.

Klinefelter returned to Gettysburg College and graduated in 1862, then joined the student body of the Lutheran Seminary to prepare for the ministry.

The incursion of Gen. Robert E. Lee and his Army of Northern Virginia interrupted his studies for a second time in as many years. On June 17, 1863, the day after the meeting that ended with his election as commander of the College Guards, now Capt. Klinefelter assembled in the Diamond at Gettysburg College and listened to a speech by Prof. Muhlenberg. That afternoon they boarded a train bound for Harrisburg and transformed into Company A of the 26th Pennsylvania Emergency Infantry.

On June 17, 1863, the day after the meeting that ended with his election as commander of the College Guards, now Capt. Klinefelter assembled in the Diamond at Gettysburg College and listened to a speech by Prof. Muhlenberg.

Nine days later, on June 26, Klinefelter and his company, dressed in fresh uniforms and armed with Springfield muskets, returned to Gettysburg. Later that day, the regiment marched along the Chambersburg Road through a drizzling rain and set up camp about three miles outside town along Marsh Creek—under orders to delay the Confederates.

Battle-hardened veterans of the 35th Battalion Virginia Cavalry soon happened upon the scene and drove off the Pennsylvanians' picket guard. The colonel of the 26th, William W. Jennings, ordered a withdrawal. The Pennsylvanians beat a hasty retreat that devolved into a disorderly rush that ended two days later when the exhausted and hungry volunteers, their new uniforms wet and soiled, arrived on the outskirts of Harrisburg. Along the

way, they encountered the enemy on at least two occasions but did not engage.

The events of June 26 and the subsequent retreat were a subject of debate for years. Some blamed senior commanders for placing the militiamen in a precarious position, and others acknowledged that the group of raw recruits with no training did the best they could under difficult circumstances.

The 26th ended its enlistment in early August 1863.

Klinefelter graduated from the Theological Seminary in 1864 and embarked on a long career as Lutheran minister to flocks of the faithful across the region. Active in veterans' affairs, he attended an 1892 ceremony to dedicate a monument to the 26th in downtown Gettysburg. A second memorial marks the spot along Marsh Creek where the regiment first encountered Confederate cavalry.

Klinefelter died in 1903 at age 66. He outlived his first wife, Anna, who passed in 1884. His second wife, Clara, and a daughter survived him.

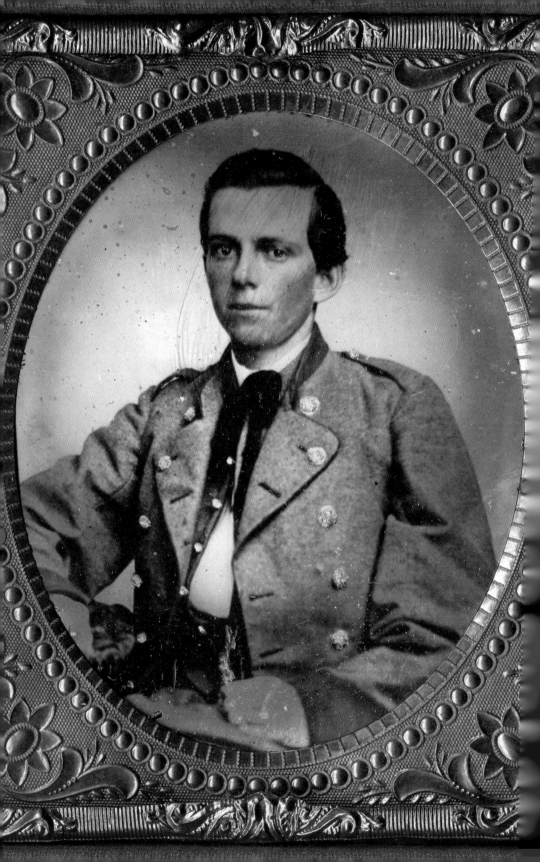

"I Hear the Booming of Artillery, and Must Prepare to Move"

As Gen. Robert E. Lee and the Army of Northern Virginia invaded Union territory in June 1863, his cavalry screened the move. The troopers, commanded by Gen. JEB Stuart, kept up a frenetic pace to conceal the operation from curious federals.

On June 21, a Sabbath day, Stuart had hoped to rest his weary forces. But Stuart's opposite number, Maj. Gen. Alfred Pleasanton, had other plans. Determined to find Lee's army, elements of his corps, supported by infantry, attacked Stuart in what became the Battle of Upperville, Va.

Forced back by the aggressive federals, Stuart made a stand at the village of Rector's Crossroads while his artillery hurriedly limbered up and prepared to flee oncoming infantry.

Meanwhile, Union artillerists lobbed shells towards the Confederate batteries. One of the projectiles landed amidst Stuart's 2nd Horse Artillery with deadly force. It tore one man to pieces before striking Pvt. Charlie Saunders in the leg above the knee.

Charles D. Saunders, the 19-year-old son of a tobacconist in Lynchburg, had joined the artillery a year earlier. A letter he wrote to his mother early that Sunday morning from Rector's Crossroads reveals his state of mind. "It is Sunday, but not the

Sixth-plate ambrotype by an unidentified photographer. Rusty Hicks Collection.

Sunday for having sweet communion with God, for hearing his gospel preached and going to Church with my *Mother*, but one, when we have to be on the watch for a vandal foe, and ready to move at any moment."

He added, "I hear the booming of artillery and must prepare to move—*trust in God.*"

That moment soon arrived, and the battle that ensued ended for Saunders when the shell mangled his leg. Surviving accounts indicate that a local reverend remained with him, as did a Saunders family slave named John who had been sent off to war with the young artilleryman.

Union troops soon overran the area, leaving a dying Saunders in the hands of the federals. They told John that he could leave, but he refused and remained with Saunders, who bled to death before a surgeon could perform an amputation.

The next day, after the federals evacuated, comrades recovered Saunders' body, placed it in a casket, and sent the remains home to Lynchburg for burial in the family cemetery. An epitaph on his stone obelisk is a moving tribute to a sacrificed soldier. It includes a reference to his last letter home, which included a line from "An Elegy on the Death of John Keats" by Percy Bysshe Shelley: "But I hear the booming of artillery, and must prepare to move. 'Trust in god' and ere the day closed, our brave, our beloved had 'outsoared the shadow of our night' in the dew of his youth, in the springtime purity of a heart, whose every pulsation was for love, faith, and duty. His soul passed away through fiery portals to join in the harmonies of the skies."

Clash at Caledonia Iron Works

As Confederate invaders pushed deeper into Pennsylvania in June 1863, clashes with hastily organized state militia were inevitable.

One such event occurred on June 23 about 15 miles west of Gettysburg. About 40 troopers from the veteran 14th Virginia Cavalry approached the Caledonia Iron Works, a factory owned by Thaddeus Stevens, an influential member of Congress and ardent opponent of slavery.

The Virginians sent the modest force of militiamen guarding the place scampering off into the woods. About this time, the Southerners faced a new threat in the form of a detachment of five Union scouts.

The scouts, dressed in new uniforms and armed with revolvers and carbines, had mustered into service earlier in the day as Bell's Adams County Cavalry. This was their first assignment.

Their number included 1st Sgt. Hugh Paxton Bigham, a Gettysburg clerk born and raised on a farm in nearby Freedom Township. He had no previous military experience, having avoided service until the war practically landed on the outskirts of his home turf.

The Virginia cavalry encountered by Paxton and his four fellow scouts at the Iron Works quickly turned into a chase. The superior number of confident Confederates rode in hot pursuit of Paxton and his detachment through thick woods as an indeterminate number of militiamen, hidden in the trees and brush, fired at the attackers. One of the Virginia lieutenants reported

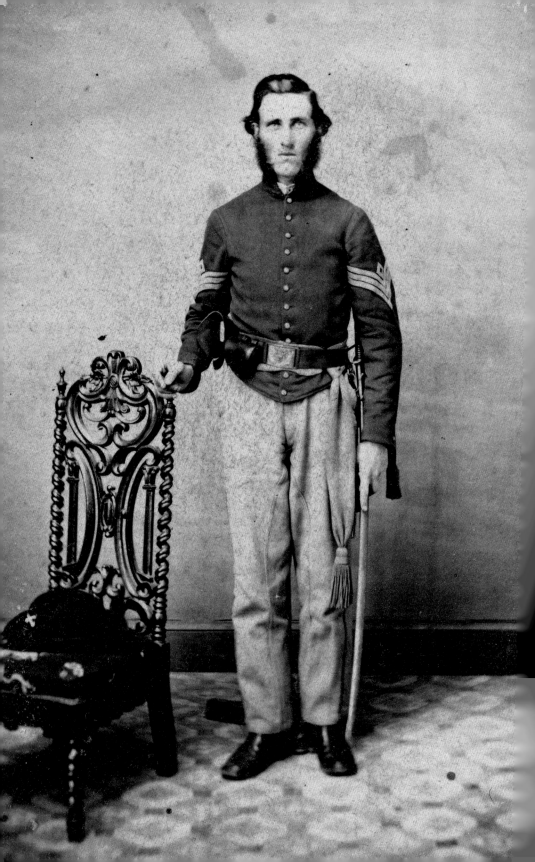

the mortal wounding of a private in his command, Eli Amick. Some historians recognize Amick as the first casualty of the Gettysburg Campaign.

The affair at the Iron Works marked the first of several encounters with Confederates by Paxton and Bell's Cavalry in the coming days. On June 26, about three miles outside Gettysburg at Marsh Creek, rebel forces gained the upper hand and ended with Bell's troopers retreating about 30 miles to York. On June 28, a reconnaissance near Wrightsville involved a clash with a Confederate infantry brigade commanded by Maj. Gen. John B. Gordon.

Paxton and his comrades did not participate in the Battle of Gettysburg. They headed to Harrisburg, the Keystone State capital, where they were mustered into federal service as Company B of the 21st Pennsylvania Infantry. The company returned to Gettysburg in August and received orders to police the area as provost guard.

The company served in this capacity three months later when President Abraham Lincoln arrived in town to dedicate the Soldiers' National Cemetery. Paxton was assigned to guard Lincoln during his stay—and bore witness to the historic events that unfolded on Nov. 19, 1863.

Paxton was assigned to guard Lincoln during his stay—and bore witness to the historic events that unfolded on Nov. 19, 1863.

Paxton stood nearby as Lincoln delivered his address at the dedication ceremony. "When the president arose," Paxton told an interviewer years later, "the audience moved about in an effort to get nearer the platform and the first part of the address was not heard clearly by the audience. Although Lincoln nodded his head during the delivery of nearly every sentence in the short

Hugh Paxton Bigham.
Carte de visite by Tyson Brothers of Gettysburg, Pa. Paul Russinoff Collection.

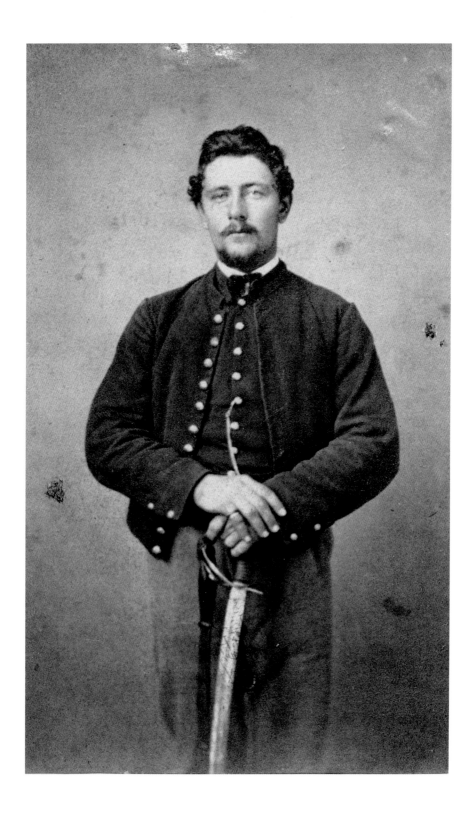

address," Paxton explained, "he made only one gesture during his speech. As he finished there was silence and then applause after which people crowded to the platform to congratulate him."

Paxton's time in uniform ended in February 1864 after an eventful nine months. He soon married, purchased a home and general store in the nearby community of Green Mount, and started a family that grew to include seven children. Paxton became the town's postmaster and played an active role in local civil and business affairs, as well as the veterans' organization, the Grand Army of the Republic.

Paxton lived until age 85, dying of pneumonia in 1926.

Rush McGaughey Bigham (1842-1874) served as a private in the same company as his older brother, Hugh. Rush stood guard at the Wills House, where President Lincoln lodged during his visit to Gettysburg in November 1863.

Carte de visite by Tyson Brothers of Gettysburg, Pa. Paul Russinoff Collection.

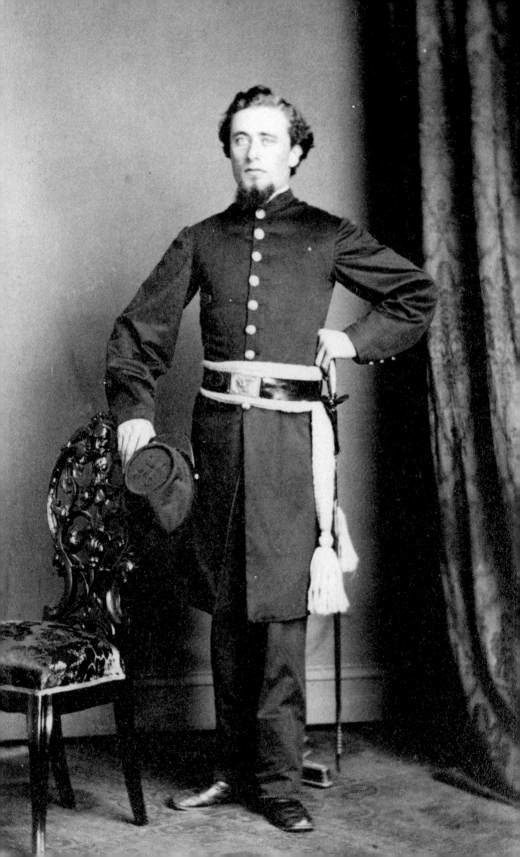

He Led Convalescents to Safety

As the Confederate invasion spread across south-central
Pennsylvania, fears for the safety of patients at the U.S.A. General
Hospital in York increased. Hospital staff prepared to move about
500 convalescents out of harm's way.

Medical personnel determined about 400 of the patients were
ambulatory and formed them into companies. Then, Hospital
Steward Albert Orion Cheney organized them into a battalion for
exercise and drill.

Cheney had previous experience as an active campaigner,
making him a logical choice for the assignment. When the war
started, New Hampshire-born Cheney left his job as a clerk in
Orange, N.J., and joined the 5th New York Infantry, popularly
known as Duryée's Zouaves. Following the Peninsula Campaign
in Virginia during the summer of 1862, he fell ill and gained
admission to the newly established hospital in York.

Before the end of the year, Cheney transferred from the bat-
tle-hardened Zouaves to become a hospital steward in the regular
army. He remained in York, tending to sick and wounded in the
same place he had so recently been a patient.

Cheney served in this capacity when rebel troops threatened
York. On June 28, 1863, as Lt. Gen. Jubal Early's Confederates
descended on the town, another hospital staffer marched the

Carte de visite by Evans & Prince of York, Pa. Author's collection.

battalion to nearby Wrightsville. Meanwhile, Cheney turned his attention to the remaining 100 less-mobile patients and led them to nearby Columbia, Pa., for safety.

After the fighting at Gettysburg ended, Cheney returned to the York hospital and helped care for the 2,000 wounded soldiers transported from the battlefield for treatment.

Cheney left York in late 1864 to accept a first lieutenant's commission in the 127th U.S. Colored Infantry. The regiment distinguished itself in several engagements during the Siege of Petersburg, including Chaffin's Farm, New Market Heights, and Fort Harrison. It went on to participate in the Appomattox Campaign, and fought at Appomattox Court House on the morning of April 9, 1865.

Two months later, Cheney, now captain and commander of Company K, and the rest of the 127th were sent to Texas. The regiment consolidated with another unit in September 1865, at which time Cheney and many other men received discharges.

Cheney went on to become a grocer in Poughkeepsie, N.Y., and patented a butter and cheese tray. He later sold real estate. Active in the Grand Army of the Republic and the Military Order of the Loyal Legion of the United States, he visited York in 1903 and reminisced with journalists at the *York Daily* about his hospital experiences. Cheney died in 1911 at age 69. His wife, Caroline, and five children survived him.

"No Wonder You Men Are Called the 'Iron Brigade'"

Second Lieutenant Lloyd Grayson Harris loved music. On June 30, 1863, as he and his comrades in the 6th Wisconsin Infantry marched through Frederick, Md., with the rest of the Iron Brigade, he noticed a music store. "I was excused from duty long enough to rush into the place and purchase a brand-new harmonica—vulgarly called a mouth organ. A simple affair, yet if well played makes enjoyable music," he later recalled.

That night, after a long day's march, Harris, 22, and his weary comrades camped beneath a starry sky. He pulled out his harmonica and played "Home, Sweet Home."

Home for Harris was the bustling big city of Buffalo, N.Y. As a teenager, he went to work for American Express. As the flourishing mail company expanded its operations in the West, Harris followed. By 1860, he had relocated to Wisconsin and become a company agent in Prairie du Chien.

Then came the war. Days after the bombardment of Fort Sumter, Harris joined the Prairie du Chien Guards, which became Company C of the 6th. Starting out as a sergeant, he proved a capable soldier and received his second lieutenant's shoulder straps before the end of 1861. He further distinguished himself in the 1862 battles of Second Bull Run and Antietam.

Less than a year later, on the morning of July 1, 1863, Harris recalled hearing the rhythmic booming of cannon as the Iron Brigade approached Gettysburg. Unaware of what lay ahead, he

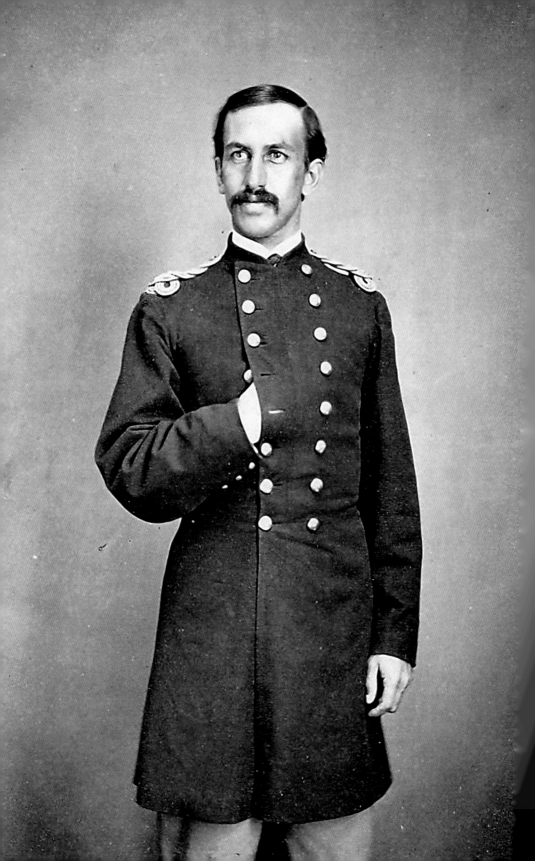

turned to a fellow officer and said, "The Pennsylvanians have made a mistake and are celebrating the 4th three days ahead of time."

Harris soon learned the truth, and before long the Wisconsin men were marching in double-quick-time, then running, toward the sound of the guns. They turned into a field and hastily prepared to engage the enemy as a band played "Hail Columbia."

Harris was not with his company, having been detailed to serve in the Iron Brigade Guard, a detachment of 20 men from each regiment in the Brigade. This body of men, led by Harris, charged ahead, following the colors as verbal orders were lost in the rising crescendo of roaring musketry and artillery. On they went into the cauldron of fire and gun smoke, men falling and the living closing ranks to fill the gaps.

Harris recalled the unity of the Brigade Guard, composed of stalwart veterans from Wisconsin, Michigan, and Indiana. "There was no difference in the fighting qualities of these men; every man was a hero, and, in my heart, it made me feel not less pride in my regiment but increased the *esprit de corps* of the 'Iron Brigade.'"

"There was no difference in the fighting qualities of these men; every man was a hero, and, in my heart, it made me feel not less pride in my regiment but increased the *esprit de corps* of the 'Iron Brigade.'"

By now, the men grappled for possession of a Confederate-occupied railroad cut that paralleled the Chambersburg Pike. In a final charge that compelled the surrender of the hard-fighting 2nd Mississippi Infantry, a buckshot blast caught Harris in the neck.

He made his way to a makeshift hospital in town for treatment. "As a surgeon was about to probe for buckshot in the fleshy part of my neck a good old lady, a volunteer nurse, who had been assisting me, declared that her nerves would not allow

Carte de visite by an unidentified photographer. Thomas Harris Collection.

her to witness such a sight. Here was my chance. Taking the harmonica from my pocket I said, 'Madam, the surgeon will be so gentle that while he is operating, I will play on this little musical affair.' So, while he in no delicate manner probed about with his torturing instrument, recklessly played 'Tramp, Tramp the Boys are Marching,' until he had finished, when the old lady with uplifted hands, exclaimed, 'no wonder you men are called the 'Iron Brigade.'"

Harris survived the surgeon's probe and beat a hasty retreat out of town when the rebels entered it. He survived his Gettysburg experience, and after mustering out of the 6th in the summer of 1864 went on to serve a stint in the Marine Corps. After the end of his service, he eventually settled in St. Louis and worked in manufacturing. Active in veterans' affairs, he recounted his war experiences in numerous writings. He lived until 1918, dying at age 68. He outlived his first wife, Florence. His second wife, Alma, and several children from both marriages survived him.

U.S.

Captain Clark and the Unexpected Recruit

"Captain, here's a recruit for you," said a sergeant in the 12th Massachusetts Infantry to his company commander. The captain, Erastus L. Clark, glimpsed the slender form of the boy in front of him. He could not have been more than 16 years old.

On any given day, the prospect of a new volunteer might have been welcome news. But on this day, June 30, 1863, the time, and place, seemed suspicious. The regiment had just encamped along a stream about five miles or so south of Gettysburg, and everyone sensed impending battle.

The sergeant had gone to the stream for water, where the boy approached him with questions about the probable outcome of current movements by the armies. The sergeant answered that he expected an encounter soon, and that they would soon be engaged in a great battle.

The boy told the sergeant that he wanted to join the army immediately "and fight the rebels."

The sergeant led the boy to camp and presented him to Capt. Clark. A salesman in Lynn, Mass., prior to joining the army, it is easy to imagine a man in his line of work had heard his share of tall tales. But Clark found the young man credible and escorted him to the regiment's commander, Col. James L. Bates. Clark listened as Bates peppered the boy with many questions. The interview ended with Bates telling Clark, "Well, captain, you may

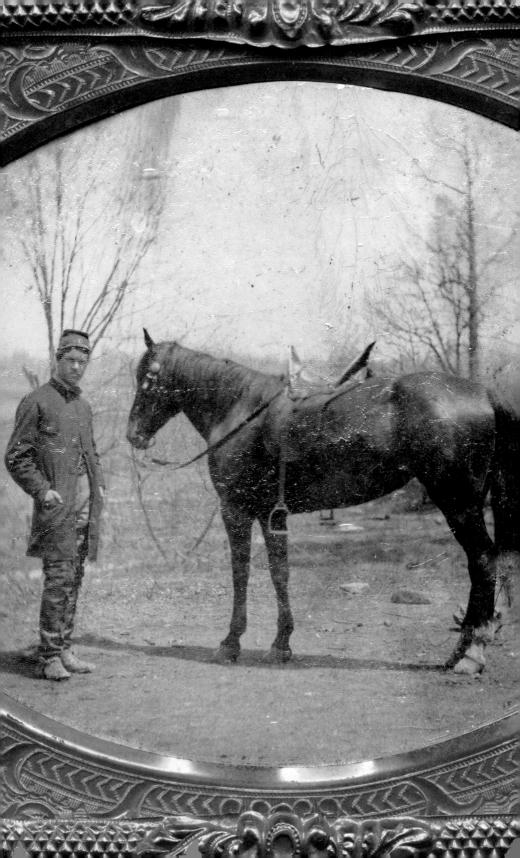

take him into your company if you wish, but we cannot muster him in now, as the books are back with the teams."

Clark returned to his Company A with the boy. The men scrounged up a cap, blouse, musket, equipment, and ammunition for the little recruit.

The next day, the boy went into action with Clark's company along Oak Ridge with the rest of the regiment. They suffered heavy casualties. The boy, Charles F. Weakley, fought like a veteran and suffered wounds in the right arm and thigh. Left behind during the retreat through Gettysburg, he eventually made it back to Union lines, recovered, and enlisted in the 13th Pennsylvania Cavalry. He drowned on Dec. 18, 1864, after an epileptic seizure.

More than two decades later, an account of Weakley's heroism at Gettysburg appeared in *The Century Magazine*. The author stated that his name and deeds were worthy of "a place upon the roll of fame beside that of John L. Burns," the War of 1812 veteran who also volunteered to fight at Gettysburg.

Col. Bates also suffered a wound and turned over command to a subordinate. He returned to the 12th and served with distinction in the 1864 Overland Campaign. He left the army in 1865 with a brevet, or honorary, rank of brigadier general of volunteers. Active in veterans' affairs, he died in 1875 at age 56. Physicians attributed his death to disease contracted in the military.

A shell, or fragment of one, hit Capt. Clark in the face. It destroyed the roof of his mouth and tore away a significant portion of his upper jaw and teeth, save three molars. He also suffered other injuries. Clark recovered and transferred to the 6th Veteran Reserve Corps for the remainder of his enlistment. In early 1867, when he was about 32 years old, Clark became a Freedmen's Bureau agent and purchased a stake in a Louisiana plantation. A dispute with his partner was settled on July 17, 1867, by a brutal duel with pocketknives. Clark lost.

Quarter-plate tintype by an anonymous photographer. C. Paul Loane Collection.

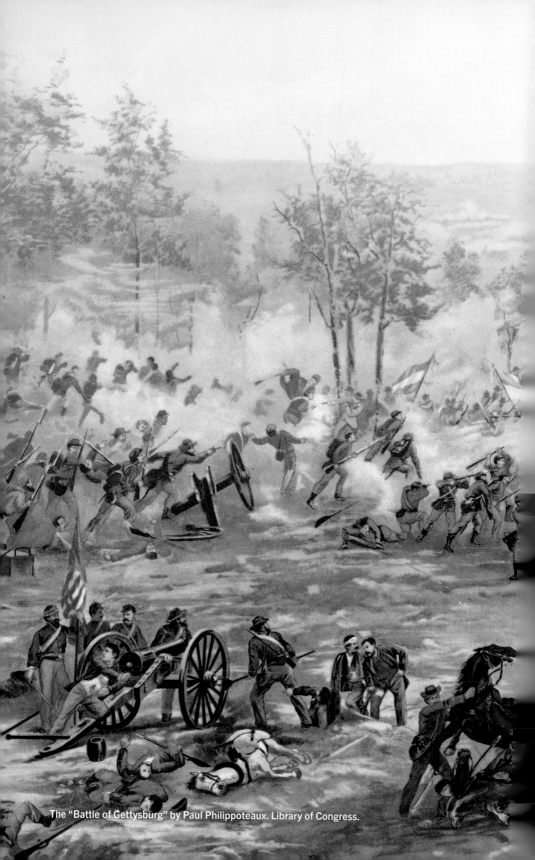

The "Battle of Gettysburg" by Paul Philippoteaux. Library of Congress.

2

THE FIRST DAY

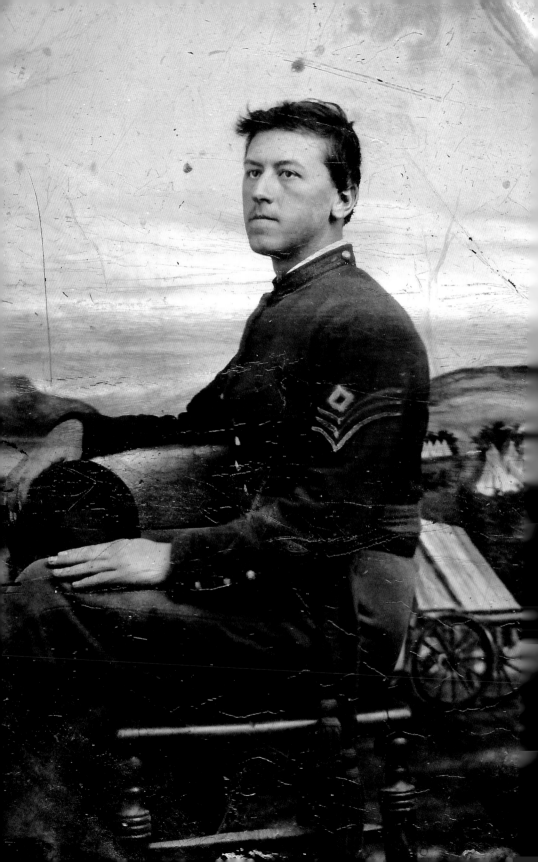

Sunrise Encounter with Ewell's Corps

Rebel forces marched south along main thoroughfares
approaching Gettysburg near dawn on July 1. Along the Carlisle
Road north of town, streaks of early-morning light revealed a
large body of troops, the vanguard of Lt. Gen. Richard S. Ewell's
2nd Corps.

The movements of Ewell's men and other Confederates
were known to scant Union cavalry forces scouting the area.
Commanders in blue acted to slow the rebel advance and to buy
time for federal infantry from the Army of the Potomac to arrive
and deploy.

Among the troopers dispatched to delay Ewell was a battalion
of troopers belonging to the 17th Pennsylvania Cavalry. Its num-
ber included Wilson S. Severs, a corporal in Company F.

Severs and his comrades were intimately familiar with the
area, for they hailed from Cumberland County, which shared a
border with Adams County and Gettysburg. Severs, the youngest
of five in a farm family in Dickinson Township, had enlisted nine
months earlier. He likely could not have imagined that the war
would come to his home county—and that he and his neighbors
would be among the first soldiers to encounter the invaders.

On the night of June 30, Severs' company and two others from
the 17th dismounted and formed a picket line along with other

Sixth-plate tintype by an unidentified photographer. Britt C. Isenberg Collection.

skirmishers from their division. The Pennsylvanians waited with loaded carbines for Ewell's Corps.

Hours later, about sunrise on July 1, gunfire erupted as the thin blue line of cavalrymen encountered the superior number of Confederates. Over the next two hours, the 17th, supported by the 9th New York Cavalry and other forces, successfully delayed the advance of Ewell's Corps. Meanwhile, the Union's 11th Corps arrived and joined the rapidly escalating fight.

It may be fairly stated that the efforts of the 17th on the morning of July 1 contributed to the final victory of the federals two days later.

Severs survived Gettysburg but did not enjoy the laurels of victory for long. In August 1864, he suffered a mortal wound in a skirmish with elements of Lt. Gen. Jubal Early's Confederates near Leetown, Va. Severs did not live to see his 21st birthday—or peace. He outlived his mother and two brothers who had died before the war. His father and two other brothers survived him.

Hit in the First Charge
of the Iron Brigade

The black-hatted Iron Brigade men marched into action on the first day of fighting unaware that their stellar performance would become the stuff of legend. One of the men who fought that day, Sgt. Theodore Dosch Bahn of the 2nd Wisconsin Infantry, numbered among the earliest to land on the casualty list.

According to a biographical sketch, Bahn suffered a bullet wound in the lower left side of his chest during the Brigade's initial charge into battle. He crumpled to the ground about 30 yards from the spot where Maj. Gen. John F. Reynolds fell. Bahn mustered his strength, and though in severe pain limped to the Adams County Court House, which had been converted to a makeshift hospital. As the chaos and confusion of fighting raged, Bahn remained in town until the close of the battle, when medical personnel transferred him to the U.S.A. General Hospital at York, Pa.

York proved an unexpected homecoming for Bahn, for he had been born and raised on a farm in York County 30 years earlier. Following the untimely death of his mother during Bahn's teen years, his family sent him to live with an uncle in the West, and he eventually made a home in Columbia County, Wis.

When the war came, Bahn enlisted as a sergeant in Company H of the 2nd. He suffered a gunshot wound in the right shoulder near the base of the neck at First Bull Run, recovered, and served

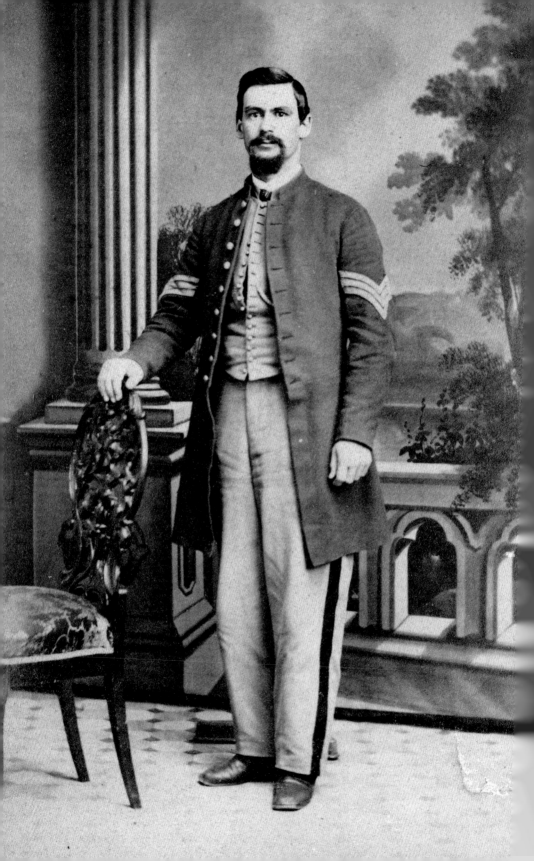

on various detached duties with the Engineer Corps until January 1863, when he returned to his regiment.

Six months later he received his second war wound at Gettysburg, and it ended his combat service. In February 1864 he transferred to the Veteran Reserve Corps as a first sergeant and served as a clerk in the commanding surgeon's office at the York hospital. A few months later, he received a discharge and left the army.

Bahn returned to Wisconsin, married, and worked for a few years. In the 1870s he moved back to York County and went to work in his brother-in-law's lumber and hardware business in Wrightsville. In 1880, Bahn opened his own business as a milliner. He eventually settled in Lancaster, Pa. Active in the Grand Army of the Republic, he died of pneumonia in 1912 at age 78. His wife, Hattie, and two children survived him.

Carte de visite by Evans & Prince of York, Pa. Author's collection.

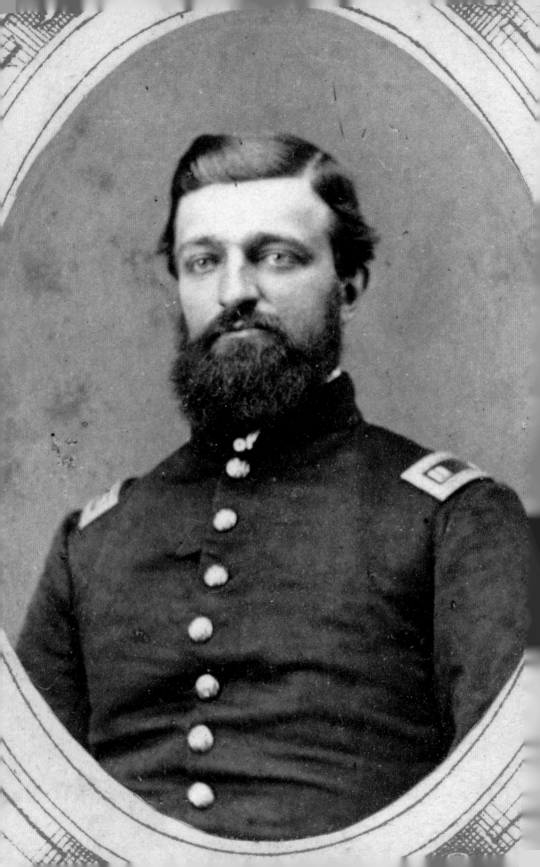

Captain Gordon's Gallantry

—————

As heavy fighting swirled around the Iron Brigade on July 1, a musket ball stunned a sergeant in the 24th Michigan Infantry. By the time he regained his senses the regiment had fallen back a few yards. He stumbled over several men and made his way back to his Company I, where he observed his captain, George C. Gordon, in action. The sergeant recalled, "Captain Gordon was using great energy in keeping his men in line. I never saw a man stand with such determined energy as he did. I was told afterwards by the commanding officer of the next company that our captain kept one of the best lines in the regiment. All who saw his conduct speak in the highest praise of his gallantry."

Gordon, a physically large and warm-hearted man with a generous spirit, possessed leadership abilities that traced to his boyhood. Born in Canada, he came to Michigan after the premature death of his father prompted his mother to place him in the care of an uncle who farmed in Michigan. Gordon attended school in the winter months and discovered a passion for education. During his teens and twenties, he taught in Canada and Michigan, eventually becoming a law student at the University of Michigan. He graduated in 1861.

The following summer, he left behind his wife, Carrie, whom he had married in 1857, and two young children to join the 24th

Carte de visite by an unidentified photographer. John Fuller Collection.

as the original captain and commander of Company I. His men, and the rest of the regiment, joined the Army of the Potomac and fought well at the Battle of Fredericksburg and other operations in Virginia.

The Michiganders distinguished themselves again at Gettysburg. They marched into the first day's fight 496 men and officers strong and suffered 316 casualties—a loss of about six of every ten men. Casualties included Capt. Gordon, who fell into enemy hands.

They marched into the first day's fight 496 men and officers strong and suffered 316 casualties— a loss of about six of every ten men. Casualties included Capt. Gordon, who fell into enemy hands.

Thus began an odyssey in Southern prisoner of war camps. Over the next 20 months, his captors held him first at Libby Prison in the Confederate capital, then transferred him to camps in Macon, Ga., and Columbia, S.C.

On Feb. 14, 1865, he and three fellow prisoners escaped from Columbia while being transported by train to what he supposed was another prison—but was a trip to be exchanged. He spent the next three weeks sick, shoeless, and half-naked in the wilds of South Carolina. At one point, a detachment of enemy cavalry commanded by Maj. Gen. Joe Wheeler recaptured him, but he escaped after the trooper ordered to guard him fell asleep. Enslaved people helped Gordon find his way to freedom inside Union lines.

Gordon reunited with his company in May 1865. Absent was the sergeant who noted his commanding presence at Gettysburg: Eugene Narden had been captured the summer before in Virginia and was sent to the prison camp at Salisbury, N.C., where he died.

Gordon ended the war with a brevet rank of major. He returned to Michigan and reunited with Carrie and their two children in Wayne County. The family grew to include six kids, and Gordon supported them as a farmer. He also became involved in civic affairs as a justice of the peace and superintendent of schools.

Like his father before him, Gordon died young. He passed away Aug. 27, 1878, at age 45. His wife and children survived him. A seventh child, a daughter, also outlived him. She was born to Gordon and his first wife, Charlotte, who died in 1855 during their second year of marriage.

Two days after Gordon's death, his funeral took place. It happened to be the 16th anniversary of the day he marched off to war with the 24th.

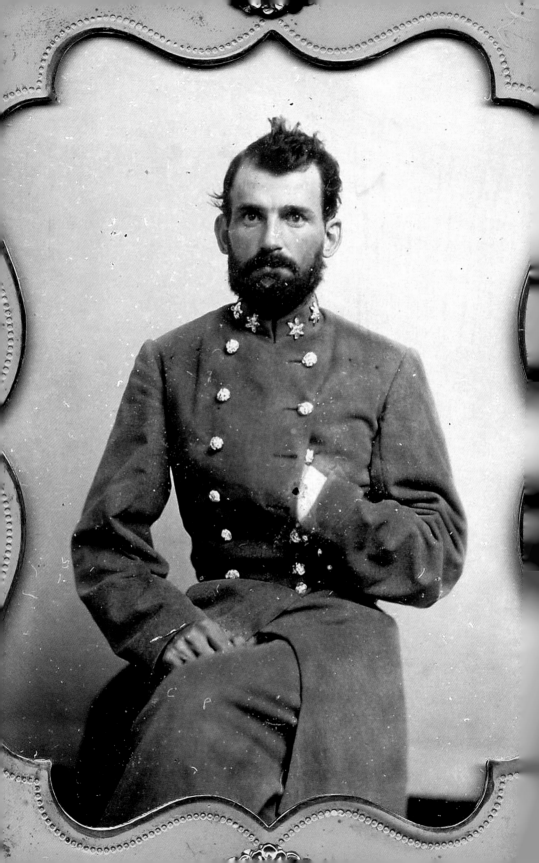

Death Trap

Half a brigade of North Carolinians charged across open ground toward Union forces defending the McPherson Farm and encountered an unexpected obstacle: a steep-sided railroad cut. At this critical moment a hail of enemy musket and artillery fire swept the ranks. The Tar Heels reacted by jumping into the cut with a view to scrambling up and out on the other side before continuing the advance.

The federals opposite them had no intention of letting them leave. One North Carolina senior officer stuck in the cut described it as a "death-trap." He was Wharton Jackson "Jack" Green, a 32-year-old colonel who hailed from an illustrious family. His father, Thomas Jefferson Green, followed the fortunes of expanding America from his home state of North Carolina to Florida, the fight for Texas independence, and the California Gold Rush. He served as a legislator in all these places.

Green enjoyed the fruits of his father's labors by attending prestigious private schools and elite universities, including a three-year stint at West Point. He resigned his cadetship in 1853 with the explanation that he had no desire to serve in the peacetime army.

Instead, he studied law and opened a practice in Washington, D.C. Green left the capital about 1859 for his family's 900-acre

Half-plate ambrotype by an anonymous photographer. Daniel Taylor Collection.

plantation, Esmeralda, in the North Carolina Piedmont region. According to the 1860 census, he enslaved 64 people.

Less than a week after the bombardment of Fort Sumter, Green put his West Point education into practice when he joined the army. Over the next two years, his military career twisted and turned much as his civilian life did: He served in two commands, was captured at the Battle of Roanoke Island in early 1862 and held prisoner for a month, and, finally, earned a colonel's commission and served as an aide to Brig. Gen. Junius Daniel in the North Carolina Brigade.

At Gettysburg on July 1, Green received orders to accompany the right wing of Daniel's Brigade and landed in the precarious position in the hollow of the Railroad Cut. In the storm of enemy shot and shell, Green advised the senior officer, Col. Edmund C. Brabble of the 32nd North Carolina Infantry, to fall back, regroup, and finish the charge.

Then, Green took matters into his own hands. He grabbed a musket, crawled to the top of the cut, and spied Union infantry about a hundred yards ahead. He raised the musket, took aim at the hat-waving officer leading the federals, and pulled the trigger. The officer fell, and Green lost his balance and tumbled to the bottom of the cut. Almost immediately, a bullet or shell fragment struck him in the back of the head. A fellow officer came to his aid and accompanied him to a field hospital.

He raised the musket, took aim at the hat-waving officer leading the federals, and pulled the trigger. The officer fell, and Green lost his balance and tumbled to the bottom of the cut. Almost immediately, a bullet or shell fragment struck him in the back of the head.

Three days later, Union cavalry captured Green and other wounded Confederates as they fled Gettysburg. A prisoner of war

for the second time in as many years, Green spent the rest of the war in camps at Fort Delaware, Del., and Johnson's Island, Ohio.

Following his release in 1865, Green returned to North Carolina, managed a vineyard, and became politically active in the Democratic Party, including two terms as a member of the U.S. House of Representatives. In 1906, his *Recollections and Reflections: An Auto of Half a Century and More* appeared in print. In it, he expressed his allegiance to Jefferson Davis. Green died four years later at age 79.

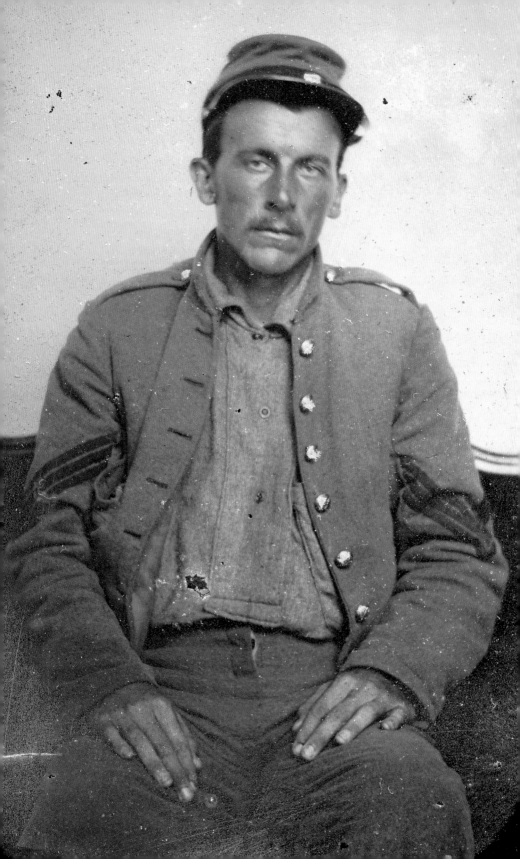

Spared to Fight Another Day

In its first major engagement at the Railroad Cut on July 1, the 55th North Carolina Infantry performed well and suffered heavy losses against elements of the Iron Brigade. Among the Tar Heels who fought here was Lt. William Henry Graham Webb Jr. of Company K. A native Virginian, he attended the University of North Carolina, leaving in 1860 with a degree and membership in Delta Kappa Epsilon fraternity.

When war erupted in early 1861, Webb lived in Granville County, N.C., just north of Raleigh. He promptly enlisted in his adopted state's 12th Infantry and is pictured here wearing his sergeant's chevrons.

About a year later, he left the regiment to accept a commission as a second lieutenant in Company K in the newly formed 55th. Webb and his comrades in both regiments served in southeastern Virginia and eastern North Carolina during this early part of the war, participating in small-scale operations in a less active region.

In June 1863, everything changed when the 55th joined a brigade in Maj. Gen. Henry Heth's Division of the Army of Northern Virginia and invaded the North.

At Gettysburg, Webb survived the fighting in and about the Railroad Cut but was not as fortunate two days later at Pickett's Charge. At some point during the assault, he suffered a wound

Sixth-plate ambrotype by an unidentified photographer. Ben Pauley Collection.

in the leg and fell into enemy hands. His captors moved him to a general hospital in Chester, Pa., to recuperate. In a case all too common among the injured, his wound became infected, and he died of pyemia, or blood poisoning, on Sept. 21, 1863. He was in his early twenties. Buried in the Philadelphia National Cemetery, his name is listed on the cemetery's Confederate Soldiers & Sailors Monument erected in 1911.

He Fought in the Spirit of the First Bucktails

Private Isaac Mall and his comrades in the 149th Pennsylvania Infantry defended their country and home state on July 1. They went into the fight wearing trademark deer's tails attached to their caps—a constant reminder that much was expected from them.

Two years earlier at the war's beginning, another Keystone State regiment, the 42nd Infantry, was the first to don the unique caps. The 42nd became popularly known as the Bucktails and went on to a distinguished combat record. These hard-fighting men and officers inspired the formation of the Second Bucktail Brigade, which included the 149th and 150th Infantries.

Organizers sought volunteers for the new Bucktails in the summer of 1862, and Mall numbered among those who heard the call and enlisted. A 20-year-old farmhand in Myerstown, Pa., he represented the ideal recruit as described in a sketch of the regiment: "The men of the 149th were of fine physique, accustomed to the rifle, and wore the bucktail as did the original regiment of that name."

Mall mustered into Company C in August 1862. Less than a year later at Gettysburg he and his brother Bucktails deployed south of the Chambersburg Pike along McPherson Ridge on the first day of the battle. Following in the footsteps of the first Bucktails, the men fought hard and stubbornly resisted overwhelming rebel forces until compelled to withdraw through town with the rest of the Union army.

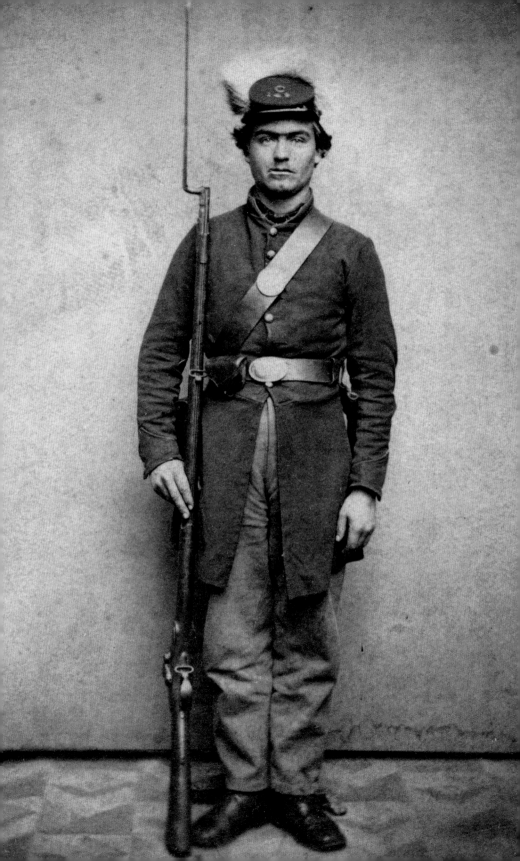

Losses in the 149th were catastrophic. Of the 450 men who began the day's fighting, 336 became casualties, or about three-quarters of the regiment. At some point during the action, Mall lost his life. His remains are likely buried with other unknown soldiers in the Soldiers' National Cemetery.

Carte de visite by Bell & Brother of Washington, D.C. Rick Carlile Collection.

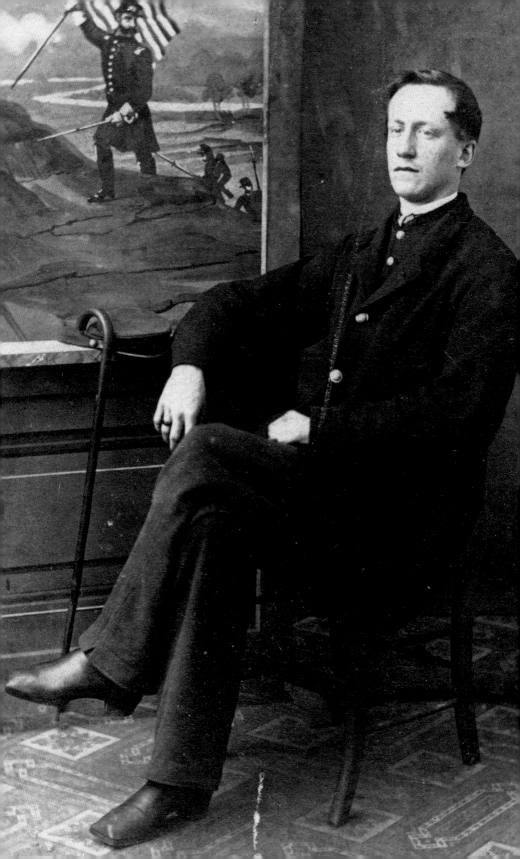

A Teen in the Ranks

Wheeling into position along Oak Ridge early on the first day's fight, the 12th Massachusetts Infantry had a commanding view of the ground in its front. The enlisted men and officers, 301 strong, glimpsed Confederate forces, three battles lines deep, plowing through wheatfields towards them. Behind this juggernaut, heavy reinforcements were plainly visible in the distance.

By this time, bullets zipped and buzzed around them, and the Bay State boys responded in kind. They tore open cartridges, rammed gunpowder and ball down the barrels of their muskets and fired back. Their number included 18-year-old Joseph Warren Thayer of Company H.

Thayer had had a hard time getting into the army. On April 16, 1861, in the frenzied rush of volunteerism following the bombardment of Fort Sumter, then 16-year-old Thayer joined the army. He returned to his Chelsea home late that night. The next morning, his father, Warren, a tinsmith by trade, confronted Thayer about his whereabouts the previous evening. Upset by young Thayer's move, he acted quickly to have his underage son's name stricken from the roll. A few weeks later, Thayer ran away and enlisted again. His father found him at Fort Warren with the 12th and consented after realizing his determination to serve.

Carte de visite by Joshua A. Williams from Lovell General Hospital, Portsmouth Grove, R.I. Michael J. McAfee Collection.

Thayer remained with the 12th and Company H until a foot wound at the December 1862 Battle of Fredericksburg landed him in the hospital. Four months later, he returned to the regiment in time to participate in the Gettysburg Campaign.

Thayer and his comrades distinguished themselves in the fighting along Oak Ridge. They kept up a lively fire until out of ammunition, then stood fast and prepared to repel the oncoming Confederates with bayonets until ordered to withdraw.

They kept up a lively fire until out of ammunition, then stood fast and prepared to repel the oncoming Confederates with bayonets until ordered to withdraw.

At some point during the action, Thayer fell with a severe wound to his thigh. In the chaos and confusion of the withdrawal, he fell into enemy hands. Four days later, Union forces found him alive and abandoned by his captors after they retreated from Gettysburg.

Thayer spent the next year in hospitals at Fort Schuyler, N.Y., and Portsmouth Grove, R.I. In the latter place he sat for this photograph. Midway through his convalescence, medical personnel determined his injury prevented him from an active role with the 12th and recommended his transfer to the Veteran Reserve Corps. He served the remainder of his three-year enlistment on light duty and mustered out with an honorable discharge in June 1864.

Thayer returned to Chelsea and went to work as a police officer until his Gettysburg wound slowed him down. He then landed a government job as a customs inspector at the Port of Boston.

He poured his heart and soul into the Grand Army of the Republic, the influential national veterans' organization. A charter member of his local post, he rose through the ranks to become a department commander. Conspicuous at veterans' reunions, he hung a banner adorned with badges from the

various events in his home. According to a newspaper report, "That the memories and attachments made during the war were very dear to Mr. Thayer may be quickly seen by his remark to a friend: 'My folks call me a crank,' said Mr. Thayer, 'and they say I would do more for the G.A.R. than for anything else.'"

Thayer remained active with the Grand Army until his passing in 1905 at age 60. He died unmarried and without children.

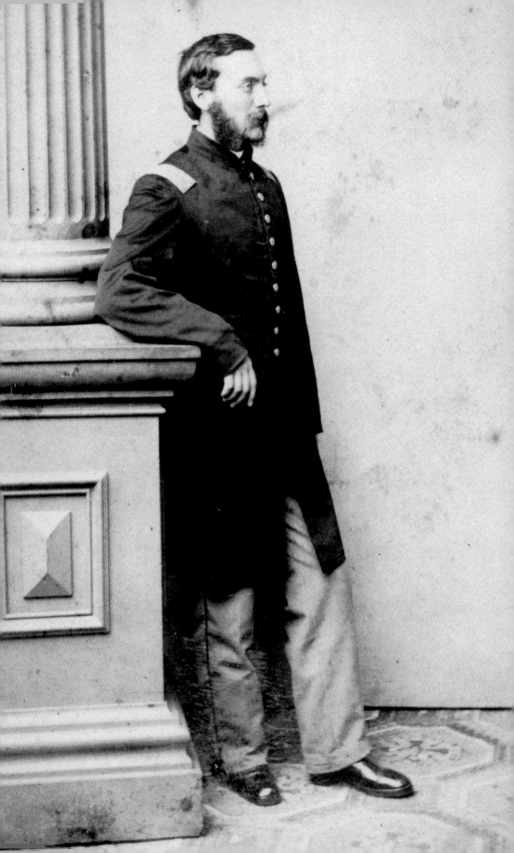

Cool Courage and Cartridges

The 97ᵗʰ New York Infantry and its brigade went into action against advancing Confederates along Oak Ridge during the first day of battle. The Empire State men loaded and fired their muskets at a feverish pace as the fighting rapidly escalated.

In Company K, one of the officers cheered his men on in the rising din of battle. 1ˢᵗ Lt. Rush Palmer Cady kept up the words of encouragement. He also helped individual soldiers by removing paper cartridges from their ammunition boxes and tearing them open, saving precious seconds. One sergeant recalled Cady was "as cool as though it was nothing but play" as "the balls went whistling by us like lightning."

Cady's calm courage during the intensity of the combat came as no surprise to his comrades. The eldest son of Daniel and Fidelia Cady, he possessed a strength of character and a methodical approach to life that belied his 21 years. Moved by the patriotism that swept the loyal states after the war began, he set aside his studies at Hamilton College in early 1862 and joined the army with a second lieutenant's commission in the 97ᵗʰ.

The regiment soon moved to Virginia, joined the Army of the Potomac, and proved its fighting abilities in the Second Bull Run Campaign and battles of Antietam and Fredericksburg. Along the way, Cady received a promotion to first lieutenant of Company K.

Carte de visite by an unidentified photographer. Charles T. Joyce Collection.

At Gettysburg, the New Yorkers again distinguished themselves during the first day's fight by charging the enemy and capturing the colors of a North Carolina regiment and taking many prisoners. As more Confederates arrived on the scene and the 97th fell back, a bullet struck Cady's right arm and passed into his body, where it lodged in one of his lungs. The sergeant who recounted Cady's valor noted that the bullet hit him as he rallied his men. The ball struck and knocked him backward. "Oh! I am hit," he cried.

Some of the men helped Cady to the rear, stopping along the way to give him a drink of brandy and water. By now the tide of battle had turned in favor of the Confederates. Cady, fading but still conscious, ordered the men to leave him and go to safety. They reluctantly obeyed, leaving him in a barn in town.

Confederates eventually discovered Cady in the barn and immediately paroled him. They may have been in too much of a hurry to carry a wounded prisoner or grasped the severity of his injury. Cady eventually made his way to a hospital, where a surgeon determined that the lead slug could not be removed. They made him as comfortable as possible for what was sure to be his final days. "I am keeping up good courage—I am in a good place, where my wants are well attended to," he wrote to his family. "How I would like to be received to your arms. O pray for me Mother, that I may have grace & strength to endure my sufferings patiently."

His mother soon arrived from the family home in Rome, N.Y. She remained with him night and day, always hopeful as she watched him sink. "Oh, my husband," she wrote home on July 23, "can we part with our dear brave boy—May God give us grace to bear all we may be called upon to do—Pray for me & him too, husband mother & child—but he may live we have great hopes yet."

Cady died the next day at 2 p.m. His mother brought his body home for burial in Rome Cemetery.

Briefly in Command

The 74th Pennsylvania Infantry arrived on the outskirts of Gettysburg about noon on July 1 as Confederate forces rolled through town. The regiment—about 136 strong, among them many Prussian immigrants—had no time to cool its heels. The rank and file spread out in a thin line to the left of its 11th Corps, in front of Dilger's Ohio Battery and near the Mummasburg Road.

The rebel juggernaut hit them hard with musketry. Among the early victims of its fire was the colonel of the Pennsylvanians, Adolph Von Hartung, who suffered a gunshot in the leg. He turned over command to his lieutenant colonel, Alexander Theobold Von Mitzel. A Prussian military educated native of Berlin in his late 20s, he had played a major role in recruiting the 74th earlier in the war.

Now, acting commander Von Mitzel worked to save his men. He coordinated the withdrawal of the regiment to a new position at Cemetery Hill in the face of overwhelming enemy forces. During the retreat, he received a wound in his right hand and fell into Confederates hands.

This was the second time he had become a prisoner of war in as many months. The first, during the Battle of Chancellorsville in May, ended with a trip to the Confederate capital and Libby Prison. Paroled and exchanged after 10 days in confinement, he soon returned to the 74th.

After Gettysburg, Von Mizel's return trip to Libby lasted considerably longer. At some point after his arrival, he hooked up

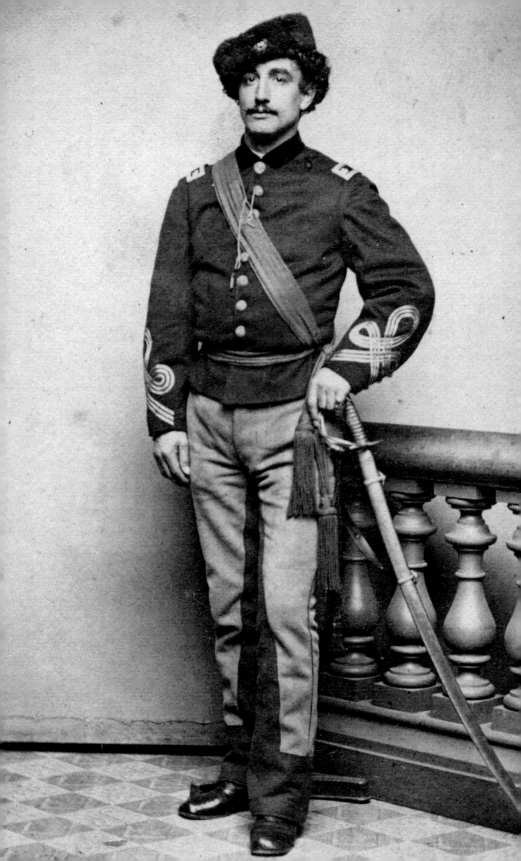

with a band of fellow prisoners determined to break out of the rat-infested, poorly maintained facility. This group of desperate, determined men dug a long tunnel from the prison to an adjacent warehouse. During the night of Feb. 9, 1864, Von Mitzel and 108 other officers crawled through the tunnel and disappeared. He and about half of the escapees made it to the safety of Union lines.

Von Mitzel returned to his regiment, but the effects of his wound and prison exposure ended with a disability discharge before the end of the year. He settled in Baltimore, the city through which he had immigrated in the 1850s, married Wilhelmina "Minnie" Frey, and started a family that grew to five children. Von Mitzel supported his brood as a restaurateur and beer importer until his death at about age 52 in 1887.

Carte de visite by an unidentified photographer. Karl Sundstrom Collection.

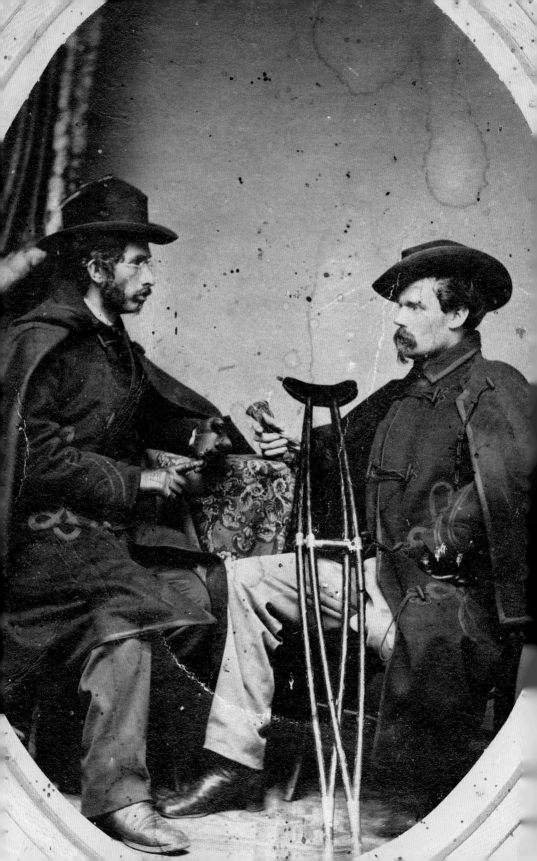

Saving Dan McMahon

Union troops put up a stiff resistance as they retreated toward Seminary Ridge during the first brutal day of fighting. In the ranks of the 20th New York State Militia, the men repeatedly rallied against the attacking Confederates.

At one point near the Theological Seminary, the New Yorkers formed a line and fired away until overwhelming rebel forces prompted orders to fall back. The line disintegrated as the men broke into a run and followed the regimental colors.

One of the officers following the flags paused at the distinctive Seminary building. "I found there on the ground Captain Dan McMahon, one of our best and bravest officers, with a shattered thigh, and beside him a man of his company, who was unwilling to leave him. The captain entreated me to help him away and I could not resist his appeal."

Daniel McMahon, an English-born veteran of the Crimean War, responded to the call to arms for his adopted country in August 1861. He accepted a captain's commission in Company D of the Ulster Guard, a regiment formed by a reorganization of the 20th New York State Militia after its return from a three-month stint in Washington, D.C., and Baltimore. The regiment mustered into federal service as the 80th New York Infantry but retained its designation as the 20th.

McMahon, right, posed for his portrait with a fellow officer, 1st Lt. Nicholas Hoysradt (1838-1879).

Albumen print by Wolff of Alexandria, Va. Seward Osborne Collection.

The regiment participated in major operations with the Army of the Potomac, including the Peninsula Campaign and the Battles of Antietam and Fredericksburg. McMahon suffered a minor wound at the Battle of Chantilly in September 1862.

His wounding at Gettysburg left him stranded at the Seminary. One gunshot had fractured his left leg and he had suffered another injury to his right thigh. In response to McMahon's plea to be moved to safety, the soldier who stayed with him, his name lost to history, leapt into action. He removed a belt and bound McMahon's legs together—forming a sort of sling. The officer who spotted McMahon, Capt. John D.S. Cook of Company I, held on to one shoulder and another man near Cook grabbed the other. The three men carried McMahon around one side of the building and down a walkway crossing the front lawn. "The weight was too much for us," recounted Cook, adding, "but I stopped a Pennsylvanian who came running after us, and he took my place while I held up the captain's head."

One gunshot had fractured his left leg and he had suffered another injury to his right thigh. In response to McMahon's plea to be moved to safety, the soldier who stayed with him, his name lost to history, leapt into action. He removed a belt and bound McMahon's legs together—forming a sort of sling.

Meanwhile, advancing Confederates came ever closer and the New Yorkers' fleeing comrades were moving farther away. Cook made the difficult decision to leave McMahon behind. He spotted a small house that might provide protection and the group made a beeline for it. Just as they approached a fence leading to the door, rebel lead hit two of the men and the entire party stumbled and fell to the ground. McMahon rolled into a ditch. Cook, unhit, arranged McMahon's limp body in the ditch, bade him goodbye, and crept along the fence and on to safety.

Union forces eventually recovered McMahon. Surgeons determined his shattered leg beyond saving and amputated it. He survived the operation and left the army in 1864. He continued his association with the regiment as its sutler, providing specialty foods, supplies, and other personal items to soldiers.

McMahon settled in Washington, D.C., after the war and earned a law degree from Columbian College (now George Washington University) in 1870. He went on to become a clerk in the Pension Bureau, where he helped process claims for disabled veterans and their widows. McMahon died in 1888 at age 49.

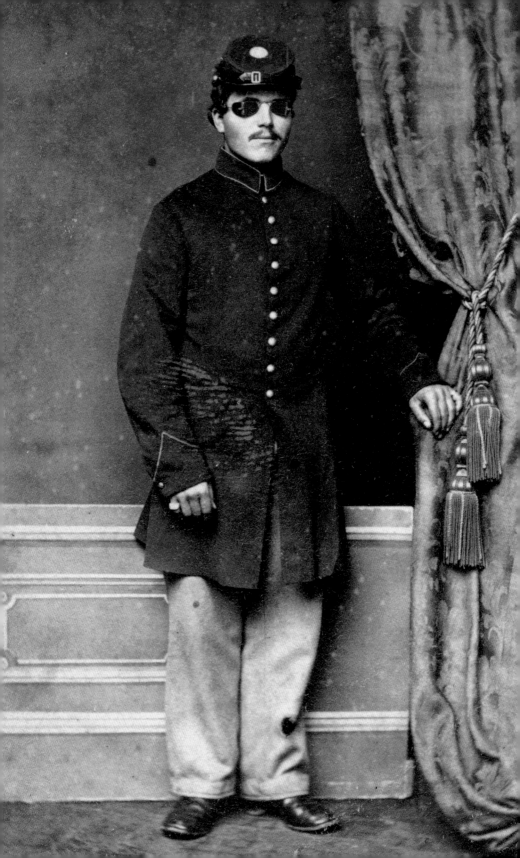

The Last Vision He Had Was a Rebel Flag

Union brigades hastily formed a defensive line along Seminary Ridge during the afternoon of July 1 as advancing Confederates massed for an attack. In one place, just west and in view of the Lutheran Seminary, a gap formed. Into this space filed the 151st Pennsylvania Infantry. The ranks included 23-year-old Pvt. Michael Link, a farmhand from Reading, Pa.

Link and his comrades had little time to spare.

The Pennsylvanians were under orders to fire at will into the advancing wall of rebels. The nature of the ground and the rapidly developing situation did not permit organized volleys. As the Confederates moved within range, the Keystone State boys peppered them with musket shot and received the same in return. The gunfire quickly escalated.

In the middle of the frenzied fighting, Link leveled his musket and as he did so a bullet found him before he could pull the trigger. The soft lead struck him full force on the right side of his head and tore through the back of both eyes before exiting the other side.

The last vision he remembered before losing his sight: a Confederate flag.

Carte de visite by Richards of Philadelphia, Pa. C. Paul Loane Collection.

Link rolled into a ditch and lay there as the fighting raged in other sectors of the battlefield. About two days later, drifting in and out of consciousness and exposed to the elements, someone found and transported him to a field hospital. A long time passed before he received proper treatment—11 days by Link's count—which suggests medical staff had left him to die.

When surgeons did finally examine him, they gave Link a prognosis he probably already knew—total and permanent blindness.

Link's disability did not prevent him from living a full and productive life. He returned to Reading and went on to Philadelphia, where he entered an institute for the blind. According to a newspaper report, his aptitude for learning and determination enabled him to become proficient as a carpet weaver, broom and brush maker, and chair caner. For fun, he played dominoes by gliding his fingers over the pieces. He used the same sensitive fingers to tell time on his crystal-less watch.

"Blind Mike," as he was affectionately known, also became a family man. At his death in 1899 at age 59, he and his wife, Margaret, whom he had married in 1868, had at least six children, and many grandchildren survived him.

Rescued from an Uncertain Fate

The 121st Pennsylvania Infantry filed into temporary breastworks of fence rails and tree stumps along Seminary Ridge with little time to spare on July 1. Soon after 2 p.m., advancing Confederates unleashed a volley of musketry. The Pennsylvanians replied not with a volley, but by taking slow and steady aim at the rebels massed in front of them. Thus began a desperate combat that lasted about an hour.

Men fell on both sides as the fighting intensified. In the Union ranks, Charles Light Atlee, a fifth sergeant in Company C, recoiled after a spent bullet nicked his chin. Realizing the damage was slight, he kept his place and continued the fight. Soon after, a second ball struck him with full force in his right leg just below the knee. He hobbled to the rear seeking treatment as his comrades kept up the fight.

Atlee, 20, had enlisted in the 121st when it formed the previous summer. The green regiment joined the Army of the Potomac in time to participate in the December 1862 Battle of Fredericksburg. Atlee came away unscathed from his first combat.

At Gettysburg, his wounding early in the action along Seminary Ridge began an odyssey as he sought treatment. He limped his way to a home in Gettysburg, where women who lived there dressed his wounds. He remained with them the rest of the day, lying low as Confederates drove the federals through town.

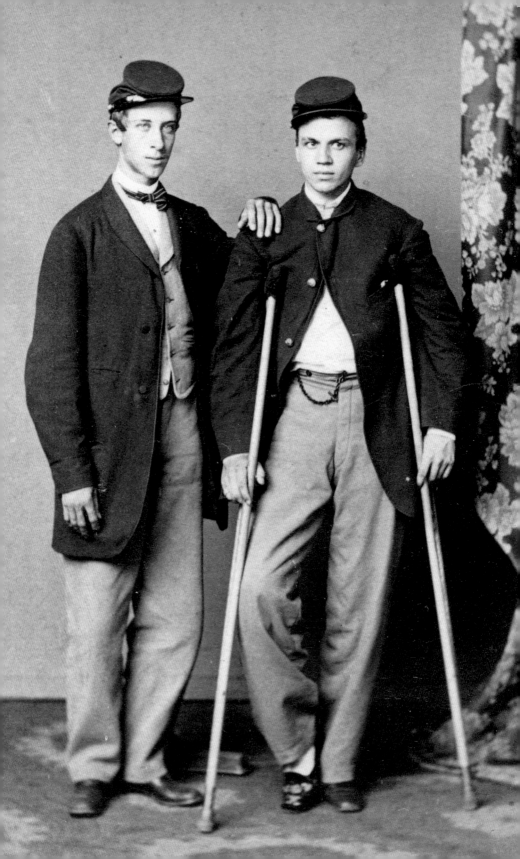

Enemy troops discovered him inside the house early that evening. A captain questioned him about his wounds and ordered him to report to a Confederate hospital for treatment. At the conclusion of the battle two days later, the rebels grouped Atlee and other prisoners together and attached them to a rebel column for a long trek to Virginia.

Fate intervened during the exodus when Union cavalry attacked the column and rescued Atlee and many other prisoners.

Sent to a hospital in his hometown of Philadelphia, Atlee stood with the aid of crutches for this portrait. Charles E. Smith, a corporal in Company C who had been captured during the battle and paroled, posed beside him.

Atlee fully recovered from his injuries and returned to the 121st by September 1863. He received the shoulder straps of a second lieutenant and, in 1864, advanced to captain and commander of his company. He survived the engagements of the Overland Campaign and the Siege of Petersburg and mustered out with an honorable discharge in December 1864.

Atlee went on to marry and start a family. They made their home in Camden, N.J., where he supported his wife and children as a bookkeeper. He died in 1904 at age 61.

Carte de visite by O.H. Willard of Philadelphia, Pa. Faye and Ed Max Collection.

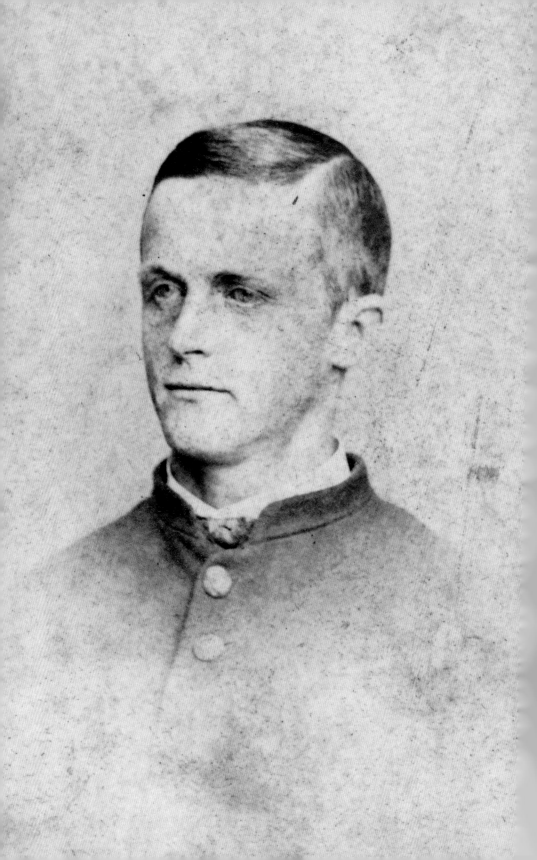

Three Bullets at McPherson Farm

First combat tested the mettle of all regiments, no matter how small or large the engagement. The 150th Pennsylvania Infantry confronted this reality at Gettysburg just west of the McPherson Barn in the afternoon of the first day's fight.

James Monroe "Roe" Reisinger, 20, served as one of his regiment's color corporals. He followed the flag with musket in hand, prepared to lay down his life in its defense.

He came close to making the ultimate sacrifice at Gettysburg. In a short period of time, he suffered three wounds. Years later, he detailed them in an affidavit.

"I was wounded at the first or second fire from the enemy, being struck in the right foot by an ounce ball which shattered the bones of the instep leading to the base of the second toe and lodged in the ball of the foot." The color sergeant and other members of the color guard urged him to go to the rear for treatment. "As we were very hotly engaged, I refused. I tried my wounded foot and finding I could stand on my heel, I kept my place in the ranks."

Reisinger continued, "We fought for some time at the fence, then charged over it for some distance, but running into a strong force we fell back to the fence and made a stand there. Some troops came in on our left flank and we had orders to fall back,

Carte de visite by Mathew B. Brady of Washington, D.C. Faye and Ed Max Collection.

which we did in good order till past the McPherson house, where we again made a stand. We again pushed back to the fence and again made a fight there. The enemy came on in such heavy force that we again had to fall back to the house."

By this time, most of the guardians of the regiment's flags had been wounded and left the battlefield. Color Sgt. Samuel Peiffer still stood, though he had been hit with a bullet in one arm. As Reisinger advanced with Peiffer from the McPherson House, "I was shot with ball weighing over an ounce, in the back of the right leg, above the knee. It went deep into the flesh, back of the knee. The ball was battered against the bone. This second shot knocked me to the ground."

As Reisinger advanced with Peiffer from the McPherson house, "I was shot with ball weighing over an ounce, in the back of the right leg, above the knee. It went deep into the flesh, back of the knee. The ball was battered against the bone. This second shot knocked me to the ground."

Down but not out, Reisinger rose with the assistance of a comrade and followed as best he could when he felt the sting of a third bullet. "I was again wounded with a round ounce ball in the right hip, the bullet passing through the lower part of the hip and lodging in the flesh of the thigh, near the surface and close to the scrotum. I fell and was unable to rise. At the time I received this last wound I was so weak that I could hardly bring my gun to my face to fire."

Reisinger finally fell back. His fellow Pennsylvanians continued the fight that afternoon and the two subsequent days. When it was all over, 260 of the 397 men present at the start of the battle had been killed, wounded, or gone missing.

Reisinger spent a full year in recovery, first in a field hospital and later at facilities in Pittsburgh, Pa., and Washington, D.C.

Some soldiers might have left the army after such an ordeal, but not Reisinger. His wounds healed and medical officials approved him for service in the Veteran Reserve Corps, established for soldiers capable of light duty but not fit for the rigors of campaign. Reisinger left the Corps to accept a first lieutenant's commission in the 114th U.S. Colored Infantry and remained with the regiment until it mustered out in Texas in April 1867—almost six full years of military service.

Four decades later, in 1907, Reisinger received the Medal of Honor for courage in the face of the enemy at Gettysburg. He died in 1925 at age 82. His remains rest at Greendale Cemetery in Meadville, Pa.

Reisinger outlived two wives, and two children survived him. His son, James W.H. Reisinger (1883-1936), graduated from West Point and served as a lieutenant colonel in World War I.

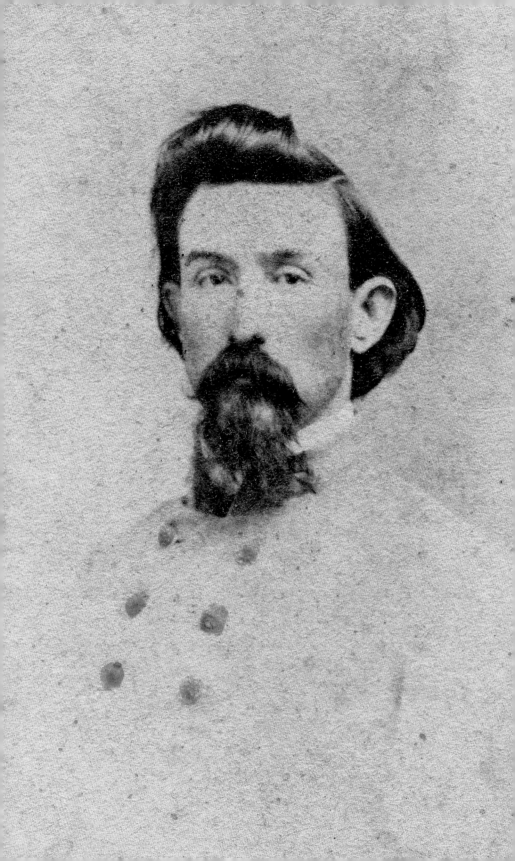

Walls of Fire

The 44ᵗʰ Georgia Infantry arrived on the outskirts of Gettysburg on July 1 after a rapid march. The regiment's major, James Washington Beck, 32, remembered the final six miles of the trek beneath a broiling sun, passing wagons pulled off the side of the road to make way for infantry. The distant boom of artillery turned into a roar as he and his comrades glimpsed the town from high ground to the north.

Beck, a Georgia-born, college-educated son of a Baptist minister, described the view in a letter about a month later, while his memories were still fresh: "Here we are permitted to halt and rest for a short time. We have been marching for at least twelve miles; the day is exceedingly hot, but the enemy can be seen darkening every hill and vale in our front, and it is no time now to talk about fatigue."

Beck understood that battle lay on the near horizon, He had started the war in 1861 as a sergeant in the 3ʳᵈ Georgia Infantry, left in 1862 to accept a captain's commission in the 44ᵗʰ, and suffered a wound during the Battle of Malvern Hill.

At Gettysburg, the 44th entered the fray on the afternoon of the first day's fight with its brother regiments in Brig. Gen. George P. Doles' Brigade. At one point, Maj. Beck recalled a column of Union troops flanked them on the right. The federals

Carte de visite by an anonymous photographer. Guy DiMasi Collection.

advanced to within 40 yards and were separated by two plank fences before they let loose a murderous volley that ripped into the ranks of Georgians. One mounted enemy officer aimed his pistol at Beck and fired. The round missed. Beck recalled that his men instantly replied with a volley that brought down the officer and his horse.

The moment passed as the Georgians and the rest of the Confederate army continued the fight, eventually driving the federals through town and winning the day.

Beck went on to describe the subsequent two days of battle with less enthusiasm—especially the failure of Pickett's Charge, in which the 44th did not participate. He remembered the shriek and screams of shells during the massive bombardment, clouds of gun smoke, the silence before the assault, and the heavy losses. "Night comes and closes the sad drama," he wrote.

Beck added, "Had we been successful at Gettysburg, we could ere this have dictated peace to the Yankee nation."

Though Beck remained steadfast in his devotion to the cause and ultimate Confederate victory, his dreams never materialized. He went on to receive a promotion to lieutenant colonel, possibly in recognition of his valor at Gettysburg. The war, however, broke his health, and he left the army weeks before Gen. Robert E. Lee surrendered the army at Appomattox.

Back in Georgia, Beck became an educator, serving as president of two Georgia institutes. He died at age 76 in 1908, outliving his wife, Margaret. Two children survived him.

Capture at Gettysburg, Escape from a Southern Prison

Iverson's Brigade of North Carolinians marched against Union forces arrayed behind stone walls along Oak Ridge during the afternoon of the first day's fight. Commanded by Brig. Gen. Alfred Iverson Jr., the brigade—1,384 Tar Heels strong—advanced to within 50 yards of the federals when a storm of gunfire devastated their ranks. In a matter of minutes, 900 Carolina boys suffered death, wounds, or capture—an eerie precursor to a similar charge made two days later by Maj. Gen. George Pickett's Division.

As Iverson's charge sputtered, a senior officer in one of the blue regiments, the 97th New York Infantry, saw an opportunity to inflict further damage to Iverson's men and ordered a countercharge. The New Yorkers sprang over the stone wall, and, joined by elements of other regiments, ran down a gully toward the remnants of Iverson's Brigade. They also encountered fresh Confederate reinforcements who forced the New Yorkers to withdraw, but not before some of them fell into enemy hands.

One of the officers of the 97th who became a prisoner was 2nd Lt. Francis Murphy, an Irish immigrant who had helped recruit Company G. Less than a year earlier at the Second Battle of Bull Run, he had suffered a gunshot wound in the groin, but managed to evade capture.

At Gettysburg, Murphy's capture marked the beginning of his odyssey as a prisoner of war. The Confederates marched him and

other captives to Libby Prison in Richmond, then on to Macon, Ga., and Camp Sorghum in Columbia, S.C.

On Nov. 28, 1864, a year-and-a-half after his capture at Gettysburg, Murphy and two other officers escaped from Camp Sorghum. Traveling by night and dependent on enslaved people for food and directions, the trio headed west into the North Georgia mountains as winter set in. Suffering from hunger and blistered feet as they forded ice-cold streams and frozen tundra, one of their number lost his will and was left behind. Murphy and the other officer continued and united with other escapees.

On the twenty-second day of their escape, a Home Guard patrol recaptured them. A small group of men that included deserters from the Confederate army, they sought revenge for Maj. Gen. William T. Sherman's march through their state. Sherman's bummers had completed their mission just a week earlier, leaving devastation and ruin in their wake.

The Guardsmen ordered Murphy and the other prisoners to deposit their valuables on the ground and exchange their uniforms for ragged clothes. Then they were arranged in a circle and told to pray as revolvers were cocked and readied to fire.

At this moment, a man of conscience happened on the scene and talked the Guardsmen down. Murphy and his comrades survived and returned to Columbia. He soon gained his release and returned to the North before the end of the war.

Murphy went on to become a farmer and remained active in his regimental veterans' association until his death in 1915 at age 86. His wife, Mary, and six children survived him.

Carte de visite by G.B. Hall of Little Falls, N.Y. Charles T. Joyce Collection.

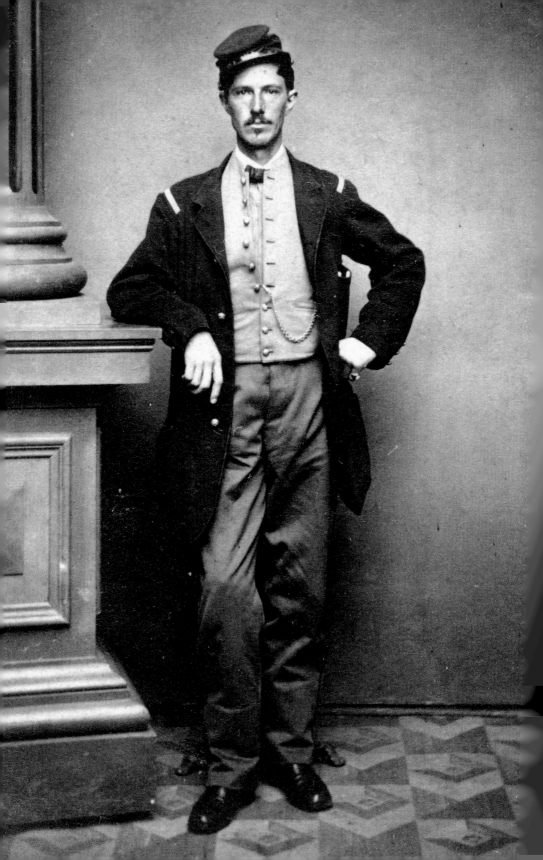

Captured While Executing Orders

As Union troops hurried through Gettysburg seeking safety south of town, 1st Lt. Robert Clark Knaggs rode through the streets toward oncoming Confederates. An aide de camp on the staff of Brig. Gen. Henry Baxter, Knaggs rushed orders to regimental commanders in a desperate bid to stem the rebel tide.

Knaggs understood the risks. Orphaned as an infant in the Michigan prairie village of White Pigeon, an aunt raised him. In his mid-teens, he went to work on the railroads, and in his early twenties he took off for Texas to work for an overland mail company. He returned to Michigan by the start of the war and promptly enlisted in his home state's 7th Infantry. He began his military service as a private and soon rose to sergeant major and then second lieutenant.

In September 1862 at Antietam, he served as adjutant of the 7th. During a critical point in the battle, Confederates shot down three of the regiment's color bearers in quick succession. Knaggs leapt from his horse, picked up the colors, and waved them in the face of the rebels. They immediately replied with a hail of musket fire, two of the bullets striking Knaggs but not inflicting serious injury. Baxter, then the lieutenant colonel of the Michiganders, also suffered a wound while rallying men around the flag.

Six months later, in March 1863, Baxter received his brigadier's star and command of a brigade in the Army of the Potomac's 1st Corps. He brought Knaggs onto his staff.

Carte de visite by Bell & Brother of Washington, D.C. Rick Carlile Collection.

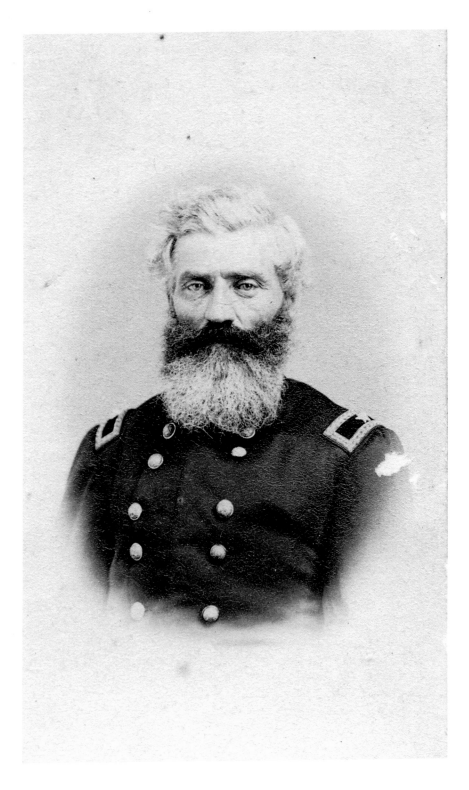

At Gettysburg, Baxter's brigade found itself in the thick of the action from the moment it arrived on the battlefield during the morning of July 1. Knaggs and other aides rode in harm's way to execute Baxter's orders as the fighting intensified. Rebel troops nabbed Knaggs as he moved through the streets of town—whatever orders he had to deliver never made it to the intended recipient.

The Confederates carried Knaggs off to Richmond's Libby Prison. He curried favor with his captors by delivering mail to fellow prisoners and earned special privileges for good behavior.

According to one report, Confederate guards entrusted him with calling the roll of prisoners each day. Knaggs turned his status against those who gave it to him when he colluded with escaping comrades by not calling their names on the day they made their prison breaks, giving them a head start.

Knaggs gained his release from Libby in March 1864, returned to the 7th, and ended his service with a captain's brevet for gallantry. Knaggs moved about after the war, living in Michigan, Illinois, Indiana, and Minnesota before settling in Chicago.

His life intersected with Libby Prison one more time. In 1889, he became manager of the Libby Prison War Museum. A year earlier, a group of investors had purchased the building, dismantled it, and hauled it by rail from Richmond to Chicago. Rebuilt in the city and opened as a museum of relics and stories, it became an instant success, drawing visitors from across the country. Four years later in 1893 when Chicago hosted the Columbian Exposition, the museum, though not technically part of the world's fair, packed in large crowds. In 1899, the museum closed, and the building was dismantled for the second time in a decade. This time, the materials were scattered never to be reassembled.

Knaggs remained in Chicago until his death at age 92 in 1927. He outlived his wife, Laura, and three children survived him.

Henry Baxter (1821-1873) started the war as a captain in the 7th Michigan Infantry and ended it as a brigadier general and commanded at the brigade level in the Army of the Potomac. He suffered wounds in four battles. After the war, President Ulysses S. Grant named him Minister to Honduras. *Carte de visite* by Cookingham of Jackson, Mich. Tom Glass Collection.

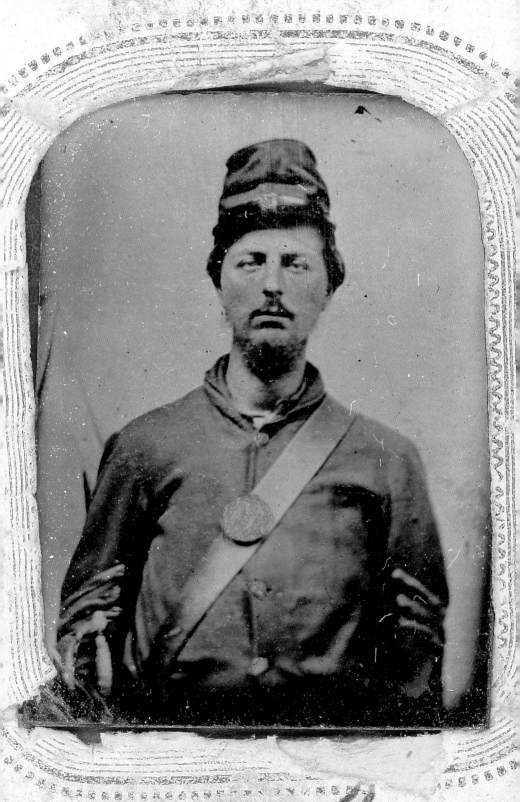

The Sad Saga of Henry Seas

The 82ⁿᵈ Ohio Infantry marched into Gettysburg about noon on July 1 and had little time to rest. Ordered to support a battery on the northern outskirts of town, the regiment hurried into position, its companies fanning out in a defensive line.

In Company D, 1ˢᵗ Sgt. Henry Seas did his part to keep the men in order in coordination with his commanding officers. A teacher from the Buckeye State's Stark County and the son of German immigrants, he had joined the 82ⁿᵈ in late 1861 as a private. When it came time for the company to elect its leadership, the rank and file voted Seas as its sergeant, perhaps in recognition of the qualities that served him well as an educator.

The Ohioans numbered 968 souls at their original muster. The number steadily decreased due to disease and casualties from battles in Virginia's Shenandoah Valley, at Second Bull Run, and Chancellorsville. Seas emerged from all these campaigns without injury.

At Gettysburg, Seas and his comrades, 258 men and officers, were hit hard by the Confederate brigades of generals George Doles and John B. Gordon about three o'clock that afternoon. The outnumbered Buckeye boys had little chance, but stubbornly resisted until forced to withdraw through the streets of town. Less than 100 of the regiment rallied around the colors and reformed along Cemetery Hill.

Ninth-plate tintype by an unidentified photographer. Charles T. Joyce Collection.

Seas was not among them. Wounded in the right leg and knee, he was likely taken with other injured soldiers to the makeshift hospital of the 11th Corps at the George Spangler Farm. The conditions were horrific—a barn on the property overflowed with wounded from both sides, and many more suffered in the open air waiting for care.

Surgeons eventually treated Seas, who wrote home to a brother that no bones were broken, and that he expected a full recovery. A follow-up letter revealed that his situation had taken a turn for the worse as his leg had been amputated above the knee. He did not survive its effects, dying on July 17.

His remains were brought home and buried at Pleasant Cemetery in Marion.

"May the Earth Rest Lightly on You"

Few Union regiments entered the first day's battle with as big a reputation for flash and derring-do as the 14th Brooklyn Infantry. It had earned its *nom de guerre* "Red Legged Devils" for its chasseur-inspired uniforms and battlefield bravery in the war's first large-scale engagement along Bull Run in Virginia. Also known as the "Fighting Fourteenth," the regiment paid a heavy price in casualties and in deaths from disease during the war's early campaigns in Virginia.

Back in Brooklyn, regimental recruiters sought fresh volunteers to fill the depleted ranks. The new recruits included Albert M. Chapin, a 19-year-old clerk and the eldest son of a local merchant. Young Chapin donned the natty uniform of his veteran comrades in late 1862 and joined Company C in time for the 1863 campaign season.

At Gettysburg on July 1, the Brooklynites lived up to their reputation as they grappled with Confederates along the Railroad Cut and other locations until overwhelmed by superior numbers and forced to retreat through the streets of town.

By the time he came to rest and regroup along high ground south of Gettysburg, many in the regiment had fallen. Chapin numbered among those missing in action. It is presumed a burial party discovered his corpse and interred it in a hastily dug grave in the immediate aftermath of the battle, and later moved his remains to the Soldiers' National Cemetery.

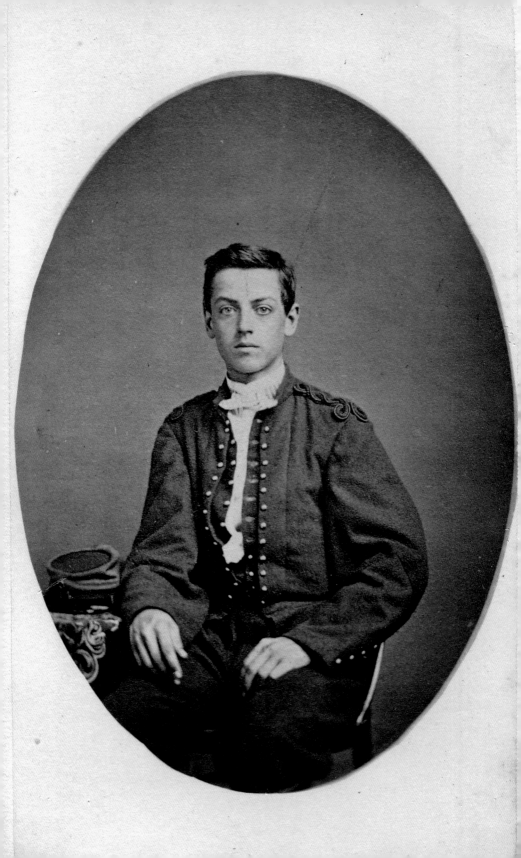

Inscribed on the back of his *carte de visite* portrait is "Sit vibi verra levis," or "May the earth rest lightly on you." The Latin phrase is found on funerary items that date to the ancient Romans.

Back of *Carte de visite.*

Carte de visite by Van Doorn of Brooklyn, N.Y. C. Paul Loane Collection.

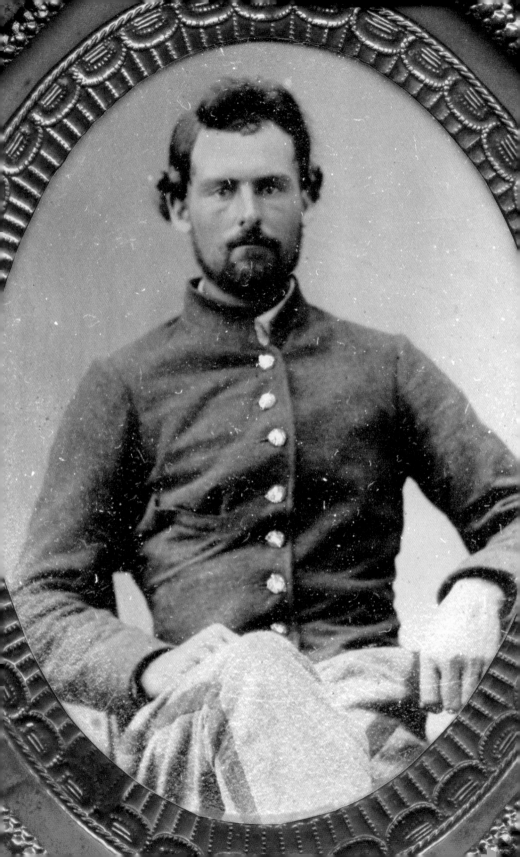

Faithful Fighter in Gordon's Brigade

Private Alexander Wilks Vaughan and his fellow Georgians in Maj. Gen. John Brown Gordon's Brigade contributed to Confederate success during the first day's engagement. Especially notable was the struggle at Blocher's Knoll in the mid-afternoon. Here, Gordon's troops and other rebel forces overwhelmed the Union division of Maj. Gen. Francis C. Barlow, for whom the knoll later became known.

During the action, Vaughan suffered a wound—one of about 91 men and officers of the 38th Georgia listed as casualties on July 1. At some point after he received his injury, details of which went unreported, federals captured him.

Vaughan's journey to Gettysburg began at home in Elbert County two summers earlier. In 1861, he joined the Goshen Blues, a local company mustered into the army as Company H of the 38th. The regiment left the state for Virginia and participated in early engagements with the Army of Northern Virginia, including Gaines' Mill, Second Bull Run, Antietam, and Fredericksburg.

Vaughan emerged unscathed from these battles—until Fredericksburg. The nature of his injury there was likely minor as his military records indicate he did not spend any time in a hospital.

Ninth-plate tintype by an unidentified photographer. David Wynn Vaughan Collection.

Seven months later at Gettysburg, Vaughan's captors sent him to DeCamp General Hospital on Davids Island in New York Harbor. Paroled in early September 1863, Union authorities sent him south, where he gained admission to the Confederate States Hospital in Petersburg, Va. Before the end of the month, medical personnel furloughed Vaughan to Georgia.

Vaughan never returned to his regiment. He spent the rest of the war in Elbert County. On May 19, 1865, about a month after the survivors of the 38th were surrendered at Appomattox and a week after the capture of President Jefferson Davis, Union forces captured Vaughan in neighboring Hart County. He received a parole, returned to his farm, and lived a quiet life until his death in 1905 at age 67.

The Boy Colonel Leads a Charge Against the Iron Brigade

During the afternoon of July 1, the 26th North Carolina Infantry marched down Herr Ridge, crossed a rail fence, and reformed on the other side. There the 800 Tar Heels looked out towards a field of oats and awaited orders to advance.

In the middle of this activity, the regiment's commander, Henry King Burgwyn Jr., strode to the front of the line. Conspicuous in his double-breasted colonel's coat, sash, and sword, he waited as his subordinates finished prepping the men.

The Boy Colonel, as he was known to some, and Harry to family and friends, Burgwyn had enjoyed a life of privilege that began with his birth in the suburbs of Boston, Mass., the home state of his mother. He soon moved with his family to the Northampton County, N.C., plantation home Thornbury, where his father managed 1,600 acres of wheat, corn, and other cash crops. Enslaved people toiled on the land.

Educated by tutors and in Northern boarding schools, Burgwyn gained admission to West Point in 1856. But he did not meet the age requirement, and Secretary of War Jefferson Davis informed the family that he had to wait a year to become a cadet. Burgwyn's impatient father hired a tutor to provide his son a basic military education, and then sent him to the University of North Carolina. Burgwyn graduated in 1859. His father, by now convinced that war between the states was imminent, packed his

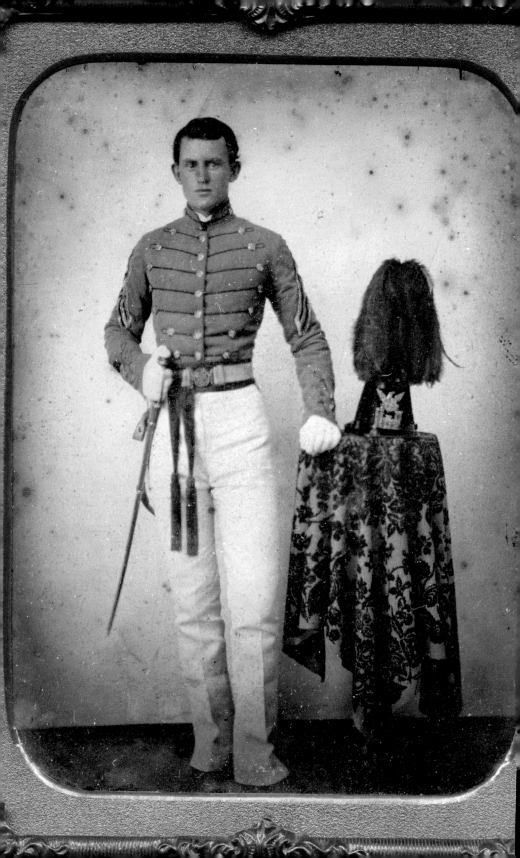

son off to Virginia Military Institute to complete his military education. Burgwyn is pictured here in his cadet uniform.

During his tenure at VMI, Burgwyn stood guard during the hanging of John Brown. Burgwyn's abilities as a soldier attracted the attention of one of VMI's professors, Thomas J. Jackson, who gave him a letter of recommendation after the Civil War began.

Burgwyn went to the capital of his home state, Raleigh, and was placed in charge of a training camp for volunteers. He whipped the green soldiers into shape, earning the respect of the men and his superiors. When the 26th formed that summer, Burgwyn accepted a commission as lieutenant colonel.

Burgwyn went to the capital of his home state, Raleigh, and was placed in charge of a training camp for volunteers. He whipped the green soldiers into shape, earning the respect of the men and his superiors.

Two years later at Gettysburg, now Col. Burgwyn stood in front of his men arranged in line of battle downslope of Herr's Ridge. He gave the order to charge, and off they went through the field of oats. They soon encountered musket fire from the Union army's 24th Michigan Infantry. This regiment belonged to the Iron Brigade, commanded by Brig. Gen. Solomon Meredith—a Tar Heel who had moved to the Midwest prior to the war.

Burgwyn and his men surged forward, firing as they went and inflicting casualties on the black-hatted Michiganders, who responded with deadly volleys. Hoosiers from the 19th Indiana entered the fray alongside the Michiganders and blasted away at the oncoming Confederates.

The Tar Heels fought on as their ranks thinned, and the colors bobbed and weaved as enemy lead felled one color guard

Quarter-plate ambrotype by an unidentified photographer. Dave Batalo Collection.

after another. At one point, the blood-stained banner fell to the ground. Burgwyn picked it up, perhaps reflexively.

Here Burgwyn met his end. Two accounts survive of what happened.

According to one version, Burgwyn handed the flag to a private, then turned to his right to confer with his lieutenant colonel, John R. Lane. At this moment, a bullet tore into the head of the private with the colors, killing him instantly. Another bullet struck Burgwyn in the side, passing through his lungs.

Another version states that Burgwyn held on to the flag and was in the act of shouting "Dress on the colors" when the bullet hit him in the lungs. As he toppled to the ground, he became caught and wrapped in the folds of the banner.

Both accounts agree that after Burgwyn fell, Lt. Col. Lane grabbed the flag, rallied his men, and broke the Iron Brigade's line, forcing them to withdraw. Lane suffered a serious but not fatal wound before the fighting ended.

The entire fight lasted about 30 minutes. The 26th suffered 588 casualties, about 74 percent of those engaged. Losses in the Iron Brigade were also heavy. They included Brig. Gen. Meredith, who suffered a head injury from a shell fragment that ended his combat career.

Burgwyn succumbed to his wound about two hours later. His men wrapped the body in a red woolen blanket, placed it in a gun crate, and buried the makeshift coffin below a walnut tree north of Chambersburg Pike to the rear of Herr Ridge.

In 1867, Burgwyn's family recovered his remains and interred them at Oakwood Cemetery in Raleigh.

"I Am Going Home"

The clash of the 26th North Carolina and 24th Michigan infantries along McPherson's Ridge on July 1 ended in success for the Confederates. Victory came at a high price. Almost three-quarters of the 800 Tar Heels who fought became casualties.

In Company F, all 91 men and officers landed on the list, including Pvt. William R. Payne. An official report described him as having suffered a slight wound in his body.

A native of North Carolina, he grew up the eldest of four children on the family farm in Caldwell County, located in the foothills of the Blue Ridge Mountains. His father enslaved five people of color. In 1861, 20-year-old Payne joined the Caldwell Guards, which became Company I of the 26th. A year later, after he and his comrades had experienced combat along the North Carolina coast at New Bern and in Virginia's Peninsula Campaign, Payne transferred to Company F.

Payne managed to escape injury in these early war engagements. At Gettysburg, his minor wound might be described as fortunate compared to many of his brothers in arms who were grievously wounded and unable to move. Any luck that Payne may have had ran out two weeks later. On July 14, federal forces in pursuit of retreating Confederates captured him along the Maryland side of the Potomac River at Falling Waters.

Union military authorities forwarded Payne and other captives to the sprawling prisoner of war camp at Point Lookout, Md.

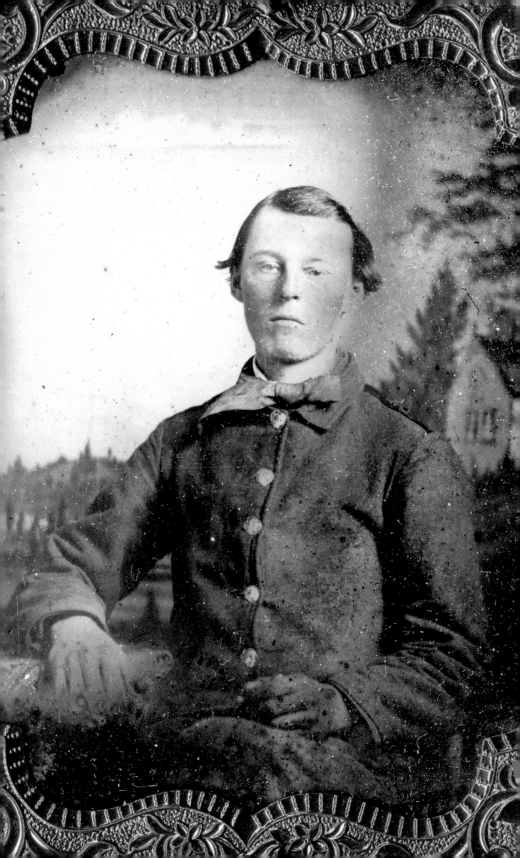

At some point he fell ill, and he succumbed to disease at the camp hospital on March 15, 1864. He was about 22. A Mississippi sergeant and fellow prisoner clipped a lock of Payne's hair and enclosed it in a letter to Payne's father. "It falls to my lot to chronicle the death of your son," the sergeant began. "He was taken very gently," the Mississippian noted, adding, "He said tell Father 'I am going home.'"

Payne's remains rest in Point Lookout Confederate Cemetery.

Sixth-plate ambrotype by an unidentified photographer. Jeff Kowalis Collection.

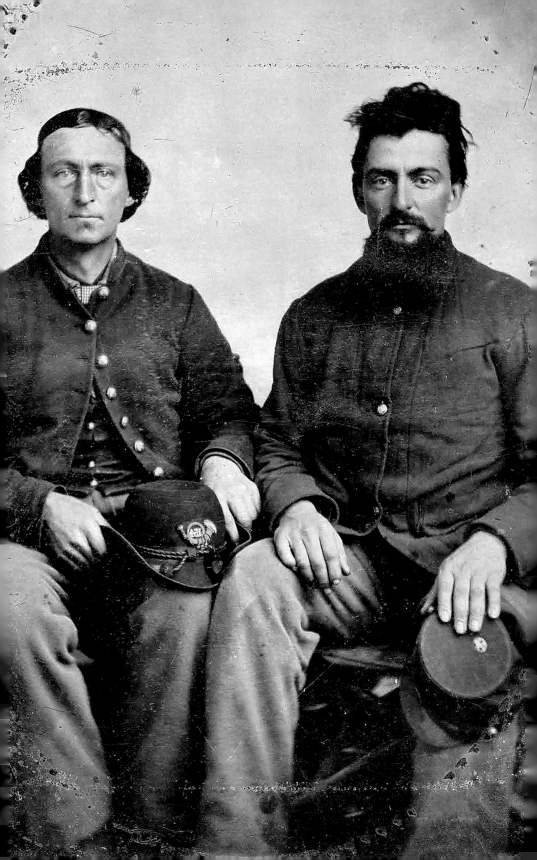

Overwhelmed at Kuhn's Brickyard

During the march into Gettysburg on July 1, Sgt. Horace Smith of the 154th New York Infantry foraged for fresh food to feed his company. He and an enlisted man gathered bread, butter, eggs, and milk from residents and then hurried to catch up to their regiment. They arrived just in time to go into battle—and never had a chance to take a bite of the delicacies.

Smith, a 26-year-old native of Franklinville, N.Y., had worked as a farmer, teacher, and clerk prior to his enlistment in the summer of 1862. He mustered into Company D as a sergeant, and traveled with his comrades to Virginia and joined the Army of the Potomac's 11th Corps. The New Yorkers had their first combat experience at the May 1863 Battle of Chancellorsville and suffered heavy losses, losing 32 killed, 81 wounded, and 115 captured and missing. Smith survived without injury.

Two months later at Gettysburg, the 154th and the other three regiments in its brigade marched in double-quick time from Cemetery Ridge through the streets of town during the afternoon of the first day's fight. They took up a position in Kuhn's brickyard on the town's northeastern outskirts as an entire Confederate division— battle-hardened veterans from North Carolina and Louisiana commanded by Gen. Jubal Early—bore down on them.

Smith, right, sits with an unidentified comrade.

Sixth-plate tintype by an unidentified photographer. Mark Dunkelman Collection.

Smith arrived about this time, dropped the food, and helped form Company D for battle.

The 154th and its brigade, commanded by Col. Charles R. Coster, did not stand a chance against the rebels, who outnumbered them three to one. The fight ended quickly and decisively, with the 154th devastated: 205 out of 265 men and officers engaged became casualties, a 77 percent rate. Smith numbered among them, having suffered a flesh wound above the knee of one leg before falling into enemy hands.

One of Smith's comrades, Amos Humiston of Company C, suffered death in the fight. The discovery of his unidentified body, clutching an ambrotype of his three children, and the national search to find his family stand as one of the battle's most poignant stories.

———

One of Smith's comrades, Amos Humiston of Company C, suffered death in the fight. The discovery of his unidentified body, clutching an ambrotype of his three children, and the national search to find his family stand as one of the battle's most poignant stories.

———

Meanwhile, Smith's captors carried him off to Virginia and imprisoned him on Belle Isle along the James River at Richmond. He survived a nine-month ordeal with scant food and exposure to the elements, and rejoined the 154th outside Atlanta, Ga., in August 1864. Soon after, he received a promotion to first lieutenant. He served in this capacity during Maj. Gen. William T. Sherman's March to the Sea and the Carolinas Campaign. At the war's end, he marched with the survivors of the 154th in the Grand Review in Washington, D.C., before mustering out in June 1865.

Smith returned to New York, married, and started a family that grew to include two daughters. He supported them as a postal clerk for a railroad company. In the early 1880s, the Smiths

relocated to the upper Midwest, eventually settling in the village of Mazomanie, Wis., located northwest of Madison. Active in civic affairs and his local Grand Army of the Republic post, he died in 1927 at age 90.

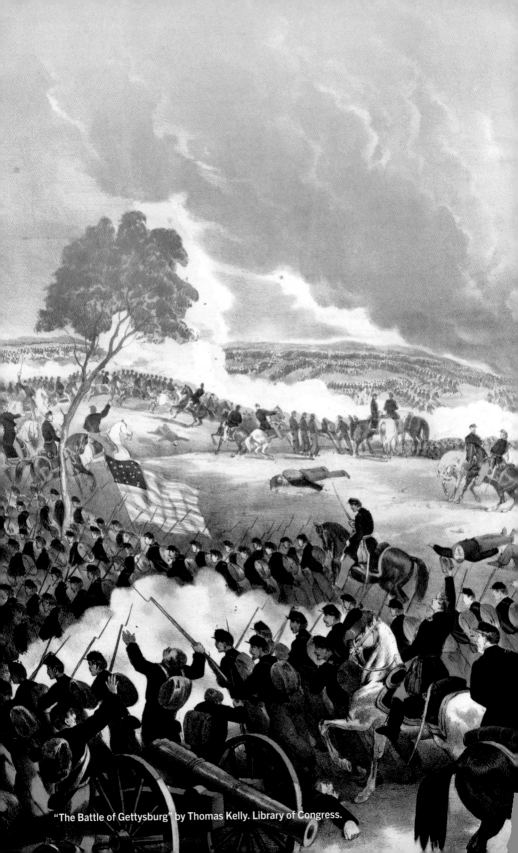

"The Battle of Gettysburg" by Thomas Kelly. Library of Congress.

3

THE SECOND DAY

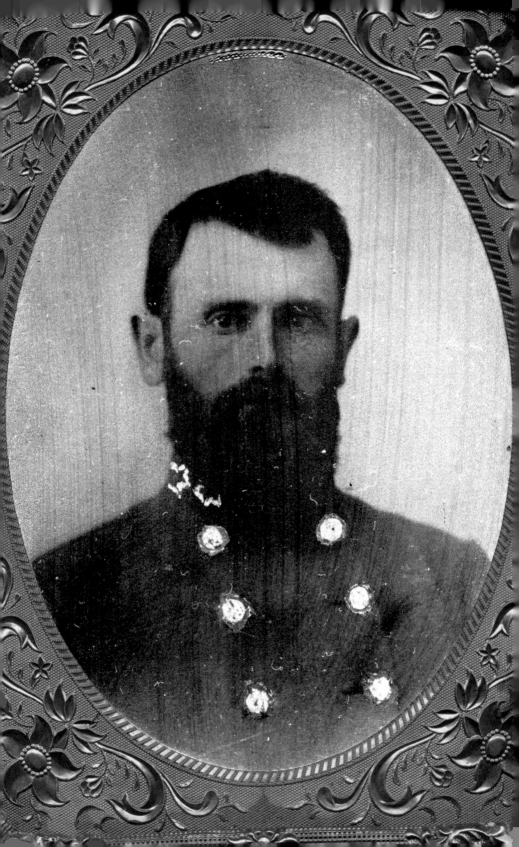

Reconnaissance at Little Round Top

During the wee hours of the second day of fighting, Gen. Robert
E. Lee ordered one of his staffers to reconnoiter the federal left.
A few hours later at daybreak, Capt. Sam Johnston set out with
an engineering officer and a small escort to explore this sector of
the battlefield.

Upon Johnston's return three hours later, he reported his find-
ings to Lee, assuring the general that he made it to Little Round
Top and found it unoccupied.

As it turns out, the Union had established a signal station
on Little Round Top, and thousands of troops encamped
nearby. Johnston failed to note any of these details—at least
they were not reported in official reports or other surviving
correspondence.

Johnston had proven himself a capable soldier loyal to the
Southern cause since the earliest days of the conflict. Born
Samuel Richards Johnston in Northern Virginia's Fairfax
County, he had worked as a peacetime civil engineer in nearby
Alexandria. According to one report, he happened to be on a
train headed south out of Alexandria when news of Virginia's
secession reached him. He stopped the train, hurried home, and
became a first lieutenant of a militia company, the Washington's

Quarter-plate tintype by an unidentified photographer. Dave Batalo Collection.

Home Guards. It mustered for Confederate service as Company F of the 6th Virginia Cavalry.

Johnston's abilities attracted the attention of Brig. Gen. JEB Stuart, who brought him on to his staff on detached duty as a volunteer aide-de-camp in early 1862. The rest of Johnston's year was a whirlwind of activity. He left the cavalry in April and joined the engineers. By June, he had risen to lieutenant and member of Maj. Gen. James Longstreet's staff. In August, he advanced to captain and joined Gen. Lee.

Less than a year later at Gettysburg, Johnston rode off on the early-morning scout of the Union left. The intelligence he gathered painted an inaccurate picture of the true situation at Little Round Top and influenced the early thinking of Lee. It is unclear, however, if the report had any serious impact on the rapid-moving events that unfolded later in the day.

Less than a year later at Gettysburg, Johnston rode off on the early morning scout of the Union left. The intelligence he gathered painted an inaccurate picture of the true situation at Little Round Top and influenced the early thinking of Lee.

Many historians have concluded that Johnston's reconnaissance was faulty, among them Karlton D. Smith, a park ranger at Gettysburg. In his 2006 paper, "To Consider Every Contingency," Smith explained, "It is this writer's belief that Johnston did not get to Little Round Top as he claimed but instead was on the slopes of Big Round Top."

Smith goes on to point out that the Lost Cause mythology that emerged following the war held Longstreet personally responsible for the loss at Gettysburg. Johnston was also held to account, though not nearly to the same extent as Longstreet.

Johnston's post-Gettysburg military career indicates that the reconnaissance left no permanent tarnish as far as his peers and

superiors were concerned. He played an active and effective role during the withdrawal from Gettysburg, and earned two more promotions, including lieutenant colonel in September 1864. Johnston also commanded a section of the defensive works along Longstreet's front at Petersburg during the war's waning months.

A letter written by Lee to Johnston in early 1865 suggests the general held his staffer in high regard. On February 25, Lee congratulated Johnston on the birth of a son. Johnston named the boy Robert Edward Lee Johnston.

Following the surrender at Appomattox, the Johnston family began life anew in the Northeast. Johnston went on to a successful engineering career in New Jersey and died in 1899 at age 66. Robert Edward Lee Johnston grew up and became a successful physician in Brooklyn, N.Y. He survived his father by only a decade, passing away at the relatively young age of 44.

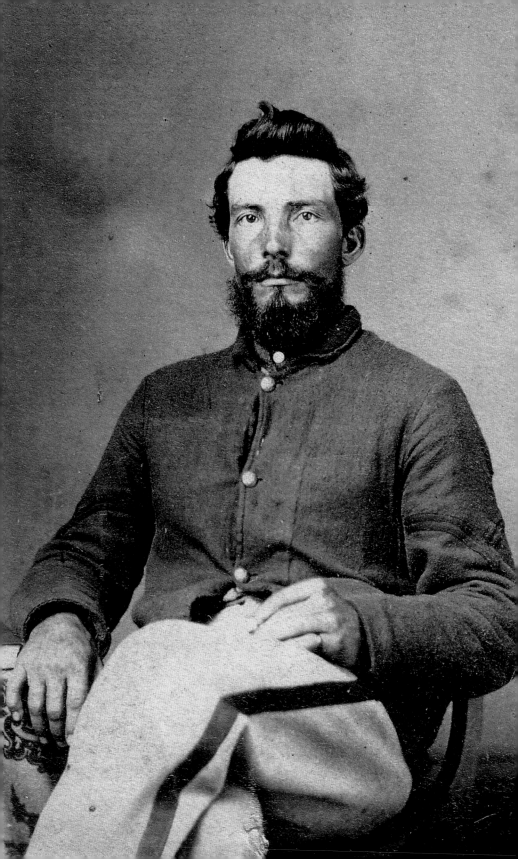

Critically Wounded Sharpshooter

A battalion of Col. Hiram Berdan's 1ˢᵗ U.S. Sharpshooters recon-noitered Pitzer's Woods early in the morning of July 2. Soon after entering the trees, the elite marksmen encountered skirmishers from a brigade of Alabamians commanded by Maj. Gen. Cadmus Wilcox. Berdan's boys pushed Wilcox's force about 300 yards back to a rail fence, where it made a stand.

A fierce firefight ended about ten minutes later when Berdan called his men back.

As the sharpshooters withdrew in orderly fashion, the Confederates kept up a lively fire and followed the federals for a short distance. During this period between the withdrawal and brief pursuit, two rebel bullets pierced the abdomen of Cpl. William Henry Leach of Berdan's Company F. Leach fell to the ground and the Alabamians captured and carried him off.

The gunshots removed an able, dependable sharpshooter from the ranks. Leach, a New York native, had settled in Vermont prior to 1861. When the war began, Berdan recruited men who possessed a keen eye, steady hands, and precision with a rifle from several Northern states. Vermont supplied Company F, including Leach. He started out as a private and earned his corporal's stripes following the 1862 Peninsula Campaign.

Carte de visite by A. S. Mears of Burlington, Vt. Brian White Collection.

A year later at Gettysburg, two bullets hit him in Pitzer's Woods. One ball struck him on the left side between the last two ribs and injured his kidney. The other, a bit lower, may have nicked his intestine before it embedded in muscle mass near his spine. Southern surgeons cared for him until the Army of Northern Virginia evacuated the area and left Leach behind.

The federals found him alive on July 5. Transported to the Lutheran Seminary, a temporary hospital, medical personnel dressed the wounds and applied cool compresses on his back to ease his great pain. They also administered opiates to help him sleep at night. His condition stabilized, and by the end of July he left Gettysburg for Harrisburg, Pa., to continue his recovery at the Cotton Factory Hospital. By the middle of August, the wounds had nearly healed, and his bodily functions had returned to near normal, though the bullet in his back limited his movement for the rest of his days.

Attending surgeons documented his case and published the successful result in the "Wounds of the Kidney" section of the landmark *Medical and Surgical History of the War of the Rebellion.*

Leach received a disability discharge from the army in January 1864 and returned to civilian life. He lived in Missouri and Kansas before settling in Elgin, Ill. He died at about age 66 in 1911. He outlived his first wife, Mary Jane, and was survived by his second wife, Kate, and children from both marriages.

Stray Shots in Trostle's Woods

First Lt. Scott C. McDowell moved into woods near the Trostle Farm with his regiment, the 62nd Pennsylvania Infantry, during the afternoon of July 2. He and his Company G occupied a position and awaited orders in the southern part of the trees as shots clipped branches and trunks.

McDowell, who had recently celebrated his 24th birthday, thrived in the structure and stability of army life after a challenging childhood. Born in County Tyrone, Ireland, he barely knew his father, who had died soon after his birth. His widowed mother, Annie, left the country with then eight-year-old McDowell in 1847—the height of the Great Famine.

They settled in Pittsburgh, Pa., and started afresh. Annie remarried and McDowell went to work at age 14 as a toll collector, and later in a dry goods store in Pittsburgh. A close friend described him as an honest and moral young man with zero tolerance for mean-spirited people.

Then the war came. In June 1861, McDowell joined the army as a first sergeant. He's pictured here soon after his enlistment, dressed in the distinctive chasseur-style uniform of the regiment. McDowell received a promotion to lieutenant following the Peninsula Campaign. He further distinguished himself in the Battles of Fredericksburg and Chancellorsville. He sent some of his soldier's salary home to support his mother, who had been widowed a second time.

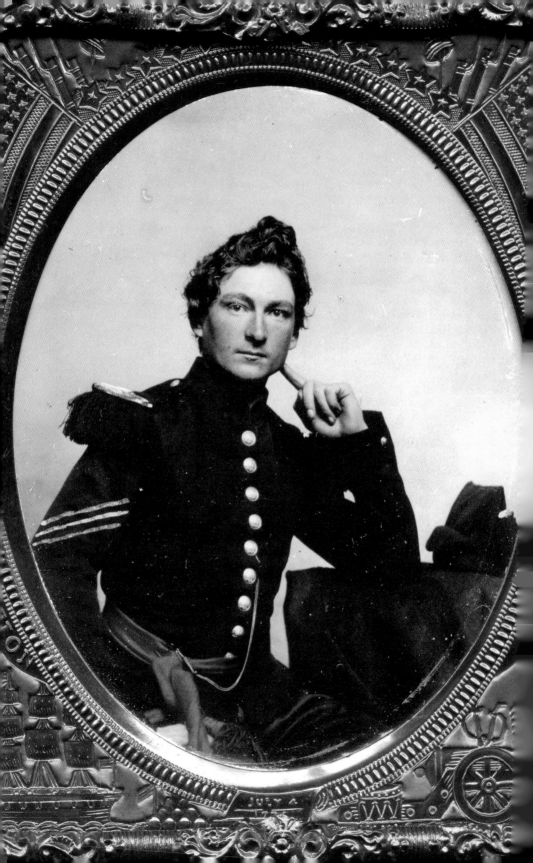

Two months later at Gettysburg, a stray shot killed him in Trostle's Woods. His comrades likely buried him where he fell as they were soon called to combat in the nearby Wheatfield, where they suffered serious wounds, including injuries inflicted with the bayonet.

Many months after the battle, Annie journeyed to Gettysburg to bring home her son's remains. How she knew where to find his body and who helped her on this grim errand of closure is lost to time. She did, however, succeed in bringing McDowell home to Pittsburgh. On Saturday morning, March 5, 1864, in a closed-casket funeral, Annie watched as McDowell's remains were buried in Hilldale Cemetery.

A local newspaper report about the funeral noted the depth of Annie's grief over the loss of "the hope and pride of her heart." Her paper trail ends here.

Sixth-plate tintype by an anonymous photographer. Ronn Palm's Museum of Civil War Images.

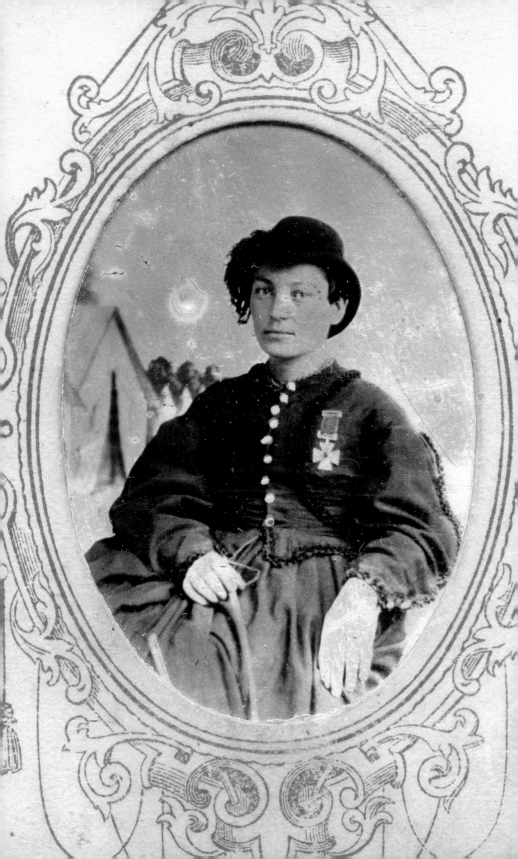

Tending to the Wounded Near Trostle House

A Pennsylvanian recalled seeing Anna Etheridge, in uniform and on horseback, as she directed care of the wounded near the Trostle House on July 2. "She was cool and self-possessed and did not seem to mind the fire," the soldier noted. Her actions also caught the attention of a Maine soldier, who observed. "I remember the wounded crying for water, and that noble woman, Anna Etheridge, trying to alleviate their sufferings. I have seen her under fire riding along as unconcerned as the headquarters staff."

Known as "Gentle Annie" or "Michigan Annie" to many in the Army of the Potomac, she volunteered as a vivandière with a Michigan infantry regiment. Following the lead of other women throughout the army who served in this capacity, she provided care and support to the men.

Born Lorinda Anna Blair in Detroit, she suffered the early death of her mother, a father in financial straits, and a marriage in her teens that ended in estrangement.

The Civil War provided something of a new beginning for Etheridge. She proved her mettle tending to the wounded of her regiment, the 2nd Michigan Infantry, in one of the earliest battles in Virginia, at Blackburn's Ford in July 1861. Over the

Ninth-plate tintype in a carte de visite-sized mount by Lothrop of Philadelphia, Pa. Chris Foard, The Foard Collection of Civil War Nursing, The Liljenquist Family Collection at The Library of Congress.

next two years, she continued her service on hospital transport vessels during the Peninsula Campaign and the Second Battle of Bull Run.

In early 1863, military authorities transferred the 2nd to the West. Etheridge opted to stay in the East and attached herself to the 3rd Michigan Infantry. She also parted ways with her second husband, James Etheridge, a soldier in the 2nd whom she married in 1862.

Etheridge had a close call with death at Chancellorsville in May 1863. One telling of her story holds that she followed the skirmish line on horseback, offering words of encouragement, when enemy fire forced her to retire. As she did so, a bullet struck and killed an officer close by her, and another ripped into her hand and through her dress, then hit her horse. She managed to recover her senses and bring her stricken mount under control, to the cheers of the men.

One telling of her story holds that she followed the skirmish line on horseback, offering words of encouragement, when enemy fire forced her to retire. As she did so, a bullet struck and killed an officer close by her, and another ripped into her hand and through her dress, then hit her horse.

She received the Kearny Cross for bravery two weeks later. The decoration was named for Maj. Gen. Philip Kearny, a division commander in the army's 3rd Corps who met his death on the battlefield of Chantilly, Va. Hundreds of soldiers received the honor, as well as one other woman: Mary Tepe, a vivandière in the 114th Pennsylvania Infantry.

Etheridge is pictured here wearing the medal—a rare display of pride. According to one biographer, "With strangers she is very reticent, and has a reserve and apparent pride of manner. With the soldiers, though sharing all their hardships, she never

spoke familiarly, and was held by them in the highest veneration and esteem, as an angel of mercy. While the contest was going on, she took the deepest interest in the issue, eagerly reading all the newspapers that she could find in camp, and keeping well informed as to the progress of the war."

At Gettysburg, she added to her fame at the Trostle House and elsewhere on the battlefield and continued her service through July 1865. Altogether, she participated in more than a dozen engagements.

Following the war, her legend grew with comparisons to Florence Nightingale and fantastical myths of leading troops into battle, firing muskets, and capturing Confederates.

In fact, Etheridge settled in Washington, D.C., and clerked for a time in the Treasury Department. She cleaned up legal messes that resulted from her marriages, and, in 1870, wed a third husband, Charles Hooks, a veteran who also worked at the U.S. Treasury.

They lived quietly together until his death in 1910. Etheridge joined him three years later at age 73 and is interred beside him at Arlington National Cemetery.

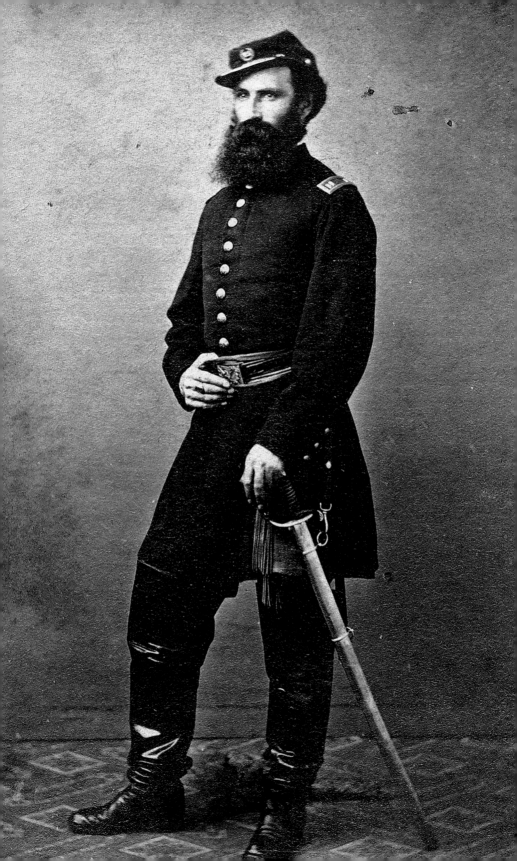

A Garibaldi Guardsman Takes Back Captured Cannon

Late during the second day of battle, a Union battery posted near the Trostle House blasted canister shot toward oncoming Confederates. The artillerymen working the guns kept at it until the loss of men and horses prevented them from firing or leaving the field. The 21st Mississippi Infantry captured the stranded cannon.

Federal forces immediately counterattacked to recover the guns, which belonged to Battery I of the 5th U.S. Artillery. The assault fell to the 39th New York Infantry, also known as the Garibaldi Guard. A heterogeneous mix of men from several European nations, the regiment included Carlos Alvarez de la Mesa.

"I really enjoy being a part of my regiment," he declared in a letter, "Because I am European, I am happy to be a member of a regiment that bears the name of Garibaldi, the hero of liberty in Italy." Giuseppe Maria Garibaldi had inspired many immigrants and native-born Americans with his republican ideals and generalship.

Born in Spain, de la Mesa immigrated to America via England about 1859 and settled in Brooklyn, N.Y. After the bombardment of Fort Sumter, a group in New York City organized the

Carte de visite by Joshua Appleby Williams of Lovell General Hospital, Portsmouth Grove, R.I. Author's collection.

Garibaldi Guard, or the First Regiment Foreign Rifles, recruiting immigrants from Italy, France, Germany, Hungary, Switzerland, Spain, and Portugal. De la Mesa answered the call and enlisted on May 17, 1861. He formally mustered into the new regiment 11 days later, bidding farewell to his newlywed wife, Mary Frances "Fannie" Taft. The couple had met at a ball in Newport, R.I., and married following a whirlwind romance.

The Garibaldi Guard wound up in western Virginia and Harpers Ferry, where it and the rest of the federal garrison were surrendered to conquering Confederates in September 1862. The men received paroles and were soon exchanged and returned to an active role.

Months later at Gettysburg, de la Mesa, now captain and company commander, led his men into the attack to recapture the lost guns. A bullet struck him in the foot as he advanced, its impact causing him to topple over a fence. He could not get out of the way of his own troops, who trampled over him in the mad dash toward the guns, leaving him with serious lacerations and contusions in addition to his crippling wound.

Months later at Gettysburg, de la Mesa, now captain and company commander, led his men into the attack to recapture the lost guns. A bullet struck him in the foot as he advanced, its impact causing him to topple over a fence. He could not get out of the way of his own troops, who trampled over him.

The regiment recaptured the cannon. Surgeons determined de la Mesa's injuries serious enough to end his combat career, and he left his beloved regiment with a disability discharge in September 1863. Still wishing to aid his adopted country, he joined the 11th Veteran Reserve Corps and served through the end of the war.

De la Mesa went on to become an agent for the Freedmen's Bureau in a northwestern subdistrict of Georgia. According to one source, he worked at a feverish pace from his headquarters in Rome, investigating labor complaints, inspecting facilities, and responding to charges of child molestation and abandonment.

The stress of this work became the basis of a claim by his wife Fannie for a pension after De la Mesa gained admission to an insane asylum and died on Independence Day 1872. He was about 44 years old. He also suffered from venereal disease, which may have been a factor in his early death. Fannie and four children, the eldest 10 years old, survived him. De la Mesa's remains rest in Arlington National Cemetery.

A quarter century after his death, de la Mesa's eldest daughter, Consuela, gave birth to a grandson he would never meet, Terry de la Mesa Allen. He went on to become "Terrible Terry," a noted World War II major general who led the 1st Infantry Division in North Africa and Sicily from May 1942 until August 1943. He later commanded the 104th Infantry Division.

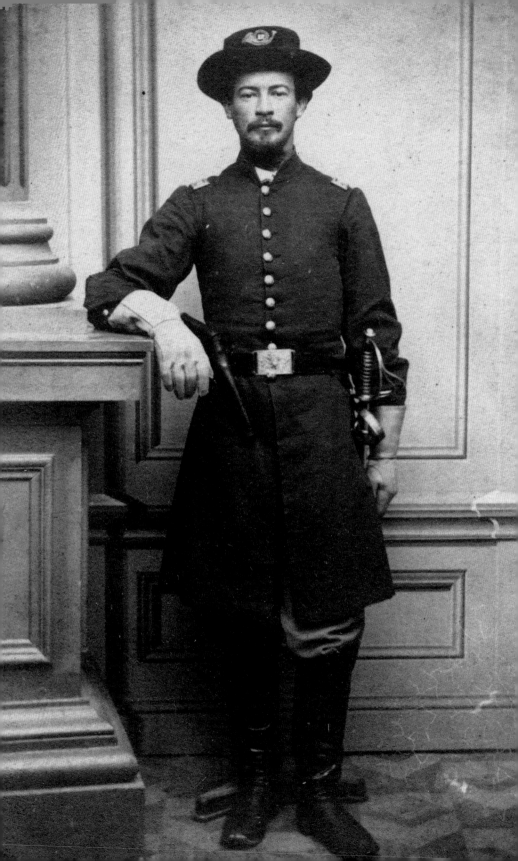

Action at Bliss Barn

Captain Harry Chew and his company from the 12ᵗʰ New Jersey Infantry dashed beneath the scorching sun towards an unoccupied barn belonging to William and Adelina Bliss. The fortress-like structure with narrow windows seemed tailor-made for sharpshooters.

The Jerseymen, in support of the 1ˢᵗ Delaware Infantry, briefly occupied the property, then fanned out in a skirmish line with the Delawareans.

Chew and an orderly sergeant took up a position along a fence near the adjacent Bliss House as enemy artillery boomed. The sergeant suggested that they move out of harm's way. Chew replied, "We are as safe here as any where, you can't run away from them things." At that moment, a solid shot crashed into and knocked a picket out of the fence, against which the orderly sergeant leaned. Chew shouted, "Get out of here," and the pair ran back to the barn.

Henry Franklin Chew's journey to the Bliss Barn began in 1860, when war talk in his Salem County, N.J., community prompted him to enlist in a militia company. He did so against the vigorous objections of his Quaker parents. When war became a reality, the militiamen became Company I of the 4ᵗʰ New Jersey Infantry and served a three-month enlistment. Afterwards, Chew

Carte de visite by Bell & Brother of Washington, D.C. John Kuhl Collection.

raised recruits for and joined the state's 9th Infantry but fell ill and resigned after only a few months. His health restored by the summer of 1862, he became a captain of Company I in the 12th. The new regiment joined a brigade in the Army of the Potomac's 2nd Corps.

In May 1863, Chew experienced his first battle while on temporary duty on his regiment's brigade staff. Gettysburg marked the first time he led his company into combat.

At Bliss Barn, Confederate artillery shots scattered farm animals and inflicted casualties on the men. Chew observed a massing of enemy troops—Brig. Gen. Carnot Posey's Mississippians—and reported the movement to Lt. Col. Edward Harris, who commanded the 1st Delaware. Harris assumed responsibility and prepared accordingly.

The Confederates attacked about 4 p.m. Harris lost his nerve and skedaddled. His troops panicked and fled along with him. Chew tried to hold on. "I was on the line and told my men to stand," he reported. "We stood as long as we could, but we were soon compelled to leave." Overwhelmed by the Mississippi troops, he ordered his company back, and it followed on the heels of the Delawareans.

Harris was arrested and cashiered for his actions. Chew came away with an untarnished reputation. "No better soldier served than Henry F. Chew. He was 'in it' from start to finish, always ready for duty. There is not a blot or stain on his record," exclaimed a comrade.

Chew went on to attain the rank of lieutenant colonel and participate in the Overland, Petersburg, and Appomattox Campaigns. He commanded the 12th at the Battle of The Wilderness, where he suffered a gunshot wound to his right elbow.

After the war, he became a dentist in Camden, N.J., married, and fathered two daughters. Active in veterans' affairs, he helped establish a regimental memorial at Gettysburg. Chew died in 1907 at age 80.

Fighting for the Colors in The Wheatfield

The 403-strong 4ᵗʰ Michigan Infantry battled for its life in The Wheatfield during the afternoon of the second day's fight. Surrounded and hit hard by a fierce Confederate charge on its right flank, the suddenness and shock of the attack surprised the Michiganders and broke their line. The color sergeant dropped the regiment's flag and the men rallied to retrieve it.

The effort ended in a brutal scrum involving hand-to-hand combat as both sides struggled to gain possession. The men of the 4ᵗʰ recovered the flag at great cost, including the life of their colonel, Harrison H. Jeffords, who suffered a mortal bayonet wound.

The casualty list for the action numbered 164 Michigan men and officers, among them Pvt. David T. Dudley of Company C. He fell into enemy hands during the melee.

An Ohio-born farmer who settled in Michigan before the war, he had enlisted when the regiment formed in June 1861. He made a "true soldier," noted Albert Cole, one of his comrades in Company C. Cole recalled, "We touched elbows from Bull Run to Malvern Hill, and back to Bull Run, Antietam, Fredericksburg, etc." At the last-named engagement, Dudley suffered a minor wound.

Seven months later at Gettysburg, Dudley's capture ended in a trip to Richmond and confinement at Belle Isle, a prison for Union non-commissioned officers and enlisted men located on

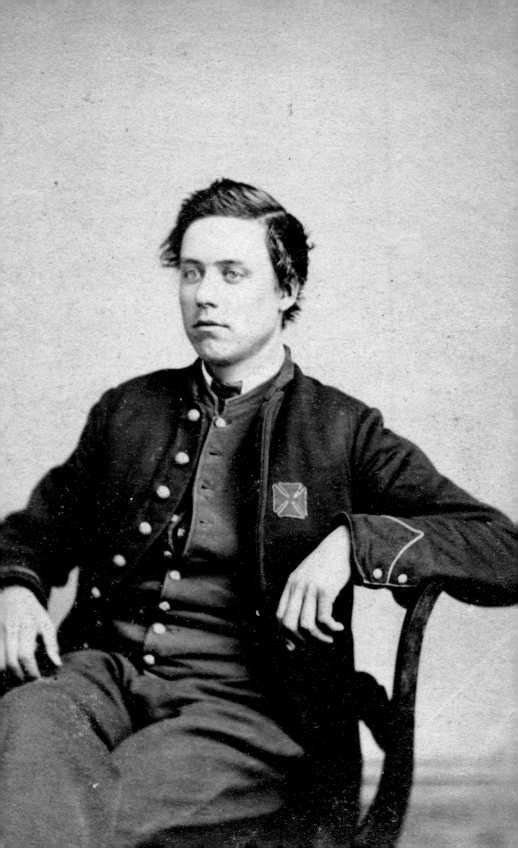

an island in the middle of the James River. Attacked by rheumatism on the march out of Gettysburg, Dudley's condition rapidly worsened in prison. By late August 1863, he could no longer care for himself. His captors paroled and exchanged him, and he returned to the North.

Dudley eventually regained his strength and returned to the 4th before the end of the year, mustering out at the expiration of his term of enlistment in June 1864.

Dudley returned to Michigan, married, and started a family. In 1869, they relocated to Weeping Water, Neb. Dudley lived until 1912, dying at age 74. He outlived his first wife, Melinda, who had passed in 1874. His second wife, Ottelia, and four children survived him.

Carte de visite by R.W. Addis of Washington, D.C. Rick Carlile Collection.

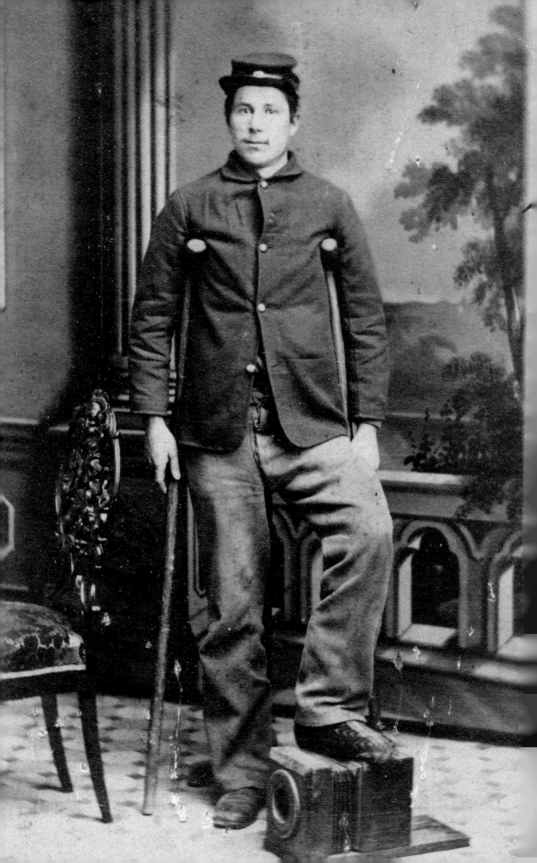

Collateral Damage to Clara's Photograph

Minié balls flew thick and fast in and about The Wheatfield as blue and gray infantry struggled for supremacy during the second day's fight. One of the bullets blasted from the musket barrel of a Confederate whizzed through the hot air and gun smoke and struck a Union soldier on the other side. The soft lead shot tore into the man's wallet and passed through a photograph of his spouse before tearing into the flesh of his left thigh near the hip.

The wounded soldier, Albert Lewis Jordan, had left his Massachusetts farm and pregnant wife, Clara, less than a year earlier and joined the army. Recruited for the veteran 18th Massachusetts Infantry, he received a signing bonus of several hundred dollars. This money, along with a $13 monthly soldier's salary, provided a healthy nest egg for a 24-year-old farmer starting a family.

Jordan took his place in the ranks of Company I. He experienced the first shock of battle at Chancellorsville in May 1863, coming away unscathed from the engagement.

The bullet that thudded into his thigh at Gettysburg landed him in a field hospital, where surgeons determined his wound severe. Medical personnel forwarded him to the military hospital located in downtown York, Pa., for further treatment. During his

Carte de visite by Evans and Prince of York, Pa. Rick Carlile Collection.

recuperation, he grabbed his crutches and hobbled to a nearby photographer's studio, where he posed for this portrait resting the foot of his injured leg on a camera.

In March 1864, medical staff transferred Jordan to Lovell General Hospital in Portsmouth Grove, R.I. He left the army with a disability discharge a couple of months later and returned to his farm near Franklin. There he reunited with Clara, and his young daughter named for his wife. Unable to work the land due to his Gettysburg injury, he became a shoemaker and supplemented his income with a government pension until his heart failed in 1890. He was 53 years old. Wife Clara received his military benefits until she passed in 1912.

A U.S. Regular Caught in the Crossfire

Private Adelbert Clinton Sherman and his comrades in the 11ᵗʰ U.S. Infantry found themselves in deep trouble on the afternoon of July 2. Ordered from the vicinity of Little Round Top and Houck's Ridge to a new position near The Wheatfield, they ran into stiff Confederate resistance. At first, the 11ᵗʰ fell back across an open field in good order. But after enemy infantry turned their right flank and hit them with a murderous crossfire the effect was deadly. In minutes nearly half the regiment became casualties—116 of 261 men and officers.

The casualty list included Sherman. A bullet struck him below the right collarbone, tore through his right lung, and exited his back near the base of his shoulder blade. Transported to the field hospital of the 2ⁿᵈ Division of the 5ᵗʰ Corps along Baltimore Pike, surgeons dressed the wound and made him as comfortable as possible while his life hung in the balance.

Sherman, a 22-year-old native of New Jersey, had lived in Roxbury, Mass., when he joined the veteran 11ᵗʰ Regulars. Formed about a year earlier, the regiment's ranks had been depleted by losses in the Peninsula Campaign and elsewhere with the Army of the Potomac. Sherman proved a reliable recruit, participating in the battles of Fredericksburg and Chancellorsville.

Following his severe wounding at Gettysburg, Sherman's condition slowly improved. Three weeks later, medical staff sent him

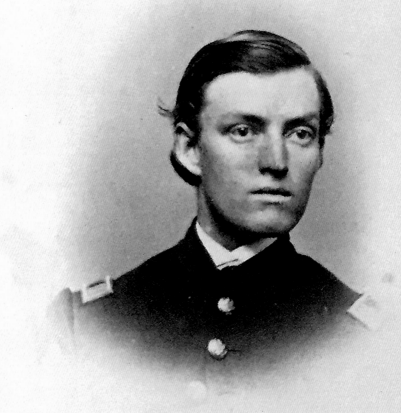

Capt A C Sherman
28th U S C Inf

to the Cotton Factory Hospital in Harrisburg, Pa., where he completed his recovery. He rejoined his regiment in October 1863.

Aspiring to become an officer, Sherman applied for and received a commission as first lieutenant in the 28th U.S. Colored Infantry. He joined his new command in May 1864 and led his company in several battles, including the Crater. In an eerie repeat of Sherman's Gettysburg experience, his regiment lost about half of its number, and he suffered another wound. This time, a gunshot struck his right leg between the knee and ankle.

Sherman recovered and remained with the 28th until it disbanded in Texas in November 1865. He left with his captain's bars, though never mustered officially at this rank.

Towards the end of his service with the 28th, he applied for readmission to the Regulars. The War Department approved his application but never assigned him to a regiment—likely the result of the lack of open positions in the downsized postwar army.

Sherman settled into life as a farmer and lived in Illinois and New York before settling in the Maine village of Monmouth. He married four times and fathered two children with his first wife, Sophia. Upon his death in 1923 at age 83, Sherman's remains were buried in Monmouth Cemetery beside his second wife, Maria, who predeceased him.

Carte de visite by an unidentified photographer. Seward Osborne Collection.

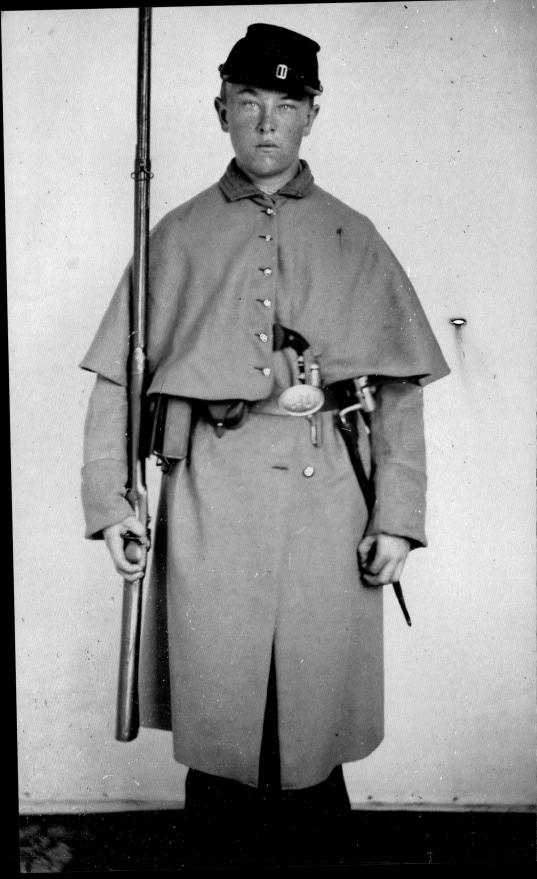

Wounded in The Wheatfield Withdrawal

Sergeant Samuel Hockley Rutter and his comrades in the 53rd Pennsylvania Infantry scored an initial success in The Wheatfield and Rose Woods during the afternoon of July 2. The Pennsylvanians, along with the rest of their undersized brigade, drove back Confederate attackers in this sector of the battlefield. But the brigade was not properly supported. Flanked by the rebels, it was hit hard and forced to retreat.

As Rutter made his way back through The Wheatfield, according to a family story, he happened upon his first cousin and fellow townsman in Pottstown, Pa., John Rutter Brooke, who had been wounded. Brooke, the original colonel of Rutter's regiment, now commanded the brigade to which the 53rd belonged.

Rutter and another soldier assisted the injured Brooke off the field. As the trio moved out of harm's way a gunshot struck Rutter in the left leg just below his knee.

Two years earlier, Rutter had enlisted in the 53rd only a few days before his 19th birthday. The new regiment soon departed the Keystone State for the South, where it participated in the Peninsula Campaign and the Battles of Fredericksburg and Antietam. Along the way, Rutter gained the respect of his comrades and earned his sergeant's chevrons.

Quarter-plate ruby ambrotype by an unidentified photographer. Charles T. Joyce Collection.

Rutter served in this capacity at Gettysburg and, after his wounding, made it with Col. Brooke to safety. A surgeon probed Rutter's leg, discovered the bullet, and extracted it—perhaps saving him from an amputation. Rutter completed his recovery in a Philadelphia hospital and returned to his company before the end of the year.

Rutter's wound appears not to have slowed him down as he advanced to sergeant major in December 1863, and, the following year, first lieutenant and regimental adjutant. He survived all the fighting in the final bloody campaigns with the Army of the Potomac and mustered out with his comrades in June 1865.

Rutter returned to Pottstown and went to work as a freight agent for the Lehigh and Susquehanna branch of the Central Railroad of New Jersey. He proved himself as good an employee as a soldier. But the rigors of camp and campaign during the war compromised his health and may have contributed to his early death after he suffered an epileptic convulsion in 1879 at age 36. His wife, Laura, survived him.

First cousin John R. Brooke also outlived him. Brooke joined the Regular Army after the war and played a minor role in the chain of command that relayed orders dispatching the 7th U.S. Cavalry to Wounded Knee in 1890. Brooke lived until age 88, dying in 1926.

The Little Corporal at Klingel Farm

The 12th New Hampshire Infantry marched into Gettysburg reduced to 224 men and officers, the result of heavy losses at the recent Battle of Chancellorsville. The regiment's staff had all been taken out of action, leaving the men in the command of a senior captain. The stalwarts in the ranks included Howard Taylor of Company C, affectionately known by his fellow Granite Staters as the "Little Corporal."

The story of how he received his *nom de guerre* dates to the bombardment of Fort Sumter in 1861. Newspaper reports of the attack on the fort's federal garrison stirred the soul of then 16-year-old Taylor. He determined then and there to become a soldier.

A year later, when neighbors and friends in his hometown of Belknap, N.H., searched for volunteers to form a company to join the newly organized 12th, Taylor declared himself to be 18 (he was in fact 17) and signed up. To meet the height requirement, he wore custom shoes fitted with padded inner soles and thick heels. "Thus toed and heeled, with pant legs long enough to cover, he walked resolutely up the company front from his place on the extreme left, faced and saluted like a West Point cadet, and passed, unchallenged, into the service of his country," reported the regimental historian.

Plucky Taylor received his corporal's chevrons and headed off with the rest of the 12th for the South at the end of September 1862.

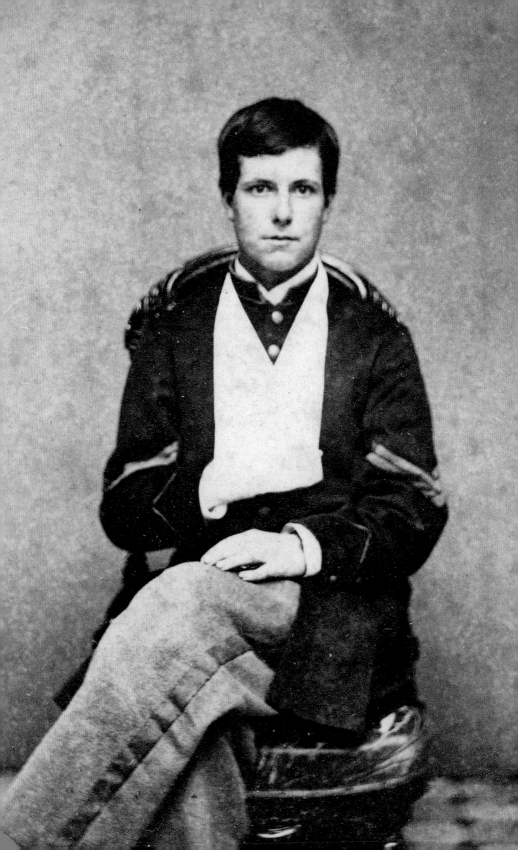

Eight months later at Chancellorsville, the New Hampshire boys marched into action 549 muskets strong. More than half became casualties, including Taylor, who suffered a minor wound in his left hand.

Two months later, during the second day at Gettysburg, they participated in the heavy fighting at the Daniel Klingel Farm. At some point the Little Corporal suffered a wound to the index finger of his right hand. The tip of that bandaged finger is just visible poking through the sling around his hand in this portrait.

The injury kept him out of action for seven weeks. Taylor returned to his company and continued to fight, suffering a third wound during the May 1864 Bermuda Hundred Campaign in Virginia. A minié bullet struck a glancing blow to his head and kept him out of action for a day or two. He earned a promotion to sergeant before mustering out with his comrades in June 1865.

The effects of the Bermuda Hundred wound were blamed for his insanity and early death at age 45 in 1890. He died unmarried.

Carte de visite by an anonymous photographer. Charles T. Joyce Collection.

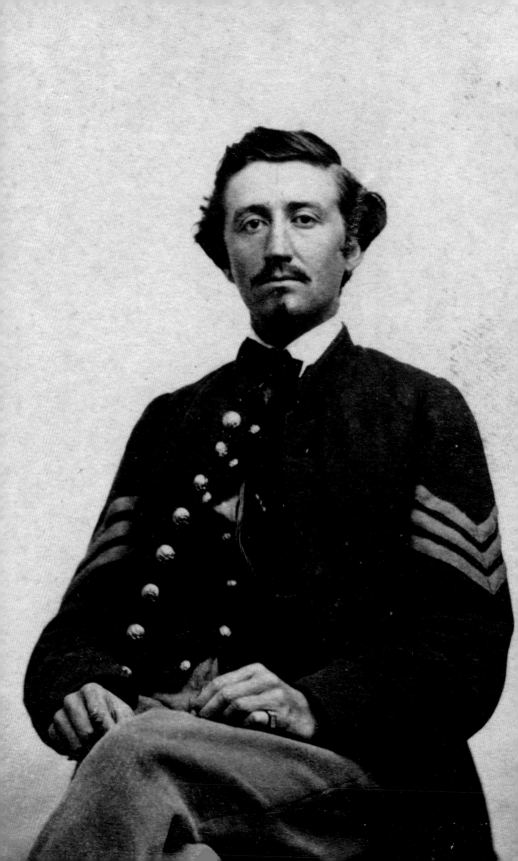

Swinging Open a Gate

The half-mile gap created in the Union lines when Maj. Gen. Daniel Sickles advanced his entire 3rd Corps ahead of their assigned place proved an invitation to disaster. The Confederate attack that followed smashed into the federal front.

One unlucky regiment caught up in the lopsided fight, the 12th New Hampshire Infantry, had just opened fire on the rebel juggernaut when orders came down from high command to turn and march to the rear.

The regiment's historian likened the move to swinging opening a gate for the Confederates. The obedient Granite State boys attempted to execute the order in the face of a withering fire and suffered the loss of 92 men as they withdrew from the scene of carnage and chaos.

The casualty list included Sgt. Joseph Knowles Whittier, a tall, commanding figure who had celebrated his 20th birthday on the first day of the battle. A bright young Christian who had set aside his college plans to join the army less than a year earlier, he poured his heart and soul into the war. "May God prosper the right is the prayer of one who loves liberty and free institutions," he wrote to his family at home in Meredith, N.H.

Military success eluded the 12th during the second day at Gettysburg. Whittier came away with a slight wound, the nature

Carte de visite by an anonymous photographer. Rick Carlile Collection.

of which went unreported. Spared a worse fate, his natural gifts as a leader came to light during the months following the battle as he rose in rank to become first lieutenant of his Company G in March 1864.

Death found him three months later at Cold Harbor when grapeshot tore through his body and killed him instantly. The intensity of the fighting made it impossible for his comrades to recover his remains, though they retrieved his sword and pocket watch. A cenotaph in Bayside Cemetery in Laconia, N.H., honors his memory. On the same monument is listed his older brother, Lyman, a trooper in the 1st Massachusetts Cavalry, who had died of disease in 1862.

An admonition Whittier had written home earlier in the war is a tribute to his character. "Let shame and confusion be the lot of him who at this crisis shall lift his hand, or voice, to stay the onward march of victory. Blasting infamy shall be his reward through this and coming generations."

In the Ranks During Barksdale's Charge

The massive assault by Brig. Gen. William Barksdale's Mississippi Brigade through the Peach Orchard breached the Union's left-center flank, scattering federal forces in its wake. One of Barksdale's veteran troops, Newton J. Ragon of the 13th Mississippi Infantry, numbered among the stalwart enlisted men who made the charge.

A farmer in Choctaw County, Miss., Ragon had volunteered to serve in his local militia company, the Winston Guards, after the war began. The militiamen mustered into Confederate service as a company in the new 13th Infantry. The colonel in command of the regiment was Barksdale, a former member of the U.S. House of Representatives, staunch secessionist, and pro-slavery newspaper publisher. According to 1860 federal census records, he enslaved 36 people.

Barksdale and his regiment soon left their home state for Virginia. Ragon posed for this portrait holding a Model 1842 musket and what appears to be a militia officer's sword that dates to the 1830s. Worthy of note is his cap with an elaborately embroidered band and tassel, tinted shirt and suspenders, and patterned pants with frame buckled belt—a quintessential early-war Southern volunteer.

Ragon and his comrades participated in the war's earliest engagements in the East, including First Bull Run and Ball's Bluff.

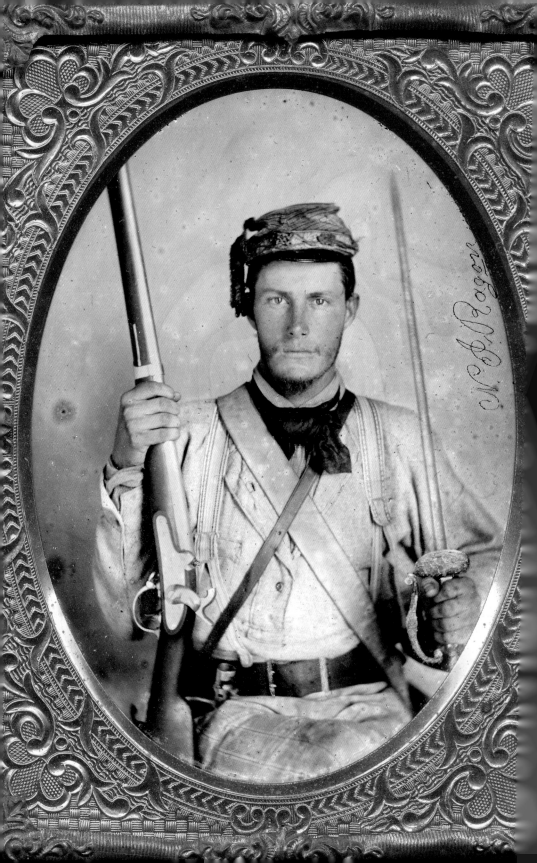

They also fought in the July 1862 Battle of Malvern Hill, the culminating engagement of the Peninsula Campaign. A few months later in Maryland, Ragon suffered a wound in the fighting along Maryland Heights that ended with Union forces surrendering Harpers Ferry. The nature of his injury was not recorded, but it caused him to miss the Battle of Antietam. He had returned to combat by the December 1862 Battle of Fredericksburg.

At Gettysburg, Ragon joined the casualty list a second time when he fell into enemy hands. Though the exact location of his capture is not known, it is likely to have occurred at some point after the Mississippi Brigade had been stopped and forced back after penetrating about a mile into Union territory. The list of casualties included Barksdale, who suffered mortal wounds.

Gettysburg proved Ragon's last battle. His captors forwarded him to the Pennsylvania capital of Harrisburg to be processed and then on to Delaware, where he spent the rest of the war as a prisoner at Fort Delaware.

Ragon signed the Oath of Allegiance to the federal government on June 11, 1865. He returned to Mississippi, married, and started a family that grew to include four children. He died in Choctaw County in 1907 at age 69.

Quarter-plate ambrotype by an anonymous photographer. Dan Schwab Collection.

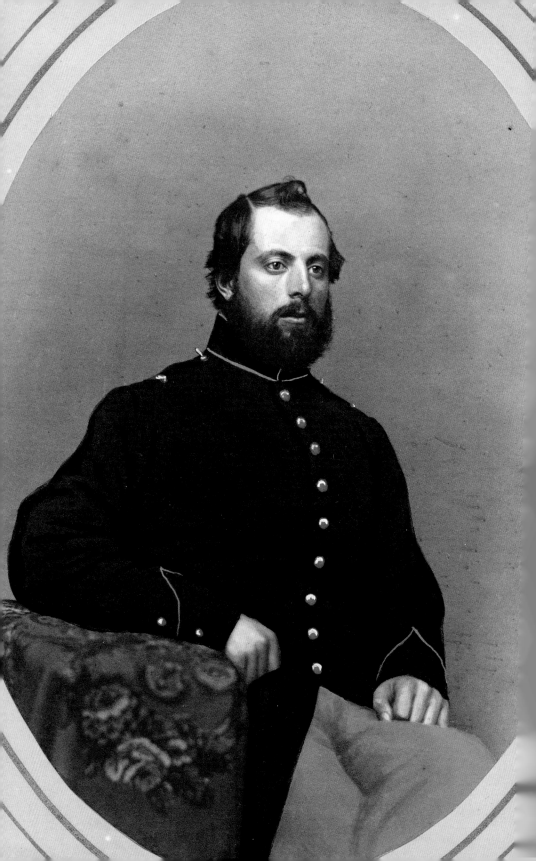

Removing the Stain of Harpers Ferry

The charge of Brig. Gen. William Barksdale and the 1,400-strong Mississippi Brigade hit the Union forces arrayed along Cemetery Ridge with extreme force. The assault fractured the federal line and the Mississippians poured through and kept on going. That is, until they were stopped by a Union brigade of New Yorkers that included the Empire State's 125th Infantry.

The 125th had been organized less than a year earlier and got off on the wrong foot. In its first combat at Harpers Ferry, Va., in September 1862, the green recruits crumbled under fire. Their poor performance, combined with the surrender of all the Union troops in the Harpers Ferry garrison, stained the regiment's reputation.

The loss was a bitter blow to the rookie regiment who were now prisoners of war. The experience of one of the men, Charles Wesley Ives, is representative of his comrades.

A clerk from Troy, N.Y., he mustered into service as a private in Company H on Aug. 27, 1862. A day later and 400 miles away at Manassas Junction, Va., Gen. Robert E. Lee's Army of Northern Virginia whipped the Union army commanded by Maj. Gen. John Pope in the Second Battle of Bull Run. The victory spurred Lee on to invade Union territory.

Large-format albumen print by an unidentified photographer. Paul Russinoff Collection.

As the Confederates moved northward, the 125th headed south with little training or preparation. They arrived at Harpers Ferry only days before the battle and surrender sealed their fate on Sept. 15, 1862—less than three weeks after Ives mustered in.

The Confederates paroled Ives and his comrades, and they reported to Camp Douglas in Chicago, Ill., to await formal exchange. Two months later, after Union and Confederate authorities negotiated a deal, the 125th rejoined the Union army. It and other regiments were received under a cloud of suspicion—branded cowards by some.

In June 1863, the 125th and three other New York infantry regiments that had suffered the same fate at Harpers Ferry were assigned to the same brigade in the 2nd Corps of the Army of the Potomac. Informally known as the New York Brigade, it was commanded by the colonel of the 125th, George L. Willard.

Redemption for Harpers Ferry came at Gettysburg on July 2. The New Yorkers arrived that morning, took their assigned position along Cemetery Ridge, and sent out skirmishers, who suffered considerably. Then came the charge, which the 125th and the rest of the New York Brigade repulsed.

Vindication and the removal of the stain of Harpers Ferry came at a high price. The long list of casualties included Col. Willard, who suffered instant death when an artillery round struck him, and Ives, killed at some point during the day. He was 19.

First Combat as an Officer

On the afternoon of July 2, Charles Augustus Foss stood with his comrades in the 72nd New York Infantry east of the Emmitsburg Road and prepared for combat. For Foss, 22, the battle marked his first time wearing an officer's shoulder straps.

Two summers earlier in Chautauqua County, N.Y., Foss had left his home in Dunkirk, a city bordering Lake Erie, and enlisted in the newly organized regiment as a corporal in Company C. His record of promotions is evidence of his leadership qualities. He received his first sergeant's chevrons following the Second Battle of Bull Run in 1862 and joined the cadre of officers with the rank of second lieutenant in Company D after the Battle of Chancellorsville.

Two months later at Gettysburg, 2nd Lt. Foss and the rest of the 72nd occupied the extreme left flank of Brig. Gen. Andrew A. Humphreys' division, to the immediate right of a brigade commanded by Brig. Gen. Charles K. Graham. After a Confederate attack by Brig. Gen. William Barksdale's Mississippians drove back Graham's troops, the exposed 72nd withdrew in confusion, only to rally and join in a counterattack from Cemetery Ridge that helped drive away the rebels.

The 72nd paid a high price in casualties. About 40 percent of the 305 men and officers engaged suffered death, wounds, or went missing. The list included Foss, who suffered a serious leg wound. Taken to a field hospital located on the Michael Fiscel

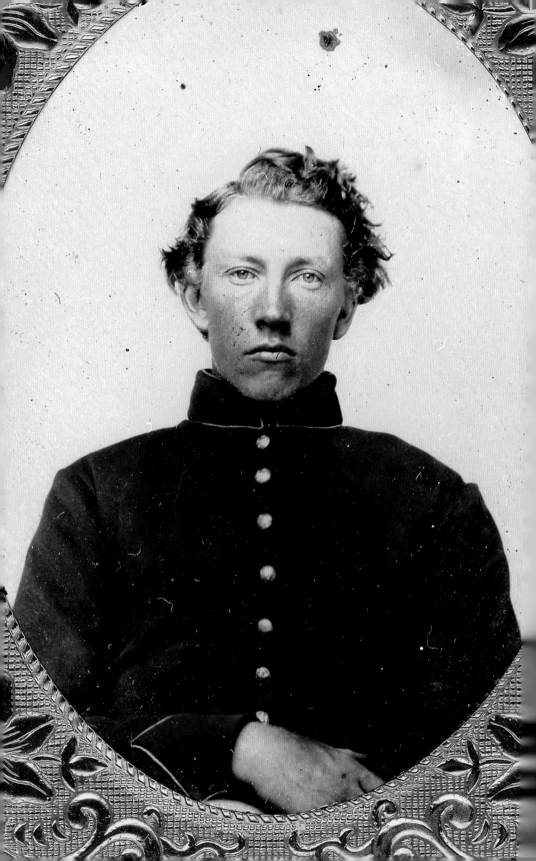

Farm, surgeons determined the limb beyond saving and amputated it.

Foss did not survive the surgery. He died on July 7 and his body was buried in a field of clover on the farmland. His remains were later reinterred in Section A, Grave 84 of the New York plot in the Soldiers' National Cemetery.

Gettysburg proved Foss's first and last battle as an officer.

Ninth-plate ruby ambrotype by an anonymous photographer. Charles T. Joyce Collection.

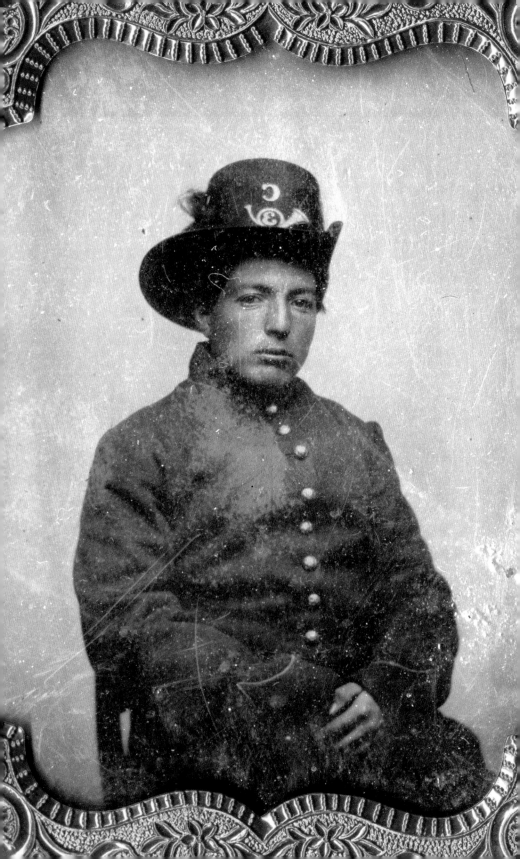

In the Color Guard
That Literally Melted Away

The 3rd Maine Infantry found itself in dire circumstances in the Peach Orchard on July 2. Pressed by South Carolinians of Brig. Gen. Joseph B. Kershaw's Brigade, the Maine soldiers—a mere 196 men and 14 officers—held their ground.

At this critical point Brig. Gen. William Barksdale's Mississippians broke through Union lines in the rear and threatened the determined New Englanders. Facing the very real possibility of imminent destruction, the regiment's commander, Col. Moses B. Lakeman, ordered his men to shift position to meet the hard-charging Mississippi Brigade.

As the small regiment wheeled and spread its line to face its new attackers, Confederates hit it with an enfilading volley of musket fire. The brunt of this wall of flame struck the color guard just as it formed a rallying point. "It literally melted away. Every man of the color-guard was killed or wounded," according to one account.

Its stricken members included Cpl. Danforth Milton Maxcy, who enjoyed a reputation as one of the best soldiers in the regiment. A peacetime clerk from Gardiner, Maine, "Dan," as his comrades called him, had participated in 16 engagements since his enlistment in June 1861. His valorous conduct was recognized

Sixth-plate tintype by an unidentified photographer. Jeff Kowalis Collection.

with the Kearny Cross, a medal named for Maj. Gen. Philip Kearny, a division commander in the Army of the Potomac's 3rd Corps killed ten months earlier at the Battle of Chantilly.

At Gettysburg, as Maxcy moved into position with the color guard, two minié bullets tore into his lower right leg, one slug shattering his knee. He and the rest of the color guard and other injured men were left behind when the 3rd withdrew. In the chaos and confusion, the survivors came away with the state flag but lost the Stars and Stripes.

Maxcy and the other wounded were rescued and carried away for treatment in field hospitals. In a story all too often repeated, Maxcy's leg seemed to heal properly, but gangrene set in. Surgeons amputated the infected leg to no avail. Maxcy succumbed to its effects at Letterman General Hospital on the outskirts of Gettysburg on Aug. 14, 1863, at 11 a.m. His remains were sent home to his family in Gardiner and buried in Oak Grove Cemetery.

U.S.

Waiting for a Fight

The hard-fighting 70ᵗʰ New York Infantry formed a line of battle by 8 a.m. on the morning of the second day's fighting. Minutes ticked by. An hour passed. Then another. Finally, at 1 p.m., orders arrived to advance in support of another brigade. The 70ᵗʰ moved into position near the Peach Orchard and lay under enemy artillery fire. Three long hours later, about 4 p.m., the regiment engaged oncoming Mississippians commanded by Gen. William Barksdale.

The 70ᵗʰ held its position, though at great cost in officers and men: 39 killed, 81 wounded, and four missing. The injured list included one of its finest officers, Maj. William H. Hugo. A bullet tore into his right hip during the combat—and he refused to leave the battlefield until assured that the rebels had been repulsed.

A New York native who had relocated to Michigan and become a successful carriage maker, his first foray into the military occurred in 1856 when he organized and became captain of a local militia company, the Lafayette Light Guard. Five years later, after the bombardment of Fort Sumter, Hugo moved quickly to enlist his 100 men. He immediately notified state authorities in Detroit, who confirmed receipt of his message. Then, silence.

Anxious and eager for action, Hugo learned that back in New York, former congressman Daniel E. Sickles needed companies to fill out regiments for his Excelsior Brigade. Hugo and his men traveled to New York and mustered in as Company C of the 70ᵗʰ.

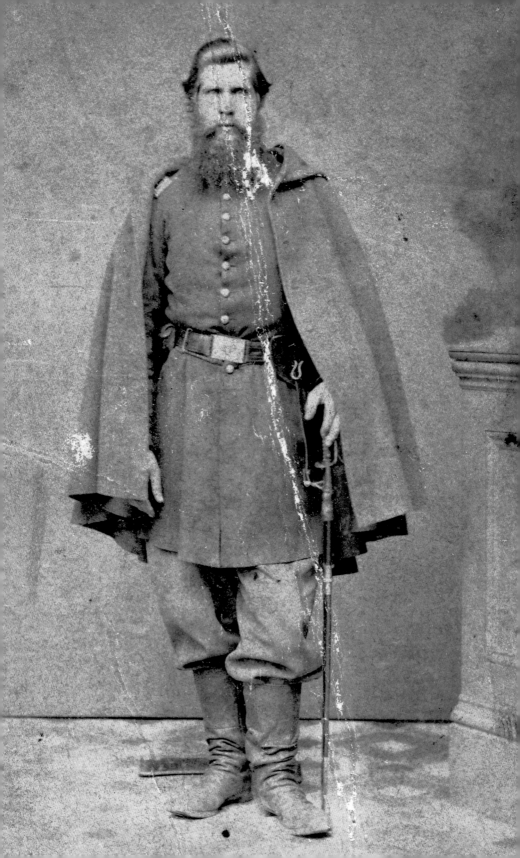

The heterogeneous regiment also included companies recruited in Pennsylvania, New Jersey, and Massachusetts.

The 70th participated in its first combat during the Peninsula Campaign, during which Hugo suffered his first wound in April 1862 when a nine-inch shot fired from an enemy cannon passed within inches of his head during the Siege of Yorktown. The concussion left him deaf in his left ear. He went on to fight at Second Bull Run, Fredericksburg, and Chancellorsville, where he earned a promotion from captain to major.

At Gettysburg, the hip wound he suffered at the Peach Orchard took him out of action until September 1863. He actively participated in the Mine Run and Overland Campaigns until mustering out with the regiment upon the expiration of its service in July 1864.

Above: Mary Hugo.

Carte de visite by Partridge of Bridgeport, Conn. Captain Wilson French Collection, courtesy Carolyn B. Ivanoff.

Left: Hugo as a captain in the 70th New York Infantry.

Carte de visite by J.J. Ardwell of Detroit, Mich. Captain Wilson French Collection, courtesy Carolyn B. Ivanoff.

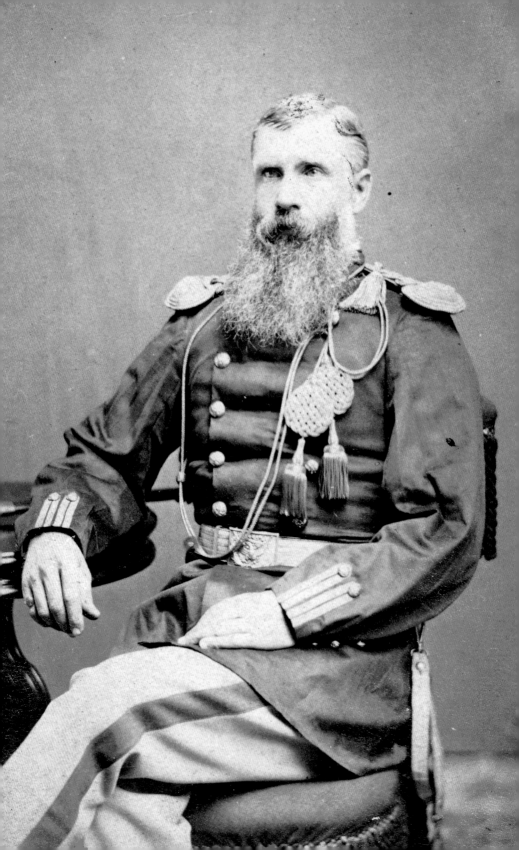

Hugo planned a return to the army as an officer with the U.S. Colored Troops, but the war ended before he received an assignment. In 1866, he joined the Regular Army as a second lieutenant, and spent the rest of his career on the American frontier in command of Buffalo Soldiers in the 25th Infantry and 9th Cavalry. He rose in rank to first lieutenant in campaigns against Apache warriors. His wife, Mary, and their two children joined him at various posts. Mary died at Fort Bayard in New Mexico. Though her exact death date is not known, Hugo was stationed there at various times between 1877 and 1880.

In 1881, Hugo's career ended abruptly after he was court-martialed and dismissed for being drunk during roll call. He appealed his sentence, claiming he had been drugged with laudanum and suffered rheumatism and asthma from years of exposure with the army. Fellow officers supported his claim. In 1889, the army overturned his sentence, restored his rank, and awarded him a pension. He died in 1905 at about age 72.

Hugo as a Regular Army officer.

Carte de visite by J.H. Prater of Paw Paw, Mich. Captain Wilson French Collection, courtesy Carolyn B. Ivanoff.

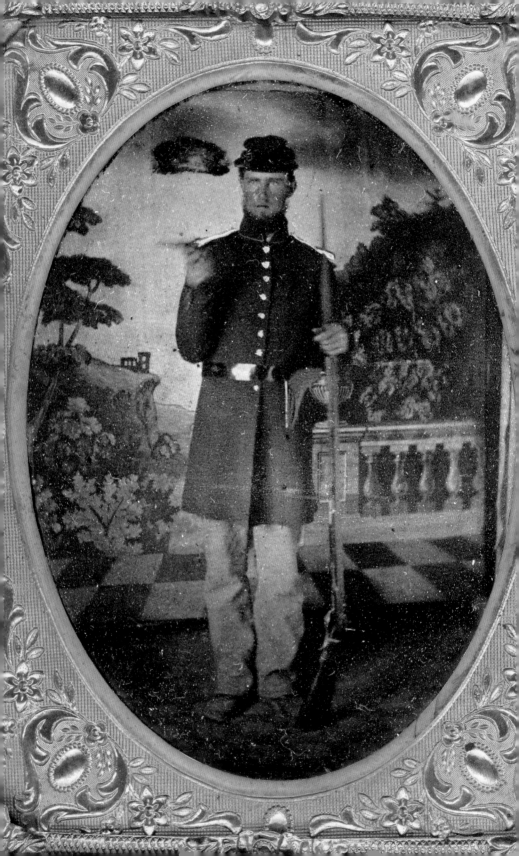

Grim Distinction

Rapid marches, scorching summertime heat, and the trials and tribulations of combat pushed soldiers on both sides to the brink of exhaustion at Gettysburg. Such was the case in the ranks of the 148th Pennsylvania Infantry.

During the second day's fight, the Pennsylvanians hurried into position near Cemetery Ridge. Confederate artillery discovered the regiment and lobbed occasional shells in its direction. The fire prompted them to relocate to a less exposed position. Fatigued from all the activity, they took advantage of the opportunity to catch a few winks despite occasional cannon blasts.

One of the enlisted men who dozed off, Pvt. George Osman of Company C, was the quintessential reliable soldier. "Always in a good humor, no matter how arduous the duty, it was willingly and cheerfully performed," noted one of his comrades, who added, "I don't think he ever uttered one word of complaint."

Born about 1838 in Centre County, Pa., Osman had enlisted in the newly formed 148th the previous August. The regiment participated in its first fight at Chancellorsville in May 1863 and suffered 48 wounded and killed. Osman emerged unhurt.

Two months later at Gettysburg, the 148th suffered 31 casualties, including Osman. His nephew, Lemuel Henry Osman, who also served in the ranks of Company C, recounted his uncle's

Quarter-plate tintype by an unidentified photographer. Faye and Ed Max Collection.

fate: "George Osman, who was no doubt in a sleep, was hit by a spent shell which struck him on the cartridge box. It was a terrible shock from which he did not recover."

Osman succumbed to his injuries on the Fourth of July. He was 25. His remains were interred in the Pennsylvania plot at the Soldiers' National Cemetery.

The 148th went on to fight in numerous engagements with the Army of the Potomac, including the 1864 Battle of Spotsylvania, where it suffered the greatest loss of any Union regiment. Nephew Lemuel survived the war and recounted his uncle's passing in the regiment's 1904 history. He lived until 1921.

Mad Dash at Stony Hill

The 66th New York Infantry ran across a nightmare landscape toward a rocky ridge known as Stony Hill late in the afternoon of July 2. The men and officers navigated an obstacle course of tall wood fences, stone walls, ditches, and boulders. They made this mad dash in the face of leaden hail of enemy artillery and musketry.

One of the Empire State soldiers, 1st Lt. Daniel Banta, 29, and his Company I dodged fence rails and ravines to shouts of "Forward!" and "Charge!" above the din of shot and shell. Banta and most of his boys made it 300 yards to the base of the hill and hit the rebels head-on, though the movement across the uneven ground had inextricable mixed up the men with those from other regiments in their brigade.

Bullets flew fast and furious. The commander of the 66th's brigade, Brig. Gen. Samuel K. Zook, had already been taken out of action. Three bullets unhorsed him, and they proved mortal. He did not live to see the end of the battle.

Other bullets hit with deadly accuracy. One of them struck Banta in his right arm below the shoulder and tore through his body before exiting his left side close to the spinal column.

Banta, a New Jersey native who worked as a peacetime tram driver in New York City, had emerged as one of his regiment's best citizen-soldiers. He had left behind a wife and two young sons in late 1861 to join the army. He started his service in the 66th as a private and received a series of promotions through

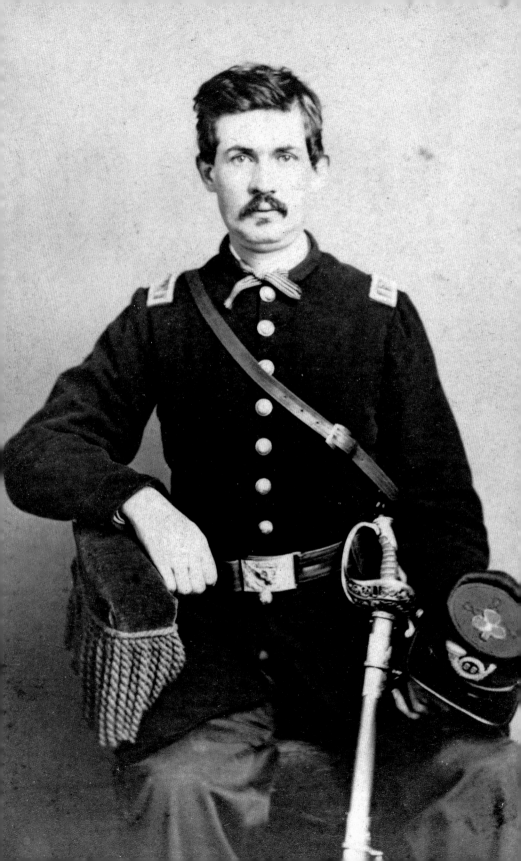

the ranks to sergeant major. His gallantry in the 1862 Battle of Fredericksburg received notice in the regiment's after-action report. In early 1863, he advanced to second lieutenant and then first lieutenant.

Gettysburg abruptly ended Banta's rise. The bullet that struck him down, fired from the musket of a South Carolinian in Brig. Gen. Joseph B. Kershaw's Brigade, penetrated his right lung, diaphragm, and intestines. Abdominal wounds were almost always fatal. Carried to the field hospital of the 2nd Corps, he suffered bouts of vomiting and spitting up blood. Fecal matter oozed out of his stricken abdomen. He lost the movement in his right arm.

Medical personnel treated him with heavy doses of opium and morphine and let nature take its course. Banta beat the odds. Over the next two weeks his condition stabilized, and he received a furlough home to complete his recuperation.

In March 1864, Banta returned to his regiment. His stay, however, was brief. Unable to perform duty with a paralyzed arm, he received his captain's bars, but never officially mustered in at that rank. Less than a month later, he received a discharge.

Banta rejoined his family and resumed his work as a tram driver in New York City. His war wounds slowed him down and, in 1879, he left his job. Banta died in 1884 at age 50. His wife, Rachel, and sons survived him.

Carte de visite by R.A. Lord of New York City. Charles T. Joyce Collection.

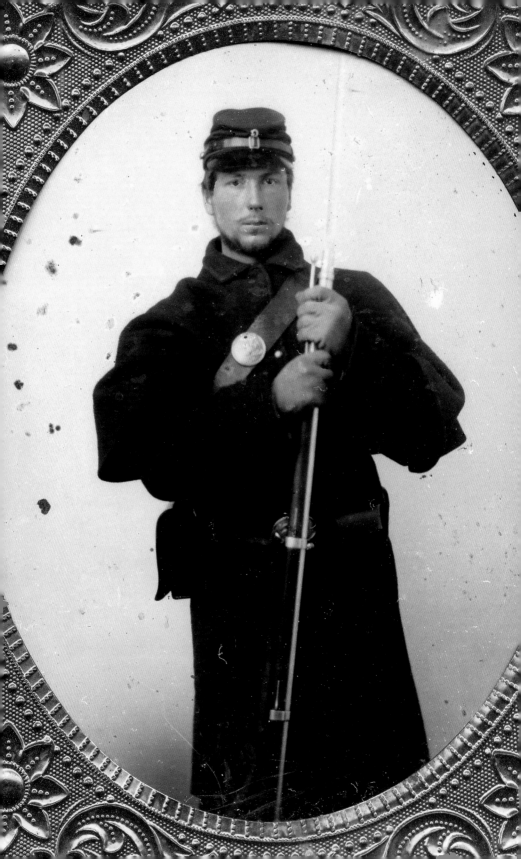

The Reliable Private Smart

Confederates moved quickly to exploit a wide gap in the main
Union line created by Maj. Gen. Daniel Sickles when he
advanced his entire 3rd Corps on the afternoon of July 2. Rebel
forces struck the exposed federals with terrible ferocity. One of
the hard-hit blue regiments, the 384-strong 1st Massachusetts
Infantry, defended its position until ordered to withdraw.

The regiment counted its losses and discovered about a third
of its number had become casualties. The majority of those on
the grim list were brought off the field and buried or treated
for wounds. Some soldiers had gone missing, including Richard
Baxter Smart, who served in the ranks of Company G.

A carpenter from Brighton, Mass., Smart had joined the reg-
iment in the first wave of patriotism that swept the loyal states
following the bombardment of Fort Sumter. Single and 21 years
old, he bade farewell to his folks and left with his new comrades
for the South.

Smart's military service papers reveal a spotless record—
no absences for sickness, no equipment lost or damaged, no
improprieties of any kind. He was present for duty in all the
regiment's many battles, including one of the earliest fights in
Virginia at Blackburn's Ford, several engagements during the
Peninsula Campaign and the Battles of Second Bull Run, and
Chancellorsville.

Sixth-plate ambrotype by an unidentified photographer. Paul Russinoff Collection.

Gettysburg ended Smart's perfect attendance. At some point during the combat on the second day, he fell into enemy hands. Carried off to Virginia at the end of the battle, his captors confined him at Richmond on July 21. Unlike so many soldiers who wasted away in Southern prison camps, Smart managed to gain his release a few weeks later. Paroled and sent to the Union's base at City Point, Va., in early August, he reported to Camp Parole, Md., before the end of the month to await his formal exchange. It came in early October 1863 and Smart returned to his regiment.

Smart's service record picked up where it left off before Gettysburg. His brief experience as a prisoner of war seemed not to impact his reliability or his health. He received his corporal's chevrons and continued to serve until his three-year term of enlistment expired in May 1864. Smart elected not to reenlist and returned to his home in Massachusetts.

Smart married in 1865 and started a family that grew to three children. Active in his local post of the Grand Army of the Republic, he lived until age 75. His death occurred July 3, 1915—52 years and a day after his capture at Gettysburg.

"There Is No More Gallant Deed Recorded in History"

On the second day of fighting, Orderly Sgt. Matthew Marvin lay on the ground with his fellow Minnesotans as rebel artillery shells hissed and whizzed. He stared into the distance on that hazy late afternoon and glimpsed enemy infantry columns. They advanced rapidly and in perfect order. Marvin noted, perhaps with a veteran's respect, how they moved without noticeable confusion.

Marvin hugged the ground, held on to his musket, and waited.

Meanwhile, Maj. Gen. Winfield Scott Hancock scrambled to patch up a gap in his line along the Emmitsburg Road after troops had been driven back in some confusion. As Hancock, commander of the 2nd Corps, shored up the broken lines he also noticed Confederates emerging from a point near a clump of trees. They presented an immediate threat to his unprotected line.

Hancock needed time to check the enemy advance while reinforcements came up and moved into position. He rode quickly to the nearest regiment, the 262 men and officers of the 1st Minnesota Infantry. "I would have ordered that regiment in if I had known every man would be killed," Hancock reportedly said afterward. "It had to be done"

Moments later, the Minnesotans were on their feet and charging towards the Confederates on a collision course. The enemy infantrymen, a full brigade of Alabamians commanded by Brig. Gen. Cadmus M. Wilcox, rapidly fired their muskets.

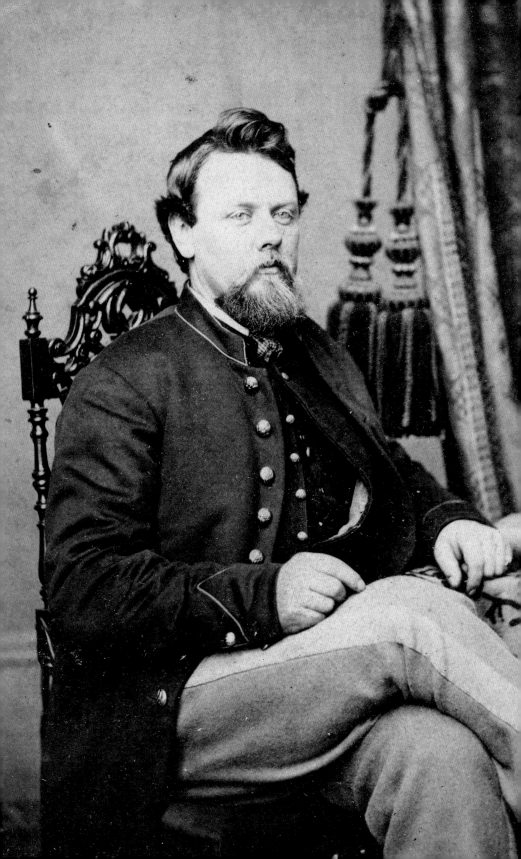

One of the slugs of lead found Marvin before he had a chance to return fire. He fell to the ground, realizing he had been hit, then jumped back up as quickly as he could. At this point he noticed the missing heel of his right brogan and blood oozing through the leather. His thoughts in the moment were only to catch up to his comrades and use his musket and bayonet to stop the Alabamians. "No rebel line could stand a charge of my regiment," he later wrote.

At this point he noticed the missing heel of his right brogan and blood oozing through the leather. His thoughts in the moment were only to catch up to his comrades and use his musket and bayonet to stop the Alabamians. "No rebel line could stand a charge of my regiment," he later wrote.

Marvin caught up to the line but quickly fainted and collapsed. He roused himself, uncorked his canteen and took a swallow of water, then splashed some on his head and wrists. Realizing he could go no further, he slowly made his way back, first hobbling and later crawling on his hands and knees. As he struggled to safety, his movements caught the attention of a fellow soldier wounded earlier in the day. This man helped Marvin into an ambulance for treatment.

The bullet entered his foot near the big toe and exited his heel. As the shock of combat and adrenal rush ebbed, excruciating pain set in.

A New York native who had settled in Winona, Minn., before the war, Marvin had been wounded twice before: First Bull Run in 1861 and in operations on the Virginia Peninsula in 1862. In the latter campaign, a Union soldier in another brigade accidently shot him in the thigh.

Carte de visite by Reynolds & Rider of Chicago, Ill. Charles T. Joyce Collection.

In both cases, Marvin returned to duty. This time, the wound ended his military service. He received a discharge in June 1864. He left knowing that he had done his part to drive back the charging Alabamians. The regiment paid a high price for victory: 215, including Marvin, suffered death or wounds. No other regiment during the war, North or South, matched the casualty rate of 82 percent.

"There is no more gallant deed recorded in history," reportedly declared Maj. Gen. Hancock.

Marvin returned to Winona and married. In 1873 he became superintendent of the town's Woodlawn Cemetery and transformed it into a picturesque place to remember loved ones. His remains were buried there after his death in 1903 at age 64. His wife, Angeline, and a daughter survived him.

Wounded in a Legendary Charge

The suicidal charge made by the 1ˢᵗ Minnesota Infantry on the afternoon of July 2 accomplished its goal. The 262 men and officers slowed an advancing brigade of Alabamians, buying time for Union reinforcements to arrive on the scene.

The Minnesotans paid a premium in blood for the precious minutes needed to strengthen the federal line: 215 of 262 men and officers suffered wounds or death, an 82 percent casualty rate.

The list of wounded transported to a field hospital for initial treatment included Ernst L.F. Miller, a corporal in Company I. A bullet hit him in the right thigh, just above his knee.

An immigrant who hailed from the German state of Saxony, Miller had settled on the outskirts of St. Paul and eked out a living as a farmhand, river pilot, and sawyer.

In the spring of 1861, Miller joined the 1ˢᵗ. A few months into his enlistment, soon after the First Battle of Bull Run, he suffered an injury while on picket duty near the regiment's camp at Edwards Ferry, a Potomac River crossing in Northern Virginia. The tip of a bayonet at the end of a musket slung over the shoulder of the man ahead of him caught Miller in the right eye.

The accident kept Miller out of action for a couple weeks. He returned to duty and participated in numerous operations, including the Battle of Antietam, for which the regiment received praise for its coolness under fire.

Less than a year later, Miller, who had recently celebrated his 30ᵗʰ birthday, marched into Gettysburg for his date with destiny.

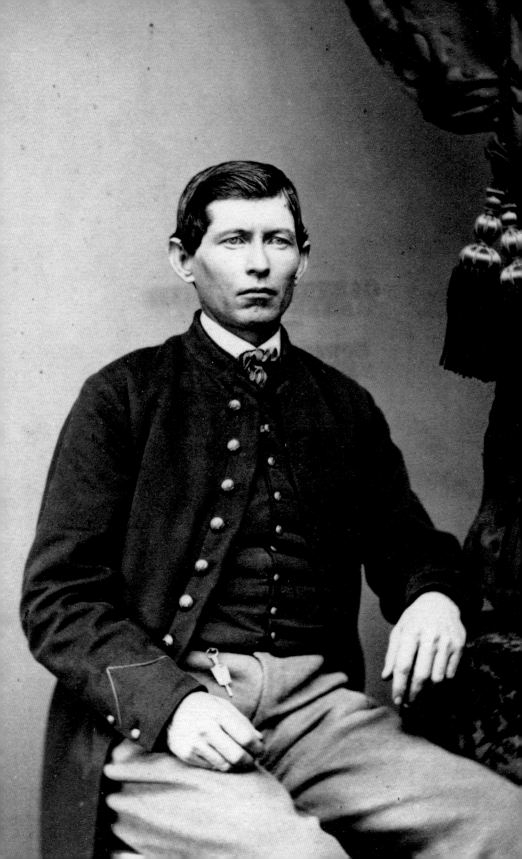

The successful charge made by the Minnesotans went down in the annals of American military history.

For Miller, the charge marked the beginning of a long road to recovery. During the days and weeks that followed, medical personnel relocated him to several field hospitals before he landed in Camp Letterman, established by the end of July just east of Gettysburg. At some point, he moved to Mower U.S.A. General Hospital, also known as Chestnut Hill for its location north of Philadelphia, Pa. He remained here until the expiration of his enlistment in June 1864.

Miller returned to Minnesota, married, and started a family in the village of Winsted. He supported them as a butcher until his death in 1883 at age 49. His left behind his wife, Mary Ann, pregnant with their sixth child, and four surviving children who ranged from four to 14 years old.

Carte de visite by J.R. Laughlin of Philadelphia, Pa. Rick Carlile Collection.

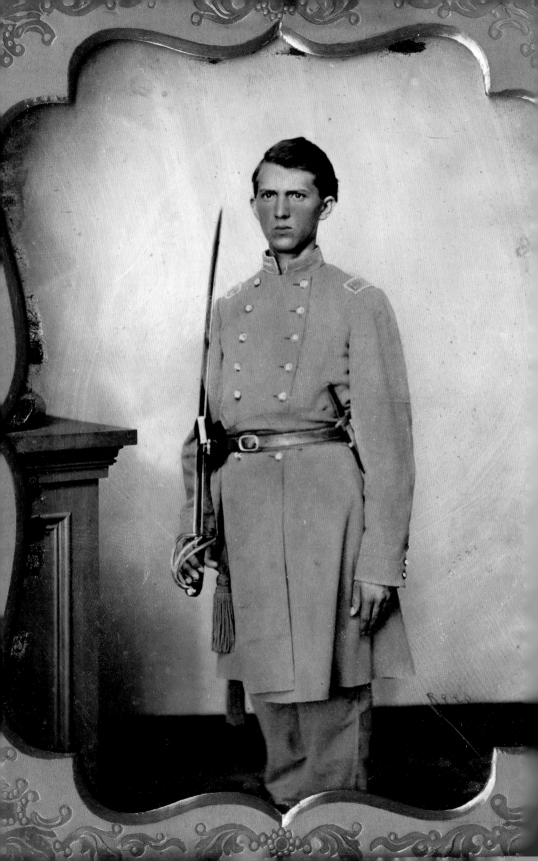

A Texan In the Triangular Field

The Texas Brigade deployed for battle along Emmitsburg Road on the southern end of Seminary Ridge by mid-afternoon of July 2. Positioned behind a line of trees, the four regiments of the Brigade and other forces prepared to march against the enemy.

In one of the regiments, the 1ˢᵗ Texas Infantry, 2ⁿᵈ Lt. Ben Campbell assisted his brother officers in preparing the men in the ranks for the anticipated advance.

Born Benjamin Asbury Campbell in Lowndes County, Ala., 21 summers earlier, he might have spent his entire life there. But fate intervened when his father died in 1848. His mother, Mary, remarried, and, in 1852, the family moved to Anderson County in East Texas.

When civil war divided the country, Campbell's family connections helped secure him a commission as a junior second lieutenant in Company G of the 1ˢᵗ in June 1861. He bade farewell to his newlywed wife, Eppinina "Eppie" Micheaux, a Kentucky belle, and an infant son, George, and set off for Virginia.

The Texans became known by the *nom de guerre* "Ragged Old First" for hard fighting and heavy casualties in numerous engagements, including the Seven Days, Second Bull Run, Antietam, and Fredericksburg. Campbell participated in none of these battles, as his superiors had assigned him to recruiting duty in Palestine, Texas. He returned to the regiment in the spring of 1863.

Quarter-plate ambrotype by Charles R. Rees of Richmond, Va. Paul Russinoff Collection.

Gettysburg marked his first fight. About 4 p.m. on the second day of the battle, Campbell, now a full second lieutenant, and his fellow Texans marched out from the tree line along Emmitsburg Road and crossed low ground sloping up toward the Triangular Field and, just beyond it, Houck's Ridge and Devil's Den. The Texans advanced into a storm of artillery and musket fire. The combination of shot and shell, and rock-strewn ground created gaps in the lines.

At one point, Campbell and his men moved to fill a space between the left flank of their regiment and the right of the 3rd Arkansas Infantry. About this time, a bullet struck Campbell in the chest and killed him. He was a day shy of his twenty-second birthday.

Campbell's remains were never recovered.

The news traveled to his family in Texas. Eppie, 20, remained a widow until her death in 1925. Her son, George, died weeks after Campbell joined the army. A second son born in 1862 and named after his father died in December 1863.

The ambrotype reproduced here belonged to Eppie.

Precarious Position Behind a Large Boulder

A handful of Georgians swarmed a captured cannon after a short, decisive charge against Union troops along rock-strewn Houck's Ridge during the afternoon of July 2. The gun, a 10-pounder Parrott, now belonged to them. One of the soldiers, 1st Lt. Pinkney Gilliard Hatchett, basked in the glory of victory. Flush with success after a heart-pounding, adrenaline-pumping scramble uphill against a hail of shot and shell, he assumed the day was won.

Moments later, federal infantrymen brought him back to his senses when they struck back with an enfilading fire. Jolted by the suddenness of the shots, Hatchett looked up and glanced in the direction of Little Round Top. He saw the mountain lined with bluecoats. A second look around revealed that he and his men had advanced 75-100 yards farther than the rest of their comrades in the 20th Georgia Infantry.

They ducked behind a large boulder and pondered next steps.

Hatchett, 23, had been in his share of tough spots since he had joined the army. Born in Georgia and known as "Pink" to his pals, he had left his father's Harris County farm, including ten enslaved persons, to enlist in June 1861. He led his Company E in some of the war's biggest battles up to that point, including Antietam and Fredericksburg, and emerged without injury.

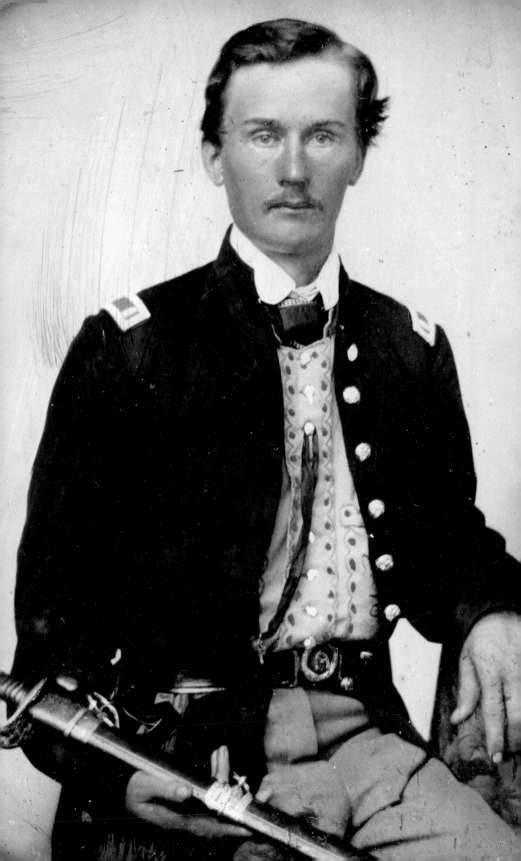

At Gettysburg, Hatchett quickly came to realize that in the din of battle and dogged pursuit of the enemy over Houck's Ridge he had missed an order to halt. The boulder behind which he took cover offered only partial shelter. Soon after, a bullet struck him in the left ankle. Unable to walk and determined not to be captured and sent to a Northern prisoner of war camp, he took his chances and slid out from the safety of the rock. Crawling on his hands and knees over the same ground he had charged a short time before, he eventually made it out of harm's way. The fate of his comrades went unreported.

Hatchett remained with the 20th until the autumn of 1864, which was the last time his name appeared on the regimental rolls. At some point he settled in Texas and avoided signing the Oath of Allegiance to the federal government until 1871. Most Confederate soldiers had signed within days and weeks of the surrender of the armies and collapse of the Confederate government.

Hatchett taught school for a time, started a short-lived cattle business, and sold kerosene. He lived until age 92, dying in 1931. His wife and two sons survived him.

Sixth-plate ambrotype by an anonymous photographer. Brian Boeve Collection.

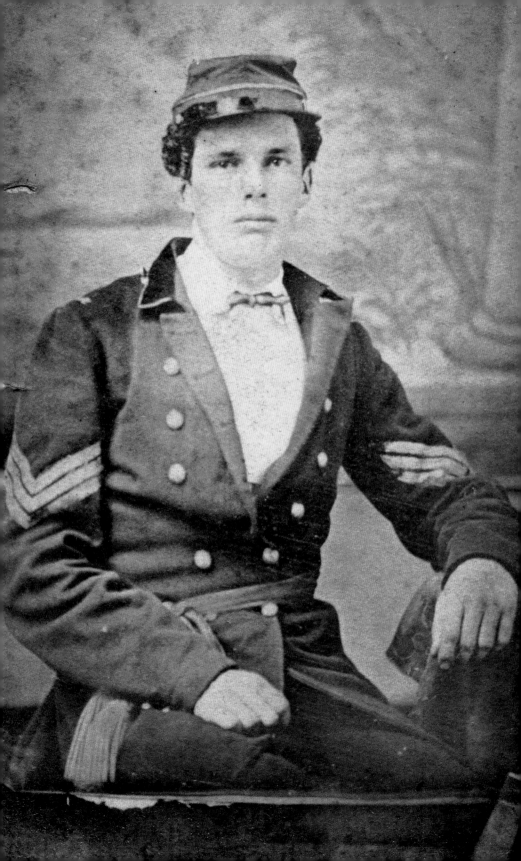

Lost in the Vicinity of Devil's Den

No one knows exactly where on the battlefield James Green Burton drew his last breath. The likely spot is somewhere in the vicinity of Devil's Den, where he and his comrades in the 2nd Georgia Infantry overran the Union position in a furious fight during the afternoon of the second day's fight.

His loss deprived the regiment of a volunteer who enlisted during the earliest days of the war. On April 19, 1861, a week after the bombardment of Fort Sumter, he joined the ranks of his local militia company, the Burke County Sharpshooters. The man who signed him up, William R. Holmes, commanded the company as its captain.

The Sharpshooters mustered into service as Company D of the 2nd Georgia Infantry. After a few months deployed along the Georgia coast in expectation of a coastal invasion that never came to pass, the 2nd moved to Virginia and joined the brigade of Brig. Gen. Robert Toombs for service with Gen. Robert E. Lee's army.

About a year later at the Battle of Antietam, Capt. Holmes, now lieutenant colonel of the 2nd, suffered instant death in a charge at Rohrbach Bridge, afterward known as Burnside Bridge. Burton and several other soldiers attempted to retrieve Holmes' body but were unsuccessful. In the attempt, Burton suffered

Carte de visite copy of a wartime photograph by Gable & Usher of Augusta, Ga. David Wynn Vaughan Collection.

a wound that landed him in a Richmond hospital for several months.

Burton returned to his company in January 1863 wearing the chevrons of a sergeant—the timing of the promotion suggests his superiors awarded it to him for his courage at Antietam. He likely posed for this portrait during his convalescence.

Six months after Burton rejoined his comrades, he forfeited his life at Gettysburg. He was in his early 20s.

Grim Errand Following the Fight on Houck's Ridge

The Confederate attack on Devil's Den and Houck's Ridge during the afternoon of July 2 landed with maximum impact on the 124th New York Infantry. Just two months earlier at the Battle of Chancellorsville, the New Yorkers had been branded the "Orange Blossoms" for their home county, Orange. The man credited with the *nom de guerre* was the regiment's colorful colonel, Augustus van Horne Ellis.

Ellis' gift for words ended at Houck's Ridge when a Confederate bullet struck him in the head and toppled him from the saddle of his horse during a countercharge against the rebels. Moments before his death wound, another bullet unhorsed the regiment's major, James Cromwell, killing him instantly.

The loss of the senior officers left only one mounted Orange Blossom officer on the field, the regiment's 19-year-old adjutant, Henry Powell Ramsdell.

The son of a wealthy merchant in Newburgh, N.Y., Ramsdell had set aside his studies the previous summer and, with three other men, recruited volunteers for what became Company C of the regiment. When the men voted for officers, a common practice among volunteers, they elected Ramsdell second lieutenant. One of his fellow recruiters, James Cromwell, became the major of the 124th, and Ramsdell soon joined him on the regimental staff as adjutant.

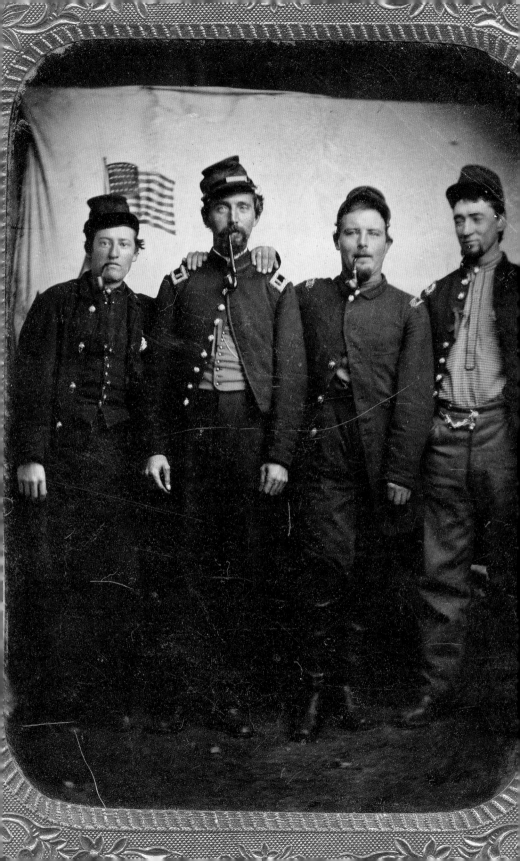

In September 1862, the 124th left the Empire State for Virginia and an assignment to the Army of the Potomac. The regiment performed well in combat at Fredericksburg in December 1862 and six months later at Chancellorsville.

At Gettysburg, the Orange Blossoms further proved their mettle against overwhelming numbers until forced to fall back with heavy casualties. Historians credit the regiment for buying valuable time for Union forces to organize and successfully defend nearby Little Round Top from a similar Confederate onslaught.

The bodies of Col. Ellis, with a small round hole in his forehead from which protruded brain tissue, and Maj. Cromwell, his uniform bloodied where a bullet had penetrated his chest, were placed in Ramsdell's care.

According to one report, Ramsdell approached the senior captain, Charles H. Weygant, and asked permission to care for the remains of the two leaders. Weygant stated in the regimental history that he called Ramsdell and asked him to take charge of the bodies and bring them home.

Weygant recalled Ramsdell's answer: "I will do my *best,* captain."

Weygant stated in the regimental history that he called Ramsdell and asked him to take charge of the bodies and bring them home. Weygant recalled Ramsdell's answer: "I will do my *best,* captain." Ramsdell fulfilled his promise.

Ramsdell fulfilled his promise. The next morning, he and a detail of nine men and the colonel's servant, Sam, left with the precious cargo. They carried the bodies on stretchers about three miles, when they happened upon a farmhouse with a covered

Ramsdell, left, stands with fellow lieutenants William Brownson, Henry Travis, and James Finnegan, who suffered a wound at Gettysburg.
Quarter-plate tintype by an anonymous photographer. Paul Russinoff Collection.

wagon parked on the grounds. Ramsdell found the owner and attempted to rent or purchase the wagon. After negotiations failed, Ramsdell confiscated the vehicle. His men loaded the stretchers in the back and stuffed straw between them to keep the bodies from shifting.

By the end of the day, they arrived in Westminster, Md., about 25 miles from the battlefield. A local carpenter built two crude wood caskets and packed the bodies in ice. The next morning, Independence Day, Ramsdell and the men continued the journey to Baltimore, encountering chaotic scenes of wounded soldiers, throngs of curious and anxious citizens, and plenty of military bureaucracy. Ramsdell's efforts to cut through the red tape proved difficult and he again turned to commandeering to get metallic caskets and rail transportation home.

Ramsdell completed his mission and delivered the remains to the grieving families by July 7, and promptly left with the detail for the return trip to the 124th.

Five months later in Virginia during the Battle of Mine Run, Ramsdell narrowly escaped death when a sharpshooter's bullet knocked him down. He soon got back on his feet, for the buckle of his waist belt blunted the full impact of the ball. But damage had been done, and he ended his service with a disability discharge before the end of 1863. He left the 124th as a first lieutenant and returned home to Newburgh.

Ramsdell went on to become a success as a paper manufacturer and in other business enterprises. He lived until age 89, dying in 1934. His wife, Adele, and a daughter survived him.

The Jones Boys in the Fray

The 146th New York Infantry was among the first Union regiments to occupy Little Round Top—and easily the most colorfully attired. Conspicuous in Zouave-inspired uniforms of light blue and yellow trim, turbans, and red sashes, the natty soldiers left a trail of light as muskets and bayonets glinted in the sultry summer sun.

One of the men in the ranks, Orlo H. Jones, and his comrades in Company D hurriedly formed a line of battle among the craggy outcropping of boulders and awaited oncoming rebels.

Orlo, about 23, a farm laborer from Oneida County in central New York, had joined the army the previous summer. Some months later, during the first half of 1863, he posed for this portrait wearing his corporal's chevrons and a Maltese cross, the badge of the 5th Corps to which the 146th belonged. He rests a forearm on the shoulder of his older brother, Adelbert B. Jones, a second lieutenant in the 97th New York Infantry. Adelbert had started as a sergeant in the regiment back in 1861 and received his officer's shoulder straps after suffering a wound in the Second Battle of Bull Run.

Flash forward to Gettysburg. Both brothers participated in the engagement, fighting in separate sectors of the battlefield.

On Little Round Top during the afternoon of July 2, Confederate attackers pushed up the slope toward the thin blue lines of Union defenders. The regimental historian of the 146th

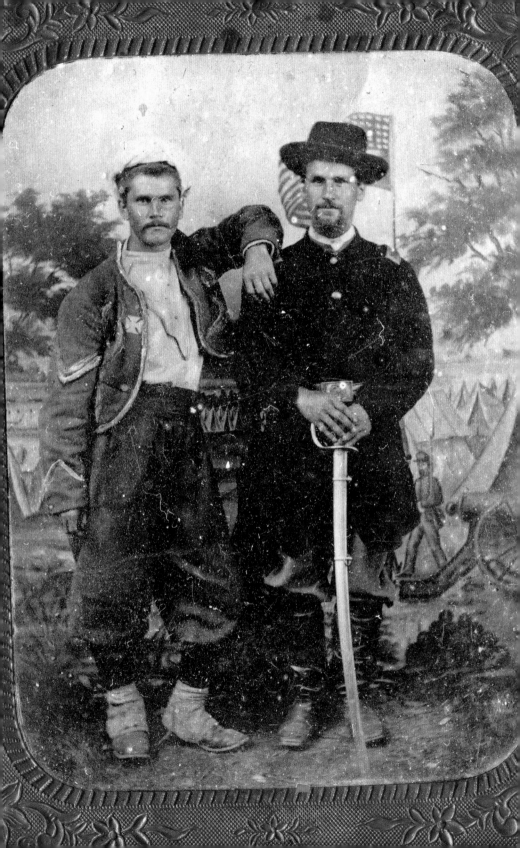

reported, "We greeted them with round after round of musketry, and it was impossible for them to make headway. They slowly fell back, after suffering great loss." The New Yorkers counted 28 killed and wounded. Orlo escaped harm.

Brother Adelbert was not as fortunate. The next day, he and the 97th clashed with Confederates in the vicinity of Ziegler's Grove and suffered serious losses, including Adelbert. Initial reports that he had been killed proved false, as he had received a slight head wound and remained with his Company B.

The war ended for the Jones boys on Virginia battlefields in 1864. Adelbert, now captain and company commander, suffered his third wounding of the war at Laurel Hill on May 8. He left the army with a discharge and lived until age 82, dying in 1920. Rebel lead cost Orlo his left leg at Bethesda Church, Va., on June 2. He fell into Confederate hands and died in captivity.

Quarter-plate tintype by an anonymous photographer. Bruce Bonfield Collection.

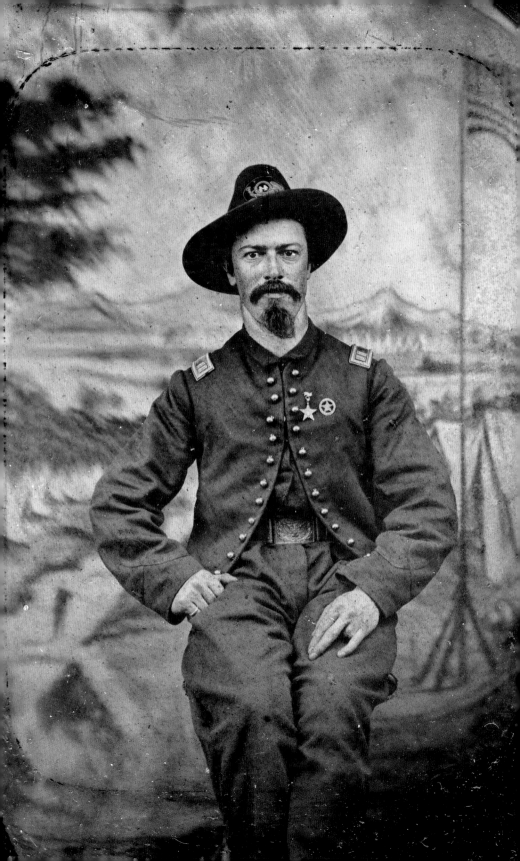

Premonition Before Little Round Top

During the leadup to the action on Little Round Top, three cap-
tains from the 44th New York Infantry made small talk while wait-
ing for orders to advance. One officer, Lucius Sherman Larrabee,
made a grim prediction. "Since our last battle I have known that
I would be killed the next time I was under fire," he said, refer-
ring to the Battle of Chancellorsville two months earlier. He then
asked them to take his watch, money, and other items.

The other captains, William R. Bourne and Benjamin K.
Kimberly, assured the normally amiable and cheerful Larrabee
that they all shared the same odds of dying and encouraged him
to hold on to his valuables.

Larrabee, 25, could not shake the feeling. He sought out the
regiment's quartermaster, who accepted his belongings.

Larrabee had lived a nomadic life before the war. Born in
Ticonderoga, N.Y., he barely knew his mother, who died when
he was 3 years old. At 11, he moved in with an older sister and
her family in Albany. Several years later, fifteen-year-old Larrabee
moved west to Chicago, Ill., and joined his brother Charles, a
dozen years his senior.

Chicago agreed with young Larrabee. In 1859, he joined the
United States Zouave Cadets, a militia company that gained
national recognition for its natty Zouave-style uniforms and

Quarter-plate tintype by an anonymous photographer. Joseph Stickelmyer Collection.

parade ground precision. Its founder and commander, charismatic Col. Elmer E. Ellsworth, took Larrabee and his comrades on a whirlwind tour of Northern cities in 1860, dazzling audiences all along the way.

Larrabee followed Ellsworth's star after the nation plunged into civil war. In May 1861, he joined Ellsworth's newly organized 11th New York Infantry as a first lieutenant. Before the end of the month, Ellsworth suffered death after he hauled down a rebel flag from an inn in Alexandria, Va., and was shot by the proprietor. The colonel's martyrdom inspired the organization of the People's Ellsworth Regiment, which became the 44th New York Infantry. Larrabee joined Company B with the same rank he held in the 11th and advanced to captain.

Larrabee proved an able officer in numerous battles with the 44th and the Army of the Potomac, including Second Bull Run, where he suffered a wound.

At Gettysburg, soon after Larrabee handed off his watch and other possessions, orders came to advance. As the regiment hastily formed a defensive line along Little Round Top, Larrabee received orders to deploy his company as skirmishers. As he and his men left the relative safety of the main line, one of the officers with whom he shared his premonition, Capt. Bourne, wished him good luck. Larrabee replied, "Good bye, Billy, I shall never see you again."

Larrabee and his men advanced no more than 200 yards when they struck the advancing Confederates. In the exchange of shots, a rebel bullet struck and killed him.

Comrades recovered his body the next day and sent it home to Chicago for burial.

A Storm at Little Round Top

In any regiment engaged in combat, senior officers on horseback and members of the color guard attracted gunfire. They were natural targets for enemy forces seeking to create chaos and confusion. James B. Storm of the 44th New York Infantry belonged to the color guard—and he had the scars to prove it from several battlefields.

Born in western Pennsylvania and a bricklayer by trade, he had relocated to Buffalo, N.Y., before the war and went to work in the ironmaking industry. In the summer of 1861, at age 27, he left the factory furnaces to join Company A of the 44th. Storm proved a capable soldier, advancing from private to first sergeant and color bearer. He landed on the regiment's casualty list twice before he and his fellow New Yorkers marched into Gettysburg. He suffered an undisclosed and likely slight wound at Malvern Hill, the culminating battle of the 1862 Peninsula Campaign. Before the end of the year, a rebel bullet caught him in the arm at Fredericksburg.

At Gettysburg on July 2, he participated in the successful defense of Little Round Top. When the fighting concluded, more than a third of his comrades suffered death or injury. The casualty list included Storm, who had been hit in the wrist with a bullet.

The stalwart color bearer soon recovered and returned to his duties. Storm remained in uniform until the regiment mustered out of the army in October 1864.

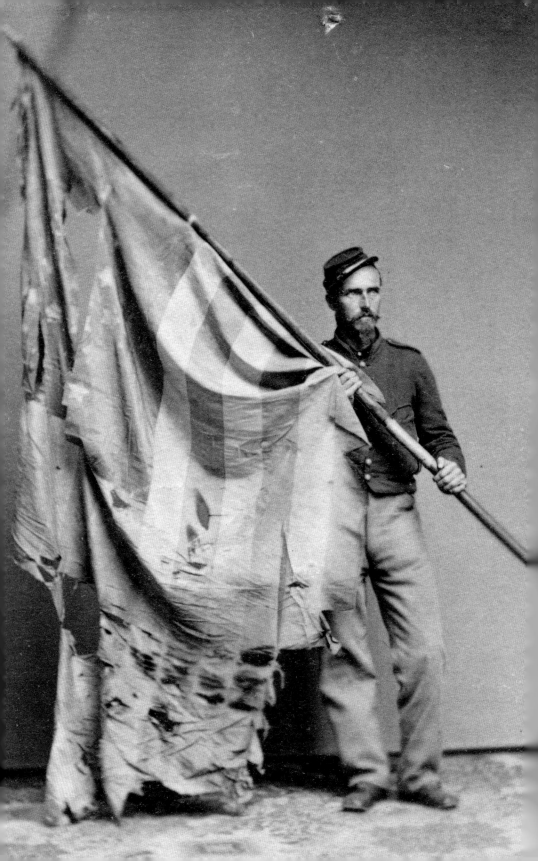

Storm made his way home to Buffalo, where he married and started a family. He went to work in a chemical company to support them and rose to become the factory's foreman. Upon his death in 1899 at age 64, obituaries referenced his bravery and courage during the late war. He left behind his wife, Harriet, and several children.

Carte de visite by Churchill & Denison of Albany, N.Y. Rick Carlile Collection.

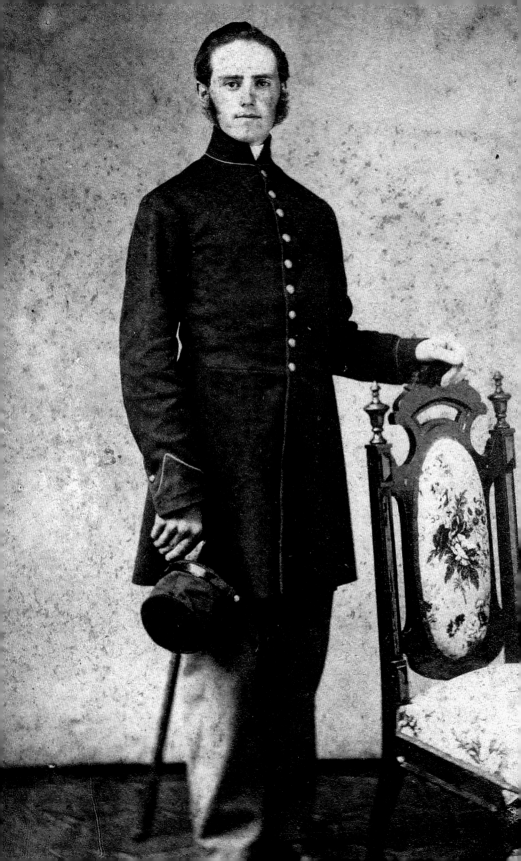

Armed with a Musket and a Prayer

About an hour before the desperate fight on Little Round Top, an officer in the 44th New York Infantry happened upon one of the boys in his company engaged in earnest prayer. George Bilson Wolcott, a young man of strong Christian values, "was not only a good soldier for his country, but, also, a good soldier of the Cross," recalled the officer, Capt. Albert N. Husted.

Wolcott's embrace of religion dated to his childhood. In 1853, then 12-year-old Wolcott's mother, Ann, died. Her last words to him were, "Be a good boy and meet me in heaven."

Wolcott became an active member of the Methodist Church in his hometown of Penn Yan, in the Finger Lakes region of New York. He left his family and friends for the Empire State capital of Albany to attend the State Normal School in 1861.

The war interrupted his studies. In the summer of 1862, a group of students from the school determined to shoulder muskets for the Union. Thus began a recruiting effort that ended with about a hundred volunteers composed of current students and recent graduates. Two of their professors, including Husted, joined them. Together, they became Company E of the 44th.

Less than a year later, Wolcott and his comrades fought at Gettysburg. Armed with a musket and a prayer, he filed into an exposed position along Little Round Top with the rest of his

Carte de visite by D. Denison's Gallery of Albany, N.Y. Joseph Stickelmyer Collection.

regiment as Confederate infantry descended on them. At one point in the action, as Wolcott dropped a ball into his musket barrel, a rebel bullet pierced his hand and continued into his forehead, killing him instantly. He died a month shy of his twenty-second birthday.

Capt. Husted recalled that Wolcott and two other members of his company were hastily interred, "We buried them side by side beneath a black walnut tree and placed a board marked with their names and the order of interment. They fought bravely and well."

Wolcott's remains were later reinterred in the mass grave of the New York section in the Soldiers' National Cemetery at Gettysburg.

An Alabamian on the Slopes of Little Round Top

In the thick of the fray along Little Round Top, infantrymen from the 4th Alabama clashed with the right wing of the 20th Maine Infantry and the 83rd Pennsylvania. As the fighting raged and the tide turned in favor of the Union, the Alabamians stubbornly withdrew from the field.

Somewhere in the human carnage strewn among the rocky slopes and lowlands below lay a farmer's son from Harpersville, Ala., with a severe head wound.

He was James Wilson Thompson of Company C, and he had enlisted in May 1861, just a few weeks after his eighteenth birthday. He posed for this portrait about this time, gamely pulling back the hammer of a double-barreled shotgun and showing off his Bowie knife.

Thompson's mettle was tested early and often after he and his comrades left Alabama for Virginia. The list of battles in which the regiment participated during the war's first two years includes most of the major actions in the East: First Bull Run. Seven Pines. Gaines' Mill. Malvern Hill. Second Bull Run. South Mountain. Antietam. Fredericksburg. Thompson survived all these fights without landing on a casualty list.

Then came Gettysburg. The 4th arrived on the battlefield on July 2 after a 25-mile march and almost immediately received orders to form for battle. The Alabamians advanced against

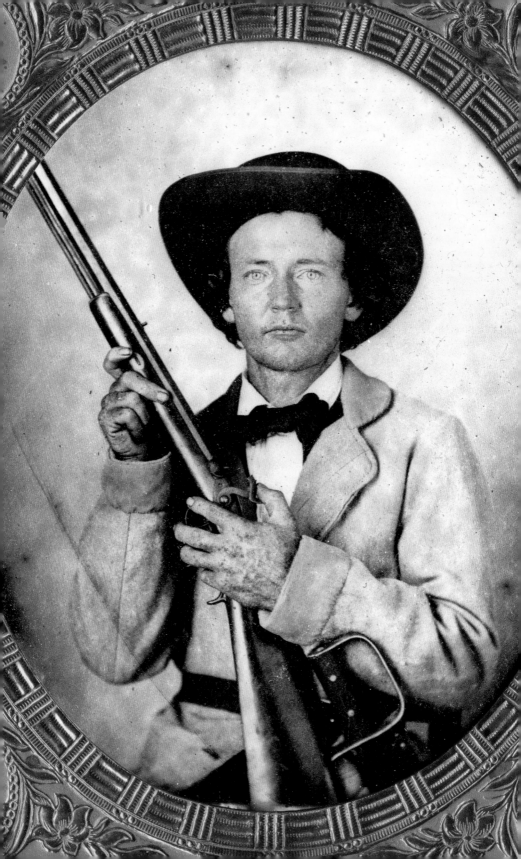

galling artillery and sharpshooter fire before mixing it up with the bluecoats from Maine and Pennsylvania along Little Round Top. At some point along the way, Union lead tore into Thompson and took him out of action.

According to one report, Thompson lay on the battlefield for two days before his comrades discovered him alive and carried him off to be treated for his wound. He made it back to Virginia and recovered in time to participate in the 1864 campaigns to defend Petersburg and Richmond against Lt. Gen. Ulysses S. Grant and the Army of the Potomac. Thompson suffered his second war wound at The Wilderness and remained with the regiment until the surrender at Appomattox on April 9, 1865, only two days after his twenty-second birthday. In all, he is credited with fighting in 26 battles—First Bull Run to Appomattox. Along the way, he advanced from private to corporal.

Following his parole and release from the army, Thompson returned to Alabama and started a family. They eventually moved to the Texas town of Groesbeck, where Thompson died in 1909 after a short illness. He was 66. His wife, Susie, seven of their 10 children, and 19 grandchildren survived him.

Sixth-plate ambrotype by an unidentified photographer. Rick Brown Collection of American Photography.

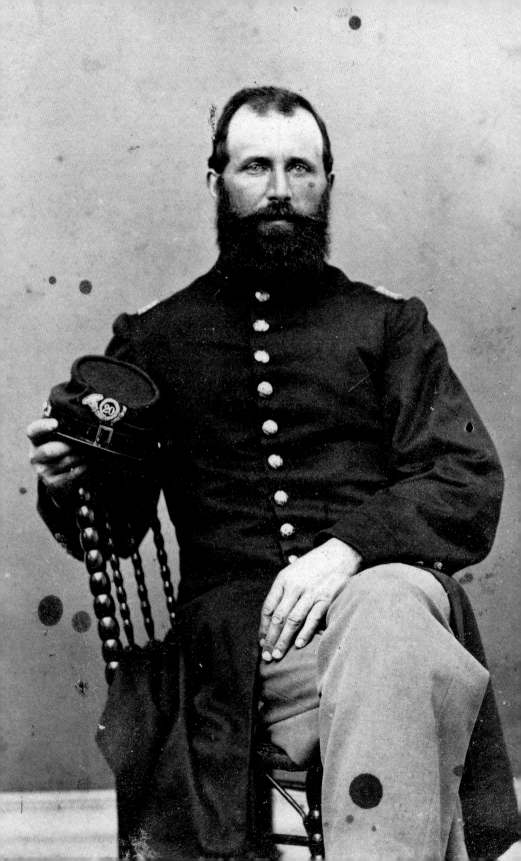

On the Left Flank of the 20ᵗʰ Maine

Along the wooded crest of Little Round Top, Col. Joshua
Lawrence Chamberlain ordered his 20ᵗʰ Maine Infantry to extend
and bend at an angle to meet oncoming Confederates. Men and
officers on the left side of the regiment executed the maneuver
in the nick of time.

The familiar zip and spist of minié bullets heralded the
advancing enemy, who soon came into focus along the rocky,
tree-covered slope below. As the rebels closed in and musket fire
began to rise toward a crescendo, Maine men began to fall.

One of first casualties in the regiment was Capt. Charles
Wheeler Billings, the 38-year-old commander of Company C.
A bullet hit him in the thigh, just above his knee.

The son of a prosperous mill owner in Clinton, Maine,
Billings had worked his way to success. As a young man, he
purchased a stake in his father's business, met and married the
daughter of a prominent local lumberman and politician, and
started a family that grew to include three daughters. He became
involved in Clinton's government as secession and war divided
the country.

Though not among the first to enlist in 1861, he cast his lot
with the Union army in the summer of 1862 when he joined the
20ᵗʰ as a second lieutenant. The new regiment soon moved to

Carte de visite by C.G. Carleton of Waterville, Maine. Paul Russinoff Collection.

Virginia and joined the Army of the Potomac. Held in reserve at the Battle of Antietam, Billings and his comrades fought in the thick of combat at Fredericksburg in December 1862.

Billings received his captain's bars in February 1863, and soon after got a 15-day furlough to visit his family.

Then came Gettysburg, his wounding, and transportation from Little Round Top to field hospitals at the Jacob Weikert and Michael Fiscel farms. On July 6, as Billings' life hung in the balance, Col. Chamberlain issued his first report of the fight. "Captain Billings," he noted, along with two others, "are officers whose loss we deeply mourn—efficient soldiers, and pure and high-minded men."

Meanwhile, word of his situation traveled to Maine, where his wife, Ellen, and younger brother, John Patten Billings, packed their bags and set off for Gettysburg. They arrived on July 15. Brother John helped Ellen get situated in town, then left her to find Billings. His search lasted late into the evening. About 10 p.m., he gently knocked at the door of the quarters of Episcopal minister Robert J. Parvin, a chaplain with the Christian Commission. Parvin, still awake and catching up on correspondence, delivered the news: Billings had died at 11 a.m. that morning, and his body was sent to an embalmer.

Shocked and stunned, John and Chaplain Parvin visited Ellen and gave her the sad news. They soon left Gettysburg for the return to trip to Maine, where they laid Billings to rest.

Six months later, on Feb. 5, 1864, Chaplain Parvin stood before a large crowd assembled inside the main chamber of the House of Representatives in Washington, D.C. The group gathered to commemorate the second anniversary of the founding of the Christian Commission, and Parvin had been selected as one of two field delegates to share their experiences.

Parvin told the story of Billings' suffering and death: Lying on the floor of an old barn, his health slowly fading as he watched in pain and frustration as his desperately wounded comrades were dying around him. His relocation to a private room, where he briefly rallied. Parvin recalled, "He asked me to give her his knapsack and sword, and other little things that he mentioned; and if she came, the message which he wished me to deliver, and then

he seemed to dismiss all these things from his mind, as he lay there calm, peaceful, a dying man as well as a dying soldier, and above all else, a dying Christian."

Parvin recalled, "He asked me to give her his knapsack and sword, and other little things that he mentioned; and if she came, the message which he wished me to deliver, and then he seemed to dismiss all these things from his mind, as he lay there calm, peaceful, a dying man as well as a dying soldier, and above all else, a dying Christian."

By this time, the crowd in the great hall had grown silent. Many wept.

Parvin finished by relating the story of Billings' final request to have his body embalmed and sent home, his death, and the encounter with John and Ellen.

Ellen remined a widow for the rest of her life, which ended in 1924. She was laid to rest next to her husband in Clinton. Ellen outlived John, who passed in 1897.

Chaplain Parvin perished in 1868 during a missionary trip to the West aboard the steamer *United States* after it burned on the Ohio River. His body was not recovered.

The granite monument erected on Little Round Top in 1886 to honor the memory of the 20th Maine includes a list of the men and officers who fell in the battle. At the top is the senior ranking officer—Billings.

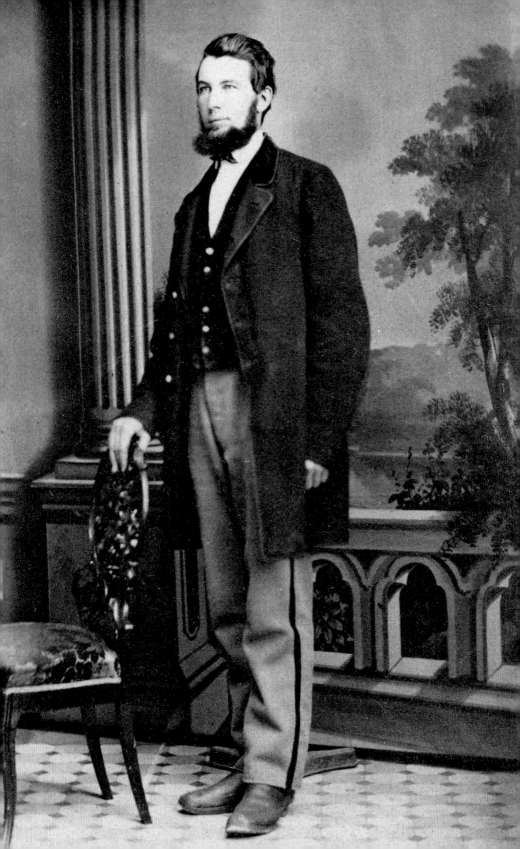

Left for Dead on Little Round Top

After the crisis had passed on Little Round Top, the grim work of burying the dead and removing the wounded began. In the ranks of the 44th New York Infantry, a comrade set aside the lifeless body of Helim Spaulding Thompson for burial.

A mountain of a man at 6-feet-4-inches and 200 pounds, Thompson had been toppled by a bullet that struck him close to the right nostril and passed through his upper jaw before exiting the back of his head about two inches behind the right ear. After he fell, another bullet tore into his left shoulder and buckshot hit him in the knees and a thigh.

His loss removed a respected man from the regiment. A teacher in Otisco, N.Y., before the war, Thompson had organized a company of Wide Awakes, a youth organization cultivated by the Republican Party in support of presidential candidate Abraham Lincoln in the 1860 election. A fellow townsman described Thompson as a natural leader and noble character.

It is no surprise that he joined the army, enlisting as a corporal in Company E of the 44th. He soon advanced to sergeant and fought in five battles with his comrades.

At Gettysburg, about four hours after his comrades left him for dead, Thompson moved slightly. The motion caught someone's attention, and medical personnel carried him to a field hospital

Thompson pictured during his recuperation in York, Pa.

Carte de visite by Evans & Prince of York, Pa. Author's collection.

for treatment. He responded favorabley, and before the end of July medical staff transferred him to the U.S.A. General Hospital in nearby York, Pa. Thompson's head wound left him with missing front teeth, paralysis on the right side of his face, and deafness in the right ear.

At Gettysburg, about four hours after his comrades left him for dead, Thompson moved slightly. The motion caught someone's attention, and medical personnel carried him to a field hospital for treatment.

Thompson remained in York until early April 1864, when he returned to his regiment and served on detached duty as a nurse and ward master in the 5th Corps hospital located at the sprawling Union military base at City Point, Va.

When his three-year enlistment in the 44th ended in October 1864, Thompson transferred to the 140th New York Infantry as a sergeant. At the war's end, he marched through Washington, D.C., in the Grand Review of the Union armies. His brother, Perry, who enlisted with him and suffered a near-mortal wound at the Battle of Chancellorsville, participated with him.

Thompson returned to New York and followed in his father's footsteps when he became a farmer. He and his wife, Julia, whom he married in 1865, relocated to Gibbon, Neb., and raised a family that grew to eight sons and daughters. Julia and seven of the children survived him after his death in 1907 at age 68. Four of his sons acted as pallbearers at his funeral.

Thompson sits at the center with a group of comrades in Company E. Five other men have been identified. To Thompson's left sits Cpl. Oliver W. Sturdevant (1835-1912), who received his sergeant's stripes before leaving the regiment to accept a captain's commission in the 10th U.S. Colored Infantry. Next to Sturdevant sits Pvt. William Royal (1841-1920), who went on to become a captain in the 9th U.S. Colored Infantry and a postwar agent for the Freedmen's Bureau in Georgia. To Thompson's right is 1st Sgt. Consider Heath Willett (1840-1912), who left the regiment to join the 2nd U.S. Colored Infantry as a captain. Standing immediately behind Thompson is Pvt. Charles F. Dorrance (about 1840-1864), who received a disability discharge in July 1864 and died the following month. Standing on the far right is Pvt. Thompson Barrick (1838-1892), who suffered a gunshot wound in the neck on Little Round Top. He recovered and joined the 39th U.S. Colored Infantry as a first lieutenant and ended his service as a captain.

Albumen print by an unidentified photographer. Paul Russinoff Collection.

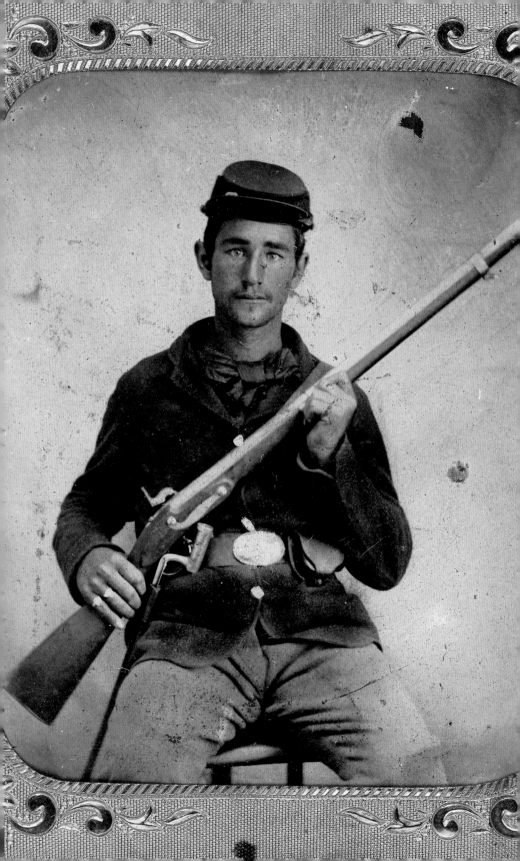

Lost in the Maelstrom
of The Wheatfield

A bullet struck and killed Will Dunn instantly as he advanced with a skirmish line into the maelstrom of The Wheatfield. A comrade in line with him watched helplessly as his lifeless form toppled to the ground.

The lanky, blue-eyed Dunn, his auburn hair prematurely graying, was no more. Born William H. Dunn about 21 years earlier, he grew up in western Pennsylvania near Pittsburgh. In the summer of 1861, he bade farewell to his parents Arthur and Eliza and his ten brothers and sisters, and headed off to war. Brimming with patriotism and full of fight, he joined the ranks of Company F of the Keystone State's 62nd Infantry.

Dunn and the other green recruits learned the art of war at Camp Cameron near Harrisburg and the defenses of Washington. In the spring of 1862, the regiment joined the Army of the Potomac along the Virginia Peninsula and experienced the realities of campaign and combat at Yorktown, Gaines' Mill, Malvern Hill and elsewhere.

During the fighting on the Peninsula, Dunn's hair began to gray. By the end of the campaign in July 1862, an ill Dunn wrote home, "I wish that this war would soon terminate for I don't feel like staying out here another winter. It has made an old man out

Sixth-plate tintype by an unidentified photographer. Charles T. Joyce Collection.

of me already. I am not half as good a man as I was when I came out but I think when I get rightly over the spell, I will soon feel up again when I get home to get some good grub, if I am spared."

Though weary and tired, Dunn determined not to follow in the footsteps of another soldier who, rumor had it, was working the system for a disability discharge. "I am as tired of soldiering as any person but before I will play sick to get my discharge, I will serve five years for I think an honorable discharge is better to me than a fortune," he declared to his parents.

A year later, Dunn died in The Wheatfield. His remains, according to the sergeant who wrote a condolence letter to Dunn's parents, were buried on the battlefield with other members of Company F, and the graves marked so that they could be found.

This engraving, originally published in the Dec. 5, 1863, issue of *Frank Leslie's Illustrated Newspaper*, was reprinted in the 1890 book *The Soldier in Our Civil War* (Volume II).

That autumn, artist Joseph Becker sketched the spot, located along the Millerstown Road leading to Little Round Top. An engraving of it appeared in *Frank Leslie's Illustrated Newspaper*. It depicts three graves with crudely lettered wooden headboards prominently marked "62nd P Vol." The name written at the top of the board on the left appears to read "W. Dunn. 62nd P Vol." The name on the second board is unreadable, and the third, "James Miller," does not appear on the regiment's roster.

Dunn's remains were later moved to the Soldiers' National Cemetery.

U.S.

End of the Line at Culp's Hill

The 137th New York Infantry filed into entrenchments along the saddle and lower summit of Culp's Hill during the early evening of July 2. The men and officers spread out in a single line recently occupied by Union troops that had been ordered elsewhere.

The ranks of the regiment included Admiral T. Coon of Binghamton, N.Y. His early life was marked by loss with the early deaths of his mother and two brothers, and an invalid father. Despite these challenges, Coon and two younger sisters made their way in life.

In the summer of 1862, Coon cast his lot with a newly organized regiment in Binghamton when he joined Company B of the 137th. He and his comrades learned the art of war on the outskirts of town at Camp Susquehanna, where Coon sat for these tintypes. He poses in one portrait with a woman believed to be his sister Ruth, and in the other with her son and Coon's nephew, Eddie.

Coon soon bade his family farewell and departed the training camp with his regiment for the South. Assigned to the 12th Corps of the Army of the Potomac, the regiment participated in its first major engagement, at Chancellorsville, Va., in May 1863. Though the Union lost the battle, the 137th proved it could fight, suffering about 56 casualties. Coon emerged unharmed.

Pvt. Coon posed with his nephew Eddie.

Sixth-plate tintype attributed to a photographer at Camp Susquehanna, Binghamton, N.Y. Charles T. Joyce Collection.

At Gettysburg, the New Yorkers formed along the base of Culp's Hill. The entrenchments were long, and they were spread dangerously thin. Even more precarious, they occupied the edge of the army's right flank in this sector of the battlefield—literally the end of the line.

A woman believed to be Coon's sister and Eddie's mother, Ruth.

Sixth-plate tintype attributed to a photographer at Camp Susquehanna, Binghamton, N.Y. Charles T. Joyce Collection.

They remained in this position when a force of Virginians, North Carolinians, and Marylanders commanded by Brig. Gen. George H. Steuart descended upon them. Steuart's Brigade, 2,100 strong, hit the 425 New Yorkers with everything it had. Over the next two hours, they engaged in a desperate fight as evening turned to night. Flashes of musket fire in the darkness and sulfurous gun smoke marked the struggle for dominance. At one point, the Confederates pumped a murderous fire into the ranks of the 137th from three sides.

When the fighting finally ended about 10 p.m., the New Yorkers held the position with the help of reinforcements. The successful defense came at a high price: 34 percent of their number became casualties. The list included Coon. He had fallen with a shot through both knees, and as he lay wounded another bullet struck him in the abdomen. Transported by ambulance to the nearby barn of Abraham Spangler, Coon died the next day. Buried on the battlefield, his remains were later exhumed and interred in New York.

Coon joined his nephew Eddie in death. The boy had died in May 1863. That same month, his mother, Ruth, and her husband brought a new son into the world. They named him Admiral.

Rebel Canister at Stevens Knoll

Cannoneer John F. Chase of the 5ᵗʰ Maine Artillery worked the first gun of his battery with the skill of a seasoned veteran at Gettysburg. The evening of the second day found the 20-year-old and his comrades positioned on Stevens Knoll, a gentle rise of land between Cemetery and Culp's Hills. Here they traded shots with enemy artillerists.

During the action, Chase, his jacket off, sleeves rolled up, and face grimy with powder and smoke, rammed a cartridge down the tube of his gun. At this moment an incoming rebel canister shot smacked into the ground about three feet from where he stood and burst, blowing fragments of metal in every direction. Many of them tore into Chase as the impact hurled him a rod from his gun, stripping away most of his clothes and leaving his mangled body, minus his right arm and covered in wounds, in a heap.

Carried to the rear, attendants loaded an unconscious Chase into a dead cart, and set him aside so that the others less seriously wounded with a chance to live might receive treatment.

The Maine battery could not afford to lose Chase. A strapping young man from a farm family in Chelsea, he had started his military service in June 1861 with his home state's 3ʳᵈ Infantry. Diagnosed with tuberculosis and discharged soon after his enlistment, he recovered and rejoined the army before the year's end with the 5ᵗʰ.

Tintype in *carte de visite* envelope by an unidentified photographer. Charles T. Joyce Collection.

Flash forward to 1863 and the Battle of Chancellorsville. In the thick of the fight, nearly all the battery's men and officers suffered wounds and death. Chase and a fellow artillerist kept firing their gun—seven times by one count—after the others were silenced. Then they dragged off the cannon as all the horses had been disabled.

Less than two months later at Gettysburg, Chase lay in a dead cart awaiting burial. On July 4, an attendant heard a groan. It was Chase regaining consciousness. His first reported words upon receiving a drink of water: "Did we win the battle?"

Chase's business card.

Taken to a field hospital, surgeons treated his missing right arm and left eye, and no less than 48 shrapnel wounds that damaged his lungs and broke his ribs.

Somehow, he survived. In early September, medical personnel moved him to a hospital to complete his recovery and discharged him just a few days after the dedication ceremonies of the Soldiers' National Cemetery in Gettysburg.

Chase went on to live a long and productive life as an inventor. He logged almost as many patents as Gettysburg wounds—47—including the Chase Aero, a competing design to the Wright Brothers' flying machine. He also became an active promoter of and lecturer about the Gettysburg Cyclorama painting and started a business manufacturing souvenirs for the lucrative battlefield tourism industry.

In 1888, he received the Medal of Honor for his gallantry at Chancellorsville.

Seven years later, he and his family relocated to the hamlet of St. Petersburg, Fla., and contributed to its rapid development.

Chase succumbed to pneumonia in 1914 at age 71. He outlived his wife, Lena, whom he had married soon after the war. Six children survived him.

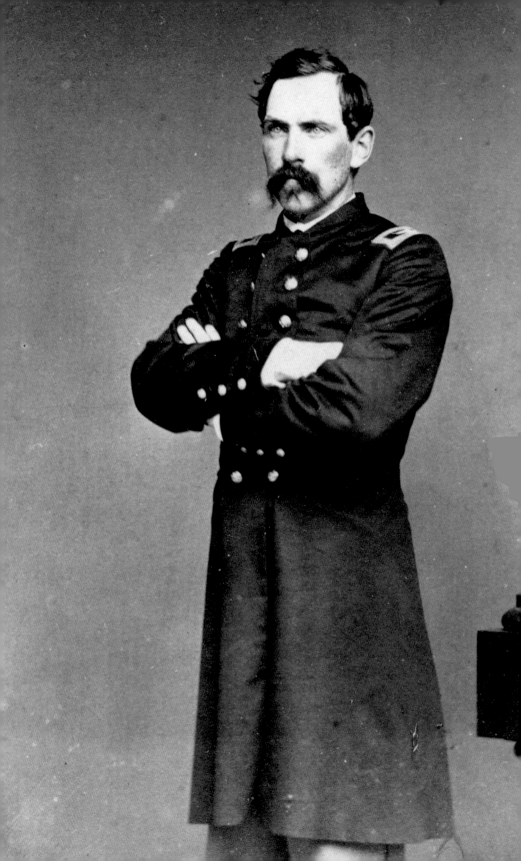

"Give 'em Hell on the Flank"

During the late afternoon of the second day's fight, Col. Wheelock Graves Veazey received orders to form an advanced picket line. He led his 16th Vermont Infantry into position along a portion of the field that, unbeknownst to him, would soon be the focus of a massive assault by an entire enemy division.

Born in New Hampshire and an 1859 graduate of Dartmouth College, Veazey had just embarked on a law career in Vermont when the war began. He set aside his fledgling practice in May 1861 and joined the 3rd Vermont Infantry as a captain and soon advanced to lieutenant colonel. He left the regiment in late 1862 to become colonel of the 16th, which had been organized recently.

Veazey and his command arrived at Gettysburg during the afternoon of the first day of battle and spent part of the second day along Cemetery Ridge reinforcing the Union army after it suffered shattering losses.

The 16th remained on picket duty the next morning, when Confederate Maj. Gen. George G. Pickett's Division attacked the federal line with all the firepower it could muster.

Veazey's Vermonters received the brunt of the assault. "It was a tremendous attack, but the assailants were forced to surge off to the right, and the regiment commanded by Colonel Veazey,

Carte de visite by Caleb L. Howe of Brattleboro, Vt. Rick Carlile Collection.

wheeled out and attacked them on the flank as they went by with withering effect," noted editors Walter F. Beyer and Oscar F. Keydel in their 1903 book, *Deeds of Valor.*

Veazey and his men passed by wounded Maj. Gen. Winfield Scott Hancock just before they struck the Confederates. Hancock reportedly said to Veazey, "That's right, Colonel, go in and give 'em hell on the flank."

Veazey and his men passed by wounded Maj. Gen. Winfield Scott Hancock just before they struck the Confederates. Hancock reportedly said to Veazey, "That's right, Colonel, go in and give 'em hell on the flank."

The Vermonters gathered up prisoners and reformed as two more brigades of Confederates moved on their flank and rear. Veazey reacted quickly to the peril. He turned to his brigade commander, Gen. George J. Stannard, who ordered him to charge the oncoming Confederates.

Beyer and Keydel recounted what transpired next. "'Veazey,' cried the general, 'your men will do almost anything, but the men don't live this side of hell, that can be made to charge down there.' But in shorter time than it takes to tell it, the regiment had straightened out, reformed, and made another change of front in the very center of the field, where the battle raged in its greatest fury, and men were falling every instant."

The narrative continued, "'I stepped to the front,' says Colonel Veazey, 'and called upon the men to follow. With a mighty shout the rush forward was made, and, before the enemy could change his front, we had struck his flank, and swept down the line, and again captured a great number of prisoners. In the two charges my regiment captured three stands of colors. The last charge brought a heavy artillery fire on us, but we lost only 150 out of 400 because the rebels never accurately found our range.'"

In 1891, Veazey received the Medal of Honor for Gettysburg. By this time, he had distinguished himself in law and politics. Active in the Grand Army of the Republic, he died in 1898 at age 62, and was buried in Arlington National Cemetery. His wife and a son survived him.

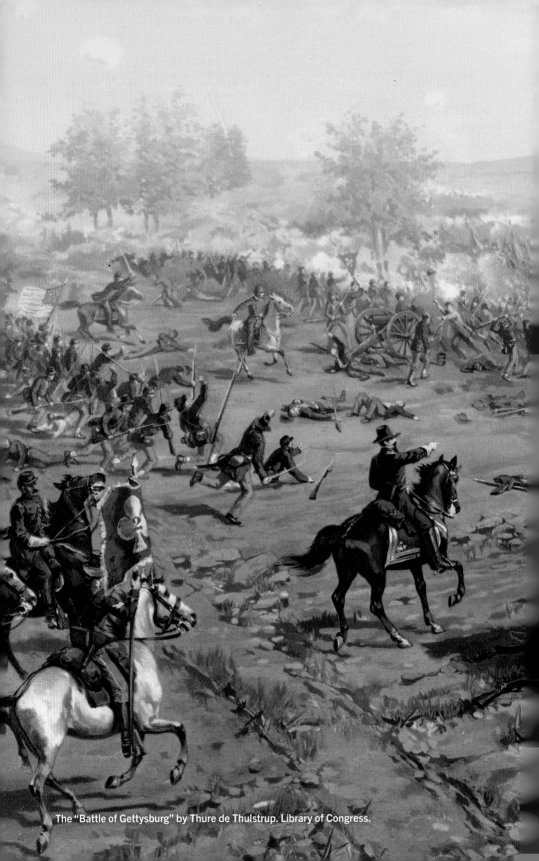

The "Battle of Gettysburg" by Thure de Thulstrup. Library of Congress.

4

THE THIRD DAY

Record Rounds in Support of Pickett's Boys

The Confederate artillerists in Parker's Battery fired their four cannons throughout the third and final day of battle. They counted a record number of 1,142 rounds beginning at 4:15 a.m. and ending after 7 p.m. It was only after the weary men were withdrawn in the evening that they learned from disappointed infantrymen that Pickett's Charge had failed.

One of the 90 artillerymen who participated was Pvt. George Washington Hancock. A resident of Manchester, Va., part of the city of Richmond, he was an original member of what was intended to be an infantry company when it formed in early 1862. Its commander, Capt. William W. Parker, had recently completed a stint in the 15th Virginia Infantry. But the new company was not fated to be foot soldiers. The unit's historian noted, "It was decided to devote our martial energies to field artillery, —which fortuitous circumstance may perhaps account for the large number of survivors who are left to tell the tale of our toils and dangers."

Hancock and his comrades in the battery participated in major engagements with the Army of Northern Virginia, from Second Manassas in 1862 through Cold Harbor in 1864, followed by the defense of Petersburg and Richmond, and the Appomattox

Sixth-plate ambrotype by an unidentified photographer. Dave Batalo Collection.

Campaign. Along the way, he landed on the casualty list twice. On that third, long day at Gettysburg, he suffered a wound, the nature of which went unreported. In the closing days of the war, on April 6, 1865, he fell into enemy hands during the Battle of Sailor's Creek. His captors took him to Point Lookout, Md., where he signed the oath of allegiance to the federal government two months later and gained his release.

Hancock returned home and lived quietly until his death in King William County in 1917. His wife, Alice, and two daughters survived him.

Fighting Like Demons on Culp's Hill

Early on July 3, a tidal wave of rebel infantry rose from the car-nage and debris scattered around Culp's Hill and swept toward waiting bluecoats with a piercing yell. The federals unleashed murderous volleys of musketry and shot and shell in response.

An unnamed correspondent in one of the Union regiments in the fight, the 137th New York Infantry, wrote with satisfaction of the gunfire. "No living thing that was exposed could live."

One of the New Yorkers in the ranks who responded that morning, Frederick A. Archibald, served in Company C. A peace-time farmer in Owego, N.Y., he bade his wife, Helen, farewell and joined the army in 1862.

Archibald and his comrades were lucky to be alive. Less than 12 hours earlier, attacking Confederates had hit them on the front, right flank, and rear with devastating fire. Twice the rebels forced the 137th out of their shallow trenches. Each time the regiment rallied, fought ferociously, and held the position.

Darkness brought an end to the fighting. Archibald and the others hunkered down in their entrenchments overnight.

They had little time to rest. The Confederates resumed the attack before dawn. The adjutant of the 137th, Samuel B. Wheelock, described what happened next. "The breastworks were fully manned, and for nearly six hours the rattle of musketry was incessant. Not an instant did the firing cease, but as fast as those

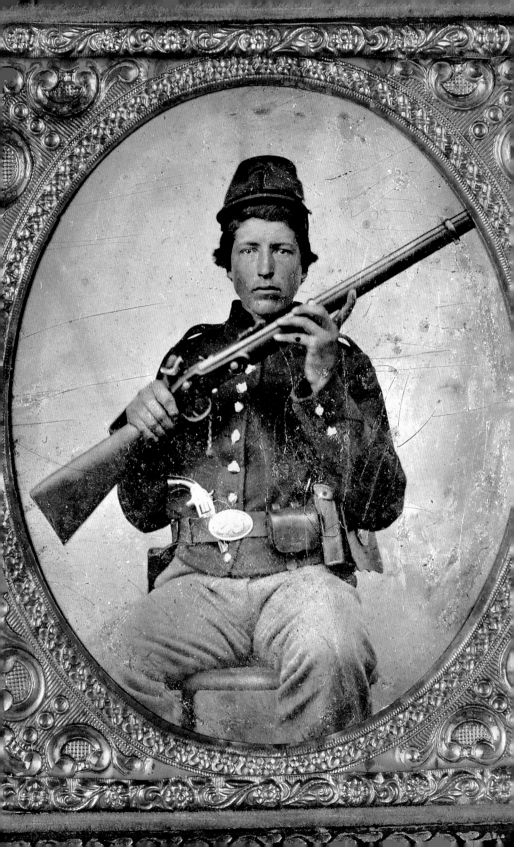

in the front exhausted their ammunition, fresh regiments would come rushing up, cheering and with flags flying, to relieve them."

At some point during the struggle, Archibald made the ultimate sacrifice. He was about 29 years old. Buried along the Baltimore Pike on the grounds of the Henry Spangler farm, his body was later removed to the Soldiers' National Cemetery. His remains rest in plot E-20 of the New York section.

Back home in New York, Helen filed for and received a pension to compensate her for the loss of her husband. They had been married for five years. She remained a childless widow until her death in 1914 at age 74. She is buried in Laurel Grove Cemetery in Port Jervis, N.Y., separated from Archibald by about 200 miles.

Sixth-plate tintype by an anonymous photographer. Charles T. Joyce Collection.

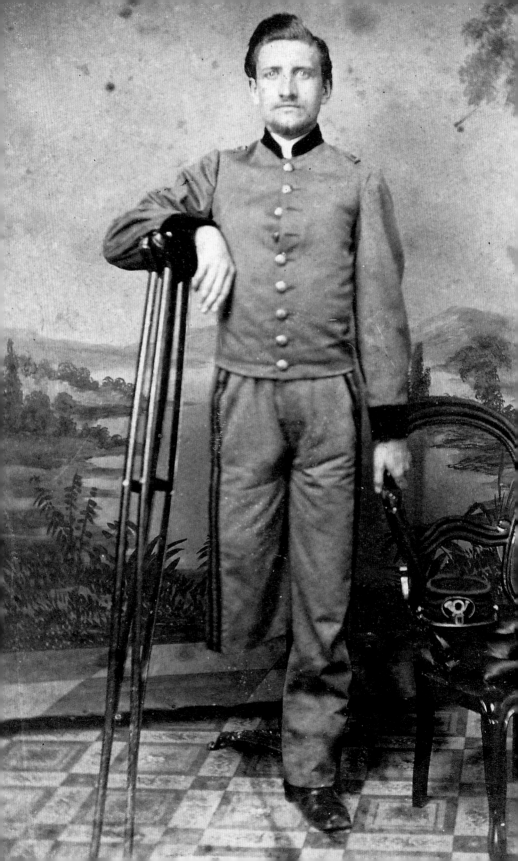

British Blood Spilled on Culp's Hill

South of Culp's Hill in McAllister's Woods, a 674-strong regiment of Marylanders spent the morning of July 2 constructing breastworks. They were the Union-loyal 1st Infantry of the Potomac Home Brigade. Their number included Roger Q. Bellis, a capable first sergeant in Company D.

Born in England to a tailor and his wife, Bellis had immigrated with his parents and siblings to America in 1851, when he was about 11 years old. The family settled in Annapolis, Maryland's capital city.

A decade later, after the bombardment of Fort Sumter inaugurated civil war, fears for the safety of Annapolis prompted Bellis to set aside his law studies and relocate to the relative safety of Baltimore. His decision to leave his adopted hometown might have been influenced by the removal of the U.S. Naval Academy from the city to Newport, R.I., in late April 1861.

A few months later, Bellis joined the army. Military officials dispatched him and the rest of the Potomac Home Brigade to the Shenandoah Valley and western Virginia. They eventually became part of the garrison of Harpers Ferry—and prisoners of war after the place was surrendered to Confederate forces in September 1862.

Carte de visite by J. Simons of Quincy, Ill. Thomas Harris Collection.

Paroled and formally exchanged by the end of the year, the Marylanders came into close contact with Confederates again at Gettysburg. On the morning of July 2, Bellis and his comrades dug entrenchments along McAlister's Woods. In the afternoon, they left with the rest of their division to support federals under heavy attack by Lt. Gen. James Longstreet's Confederates.

The Marylanders returned to Culp's Hill later in the day and discovered their entrenchments occupied by enemy troops commanded by Maj. Gen. Edward "Allegheny" Johnson. Fighting resumed the next morning as Johnson's men pounded the Union lines without success. Casualties were heavy in the ranks of the Potomac Home Brigade. The list included Bellis, who suffered a severe wound to his right leg.

Carried off to a makeshift hospital, surgeons amputated the mangled limb. Bellis remained in Gettysburg until September, then transferred to Annapolis to complete his recovery. On Christmas Eve 1864, more than a year and a half after his wounding, Bellis joined the Veteran Reserve Corps as a second lieutenant. He's pictured here about this time in the distinctive light blue uniform of the Corps. He served through the rest of the war.

Back in Maryland, Bellis completed his legal studies and become a successful lawyer. He went on to serve as the state's attorney for Prince George's County and mayor of Hyattsville. He died in 1917 at age 77. His wife, Rebecca, predeceased him, and three children survived him.

An Abrupt End to an Unexpected Reunion

The 149th New York Infantry and other federal forces held Culp's Hill against Confederate attacks through the evening of July 2. After fighting resumed the next morning, the New Yorkers received orders to relieve a regiment in a different section of the main line. The 149th obeyed and promptly filed into the new position behind entrenchments as shot and shell rained down.

The assignment proved an unexpected reunion as the troops to he 149th's right belonged to the 122nd New York Infantry. Both regiments had been raised in Onondaga County. According to one report, the cheers of joy with which the regiments greeted each other briefly drowned the din of battle and may have intimidated the rebels opposite them.

The reunion of Onondaga brothers ended abruptly for Capt. James E. Doran of the 149th when a bullet ripped into his right forearm near the wrist and took him out of action.

Doran's wounding deprived Company K of its commander. A popular, prosperous grocer in Syracuse, N.Y., the energetic and cheerful Doran had helped organize the company less than a year earlier. When the recruits voted for officers to command them, a common practice among volunteers, Doran received the captaincy.

Doran pictured with his son, James Jr.

Carte de visite by an unidentified photographer. Rick Carlile Collection.

Company K and the rest of the 149th left Syracuse in late
September 1862 and reported to the Army of the Potomac's
12th Corps in Virginia. The regiment fought its first battle at
Chancellorsville and suffered significant casualties. Doran sur-
vived without injury.

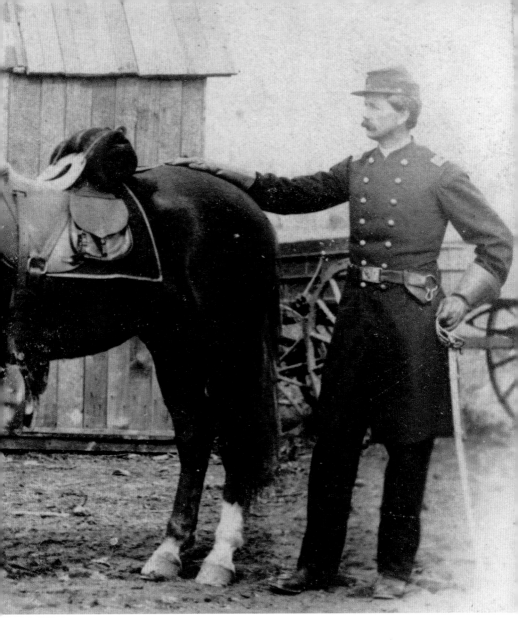

Two months later at Gettysburg, the bullet that struck Doran ended his service in the 149th. Sent home to Syracuse to recuperate, he rejoined his wife, Anna, and their three children. The eldest, 10-year-old James Jr., born deaf, holds the reins of his father's horse in this portrait. By this time, Doran had healed from his wound and joined a newly formed regiment that included men from Onondaga County—the 24th New York Cavalry.

Doran and his troopers joined the Cavalry Corps of the Army of the Potomac and experienced hard fighting in operations against Richmond and Petersburg. In one of the war's final battles in Virginia, at Dinwiddie Court House on March 31, 1865, Doran and his command charged rebel forces when a bullet struck him in the right thigh and fractured his leg. As his men carried him to the rear for treatment, a second bullet ripped into his right shoulder, passed through his body, and exited his left shoulder. Along the way, the ball tore through his right lung. Left behind and captured, an unnamed Southern woman provided him with basic care.

Doran's captors released him less than a day later, perhaps due to the severity of his wounds and his high rank. Transported to the safety of a Union hospital at City Point, Va., he breathed his last on April 14, the same day John Wilkes Booth assassinated President Abraham Lincoln. Doran was about 33 years old.

Embalmers prepared Doran's body and sent the remains home to Syracuse, where they were laid to rest beside his wife—Anna had died a few months earlier, leaving their children in the care of a guardian. Doran's army pension provided support for James Jr. and his two sisters until they turned 16 years of age.

James Jr. grew up and became a husband, father, and post office clerk in Syracuse. His life was cut short in 1905 when a train struck him while he was on his way to visit a sick friend. He was 52.

Captured Carrying Dispatches
for Kilpatrick

Aides de camp often found themselves in hot places during
combat, and such was the case for 2nd Lt. George Washington
Chandler on July 2. Confederates nabbed him while he carried
dispatches for Brig. Gen. Hugh Judson Kilpatrick. Though details
of his capture are unclear, it is a good bet that he fell into enemy
hands in the vicinity of Hunterstown. It was here, about five miles
northeast of Gettysburg, where Kilpatrick's Division skirmished
with rebel horsemen commanded by Gen. Wade Hampton.

Superior officers detailed Chandler on various staff duties
early in his enlistment. A peacetime farmer born in Birmingham,
Ohio, a village about 45 miles west of Cleveland, he enlisted
in the Buckeye State's 8th Infantry in June 1861. He joined the
ranks of Company D and within a few months became an orderly
sergeant. By the end of his first year in the army, he received a
promotion to second lieutenant in the 1st West Virginia Cavalry.
He spent little time with his new regiment after being detached
as a staffer on the brigade and division level to Brig. Gen. Julius
H. Stahel.

By Gettysburg, Chandler served as an acting aide de camp
to Stahel's successor, Kilpatrick. Chandler's capture began a
20-month odyssey as a prisoner. He spent the rest of the war mov-
ing from camps in Richmond and Danville, Va., to Macon, Ga.,
and Columbia, S.C.

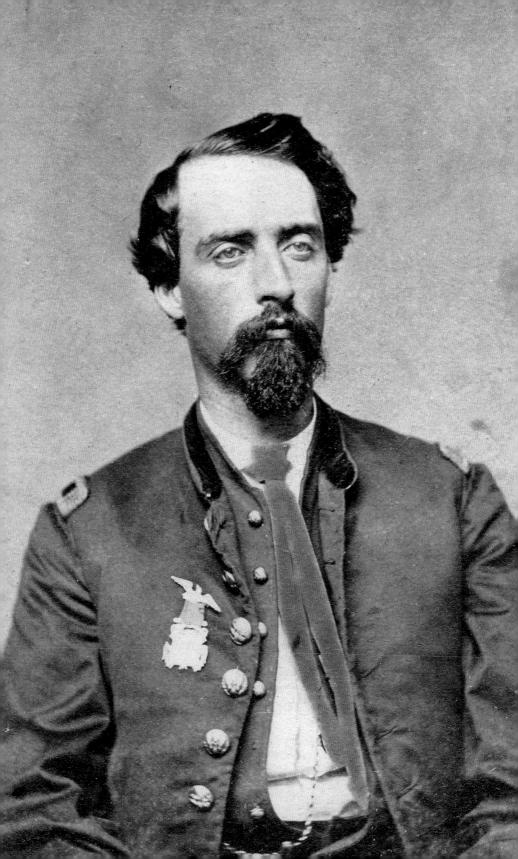

According to one account, while in prison he and three other inmates formed Chandler's Band. Chandler played first violin. The tunes touched both prisoners and guards, and the bandsmen were well fed by their music-loving captors.

At the camp in Columbia in 1864, Chandler's violin playing did not prevent Confederate authorities from removing him to nearby Charleston, where he and a group of other prisoners were used as human shields to prevent Union forces from bombarding the city. Chandler survived the ordeal and his captors paroled him on March 1, 1865. He returned to his regiment two months later and mustered out a short time afterward.

Chandler posed for this portrait at the end of his service sporting the long red tie and Custer Medal given to veterans of the 1st West Virginia Cavalry who served in Maj. Gen. George A. Custer's command.

Chandler went on to live in his native Ohio and Kansas City, where he worked in real estate and pharmaceuticals. He died in 1902. His wife, Mary, survived him.

Carte de visite by Partridge of Wheeling, W. Va. Karl Sundstrom Collection.

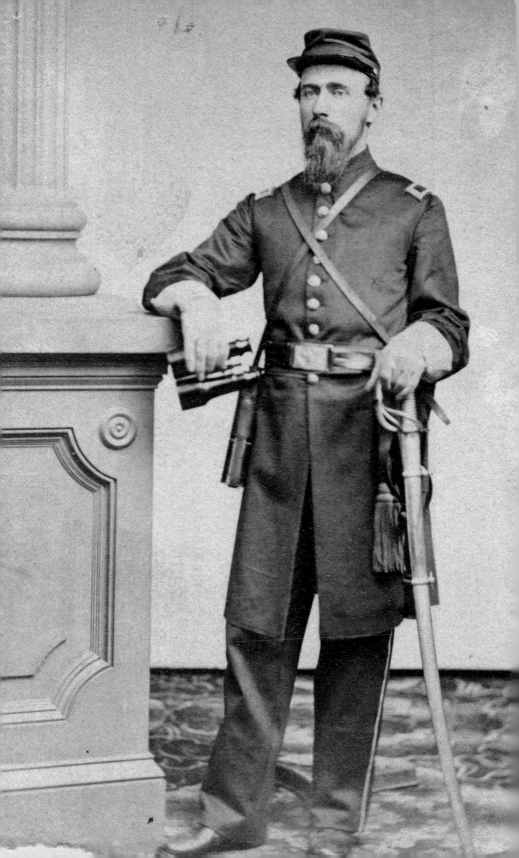

Improvising a Signal Flag Under Fire

A network of signal stations dotted the battlefield at Gettysburg, and the soldiers who occupied them kept critical information flowing from the field to commanders. Notable locations on the Union side included the station at Gen. Meade's headquarters at the Lydia Leister farm near Cemetery Hill.

At some point after the bombardment preceding Pickett's Charge began, Signal Corpsmen deemed the position unsafe, packed their flags and other equipment, and departed.

Only one man elected to stay at the now abandoned station after his comrades had moved to safer ground: Capt. Davis Eugene Castle.

A New York native, Castle had moved to Indiana before the war and worked in the railroad industry. In 1861, he left his job and joined his adopted state's 19th Infantry as a first lieutenant in Company B. His tenure in the Hoosier regiment ended in early 1862 when he transferred to the fledgling Signal Corps, which desperately needed good men.

Castle proved himself a respected officer, earning his captain bars with the Army of the Potomac. His superiors recognized him for his contributions during the Peninsula Campaign and the Battle of Chancellorsville.

Carte de visite by an anonymous photographer. Rick Carlile Collection.

At Gettysburg, Castle occupied a precarious position as the bombardment intensified. Castle stayed because he felt the need to pass along the very latest activity to Gen. Meade, who had left to visit the headquarters of one of his subordinates, Maj. Gen. Henry W. Slocum.

Without his signal flags, Castle had no way to communicate. So he improvised. He quickly cut a crude pole and found a bedsheet, which he tied to it. With this makeshift flag he sent dispatches as enemy artillery fire continued to roar around him—and he remained in position until it subsided. Castle's gallant deed came to the attention of the Army of the Potomac's Chief Signal Officer, Capt. Lemuel B. Norton. He commended Castle in his official report of the Corps' actions during the engagement.

Castle mustered out of the service about a year later and became a civil servant in Washington, D.C. Upon his death in 1886 at age 50, he worked at the General Land Office, part of today's Bureau of Land Management. His outlived his wife, Anna, whom he had married in 1866, and was survived by two children. His remains rest in Oak Hill Cemetery in the Georgetown neighborhood of Washington, D.C.

Charging Like a Thunderbolt

Union Capt. Walter Symonds Newhall might be among the least
likely officers to draw his sword in combat. As acting adjutant
general of a cavalry brigade in the Army of the Potomac, his
duties generally kept him out of harm's way. But that changed in
a field east of Gettysburg on July 3 when rebel troopers advanced
and threatened his regiment, the 3rd Pennsylvania Cavalry.

Newhall happened to be delivering orders when he observed the
peril to his comrades. The six-feet-tall, 22-year-old natural athlete
could not resist taking part in a headlong charge against the enemy.
An admiring biographer recounted what happened next, "Newhall
had made straight for the battle-flag, and raising his sabre charged
like a thunderbolt upon the color-bearer, but the latter suddenly
lowered the spear-head of the banner and struck his antagonist full
on the chin with terrible force, shattering his jaw, tearing his cheek
to pieces, and knocking him senseless from his horse."

His wounding deprived the federals of a vigorous staff officer.
Born in Philadelphia, Pa., and raised in nearby Germantown, he
distinguished himself on the playing field from a young age. He
came of age in the cricket clubs of his hometown, rising to become
one of the top players in the nation. He could also be intensely
sensitive. As a boy, his father took him to see *Uncle Tom's Cabin*, a
play based on Harriet Beecher Stowe's recently published book.
His biographer described how young Newhall became so agitated
by the inhumanity of slavery that he started crying and begged his
father, Thomas, to leave the theater. His father complied.

Two days after the bombardment of Fort Sumter rocked the
nation, Newhall and friends organized a cavalry company in

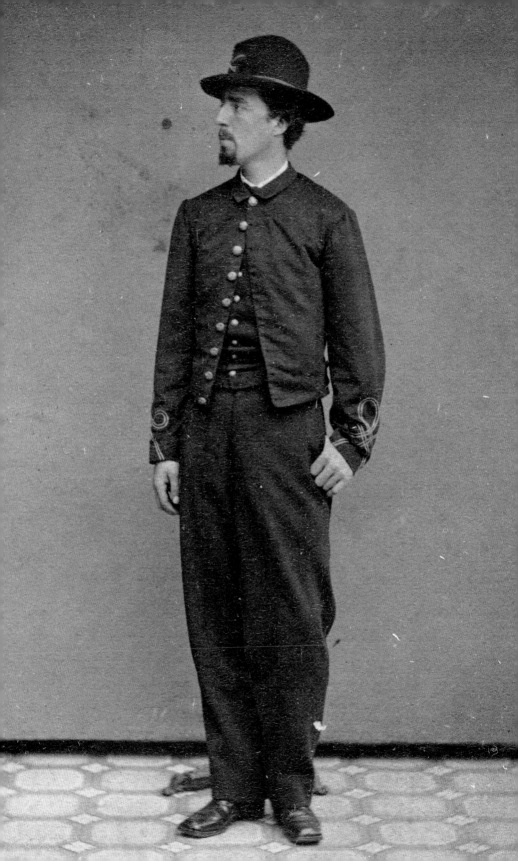

Germantown but were unable to find a regiment to accept them and disbanded. Eager to fight, Newhall petitioned Maj. Gen. John C. Frémont, the well-known explorer and former Republican presidential candidate then commanding troops in St. Louis, for a position. Having never met the general, Newhall's first request did not meet with encouragement. Down but not out, Newhall persisted and in August 1861 received a positive reply. He departed the same night for St. Louis. Before long, the strapping athlete received a first lieutenant's commission and assignment to Frémont's Body Guard, an elite cavalry unit dressed in Hussar-styled uniforms.

Though the Guard disbanded by the year's end, it provided Newhall with experience and recognition. In January 1862, he received a first lieutenant's commission in Company A of the 3rd Pennsylvania Cavalry. His winning ways attracted the attention of senior leadership, who tapped him for various duties as an aide de camp. Newhall thrived in this role and received high marks for his courage along the Virginia Peninsula and in various cavalry operations elsewhere with the Army of the Potomac.

At Gettysburg, the collision with a rebel flag bearer left him lying on the battlefield and bleeding profusely from the wounds to his face. He and other injured men found their way to the safety of a nearby farmhouse. Over the next several days, Newhall received basic treatment and then took a trip home. During his recuperation he posed for this photo, his disfigured face hidden from view.

Newhall returned to the army before the end of the summer and resumed his fighting ways in small skirmishes in Virginia. On Dec. 18, 1863, as he made his way home on a leave to visit his parents for Christmas, he became hopelessly mired in mud while attempting to cross the rain-swollen Rappahannock River on his horse and drowned.

Newhall's life and deeds attracted the attention of a manager of New York's Metropolitan Fair, a major fundraising event organized by the U.S. Sanitary Commission in 1864. A volunteer, working in collaboration with family, friends, and fellow officers, wrote *Walter S. Newhall. A Memoir* as an inspiration to other Union patriots. The book was published for the benefit of the Commission.

Carte de visite by O. Knipe of Philadelphia, Pa. Rick Carlile Collection.

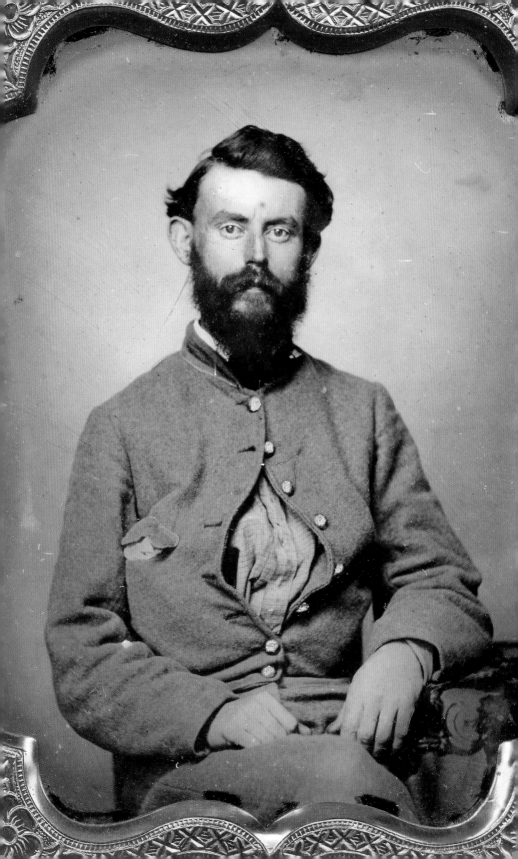

Captured a Few Feet from Where Armistead Fell

A fateful drama played out in the 9th Virginia Infantry at the out-set of Pickett's Charge. As 2nd Lt. John Vermillion, pictured here, and 1st Lt. John C. Niemeyer marched towards the federal lines one of their men made an urgent request. Pvt. Mills Brinkley turned to Niemeyer and asked to leave the ranks and go to the rear because, he believed, he was going to be killed. The premonition of death had visited Brinkley before the regiment arrived in Gettysburg, and now the sense came over him again with renewed urgency.

Niemeyer refused and ordered Brinkley back in line. Vermillion intervened on the private's behalf. He reminded Niemeyer, the ranking lieutenant, that Brinkley was a brave soldier.

This is not the first example of Vermillion's compassion. Back in 1855, at about age 19, he assisted yellow fever patients after an epidemic swept through his hometown of Portsmouth, Va. The son of a ship's carpenter, Vermillion and his older brother, Dennis, enlisted in the army days after the bombardment of Fort Sumter. The brothers joined Company K of the 9th. Vermillion started as a private and Dennis a first lieutenant. Dennis advanced to captain and company commander during the 1862 Peninsula Campaign and lost his life in its culminating battle at Malvern Hill.

Sixth-plate ambrotype by an anonymous photographer. Paul Russinoff Collection.

Vermillion, by this time a sergeant, received a promotion to second lieutenant following his brother's death and served in this capacity at Gettysburg.

At Pickett's Charge, Vermillion's appeal to allow Pvt. Brinkley to go to the rear was denied by Niemeyer. By this time, the advance was well underway. The three men continued as shot and shell spewed from the mouths of Union field cannon. No more than twenty paces later, a shell fragment struck Pvt. Brinkley in the forehead and killed him instantly. A few minutes later, Niemeyer joined Brinkley in death.

Vermillion's military service ended moments after Pickett's Charge collapsed. According to one report, he fell into enemy hands just a few feet from where his brigade commander, Gen. Lewis A. Armistead, fell mortally wounded. Vermillion spent the rest of the war as a prisoner of war at Johnson's Island, Ohio, and Fort Delaware, Del. He gained his release in June 1865.

Vermillion returned to Virginia and settled in Norfolk, where he operated a liquor store for a time and joined his local business association and Confederate Veterans' camp. He died, unmarried, in 1911 at about age 75. He was survived by several siblings, including younger brother Guiliaume, who had served in the Confederate Signal Corps.

A Farmville Tobacconist at Pickett's Charge

Catastrophic losses in the 18th Virginia Infantry during Pickett's Charge left few survivors. A total of 312 men and officers made the assault and 67 came out unscathed. Those fortunate few who stumbled back to Confederate lines lacked unit cohesion because Union fire had devastated the cadre of officers.

The officers left on the field of battle included Capt. Zachariah Angel Blanton, 30, of Company F. A round struck him in the head, inflicting massive damage to the right side of his face—the bullet obliterated a significant section of his upper jaw and lacerated his tongue.

A tobacconist by profession, Blanton lived and worked in the village of Farmville, located about 65 miles west of Richmond. Less than two weeks after the bombardment of Fort Sumter, he enlisted as a sergeant in his local militia company, the Farmville Guards. He's pictured here about this time wearing a cap with the letters FG and armed with an old flintlock musket of the 1816 style, converted to modern use as a percussion-fire gun.

Blanton and his fellow Guards became Company F of the 18th. Before the end of his first year in uniform Blanton traded his sergeant's chevrons for the insignia of a first lieutenant, and, in 1862, he advanced to captain and company commander. Along the way, the Virginians participated in some of the war's momentous battles, including First Bull Run and Antietam. Blanton escaped injury in these engagements.

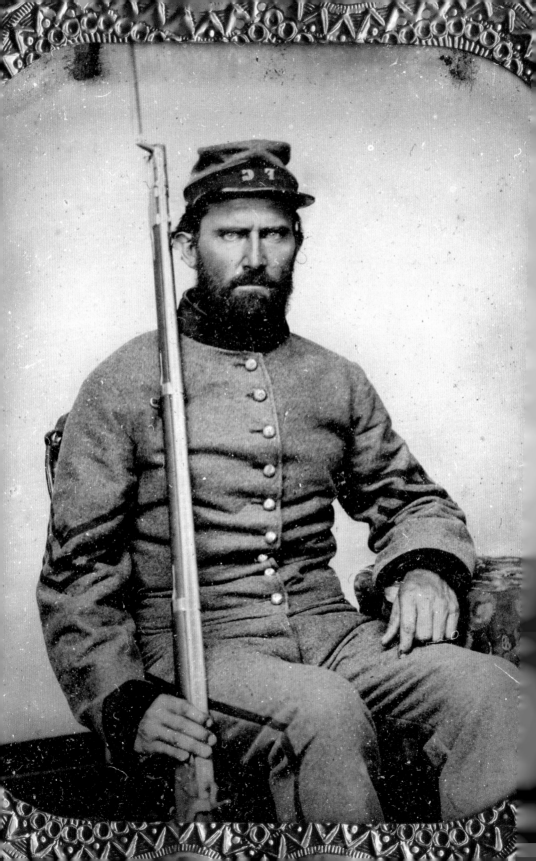

The 18th arrived at Gettysburg about sunset of the second day's battle and encamped near Spangler's Woods. The following afternoon, the regiment marched into combat with its brigade commanded by Brig. Gen. Richard B. Garnett. Though federal fire shattered the Virginians' ranks as they made their way across Emmitsburg Road, some made it to the angle along Cemetery Ridge, the climax of the Charge. Garnett lost his life within yards of the Union lines.

The exact location where Blanton fell is not known. According to one newspaper report, he lay on the battlefield for three days and nights before receiving attention. Transported to Baltimore, his captors held him for a month before forwarding him to the prisoner of war camp at Johnson's Island. Ohio. In mid-1864, after ten months in captivity, he gained his release and returned to Virginia, his combat career over.

According to one newspaper report, he lay on the battlefield for three days and nights before receiving attention. Transported to Baltimore, his captors held him for a month before forwarding him to the prisoner of war camp at Johnson's Island. Ohio.

Though unable to endure the rigors of campaigning in the field, Blanton participated in local duty patrolling Farmville while working as a clerk in the Farmville Bank.

Blanton made one more contribution to the Confederacy before the end of hostilities. In April 1865, after news arrived of the surrender by Gen. Robert E. Lee of the Army of Northern Virginia, clerk Blanton gathered up all the bank funds and hurriedly left town. He kept the money safe until able to return to Farmville, at which time he returned the funds to the bank.

Sixth-plate tintype attributed to Charles R. Rees of Richmond, Va. Charles Darden Collection.

Blanton returned to the tobacco business and went on to lead a productive life as a civic leader, husband, and father. He died in 1893 at age 60. His wife, Ida, and three children survived him.

Homecoming After Pickett's Charge

Frank Crocker marveled at the steadfastness of his fellow sons of Virginia who charged Union lines with Brig. Gen. Lewis A. Armistead's Brigade on July 3. Recalling the advance more than three decades later, he wrote, "Men fell like ten-pins in a ten-strike. Without a pause and without losing step, the survivors dressed themselves to their line and our regiment to the diminished regiment, and all went on as serenely and as unfalteringly as before. My God! It was magnificent—this march of men."

Crocker, the 35-year-old first lieutenant and adjutant of the 9th Virginia Infantry, did his part to hold the lines together until a bullet struck him in the right leg—his second injury of the war. Almost exactly a year earlier at Malvern Hill, he suffered superficial wounds in the throat, shoulder, and arm and managed to make it to safety.

This time, he became trapped after Union forces repulsed the great charge and fell into enemy hands along with the mortally wounded Armistead and many others.

Taken to a field hospital at the George Bushman Farm, Crocker happened upon Prof. Martin L. Stoever of Pennsylvania (now Gettysburg) College. They instantly recognized each other, for Crocker was valedictorian of the college's Class of 1850.

Like many Virginians who hailed from families rich in lands worked by enslaved people, James Francis Crocker left his home in Isle of Wight County to be educated in the North. He excelled in his studies at Gettysburg College. His education propelled him

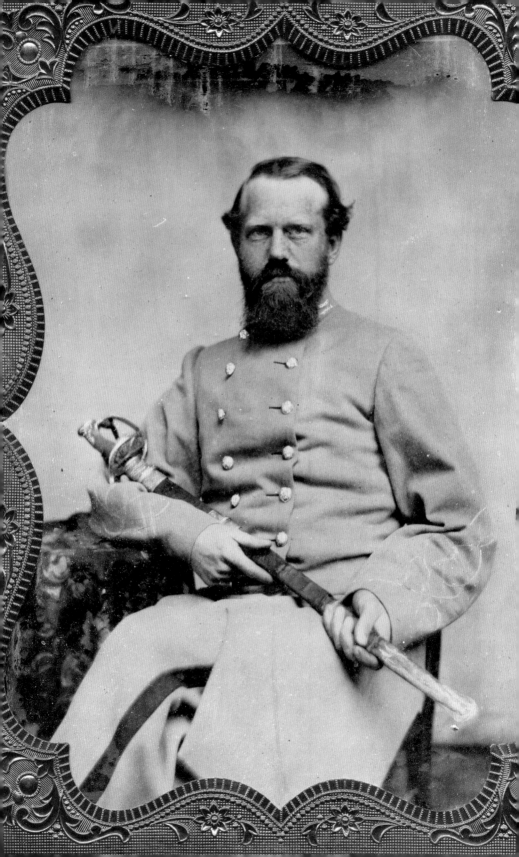

on a successful career path from professor to attorney and member of the commonwealth's House of Delegates.

By the time Virginia seceded from the Union, Crocker had settled in Portsmouth and practiced law in partnership with a fellow attorney. Days after the bombardment of Fort Sumter, he stepped away from his law practice and into the ranks of Company K of the 9th. His promotion to first lieutenant and regimental adjutant provided an opportunity to exercise his intellect and political acumen.

Days after the bombardment of Fort Sumter, he stepped away from his law practice and into the ranks of Company K of the 9th. His promotion to first lieutenant and regimental adjutant provided an opportunity to exercise his intellect and political acumen.

Following his capture at Gettysburg, and an unexpected and pleasant reunion with Prof. Stoever, Crocker used his influence and position to contact a friend in Baltimore for a loan to buy new clothes and other necessities and negotiated a pass to roam about town. His leg wound proved minor, enabling him to travel freely and catch up with professors and classmates. He also attempted to visit Brig. Gen. Armistead, only to find he had succumbed to his wound.

The good times soon ended after he was transported to the prisoner of war camp at Johnson's Island in Ohio.

Like many Southern soldiers, he remained convinced that the South would never be conquered. At Davids Island in New York, a temporary stop while he and other prisoners awaited transportation to Ohio, a *New York Tribune* reporter found Crocker in a pavilion tent writing a letter. The correspondent reported

Half-plate ambrotype by an unidentified photographer. Dave Batalo Collection.

Crocker's warning: "He said it was impossible for the North to subdue the South. The enemy might waste their fields, burn their dwellings, level their cities with the dust, but nothing short of extermination would give the controlling power to the North. The intelligent people of the South looked upon the efforts to regain their rights as sacred, and they were willing to exhaust their property and sacrifice their lives, the lives of their wives and children, in defending what they conceived to be their constitutional rights."

Crocker held these views through the remainder of the war, which he spent in prison. He included the *Tribune* profile in his prison reminiscences published in the *Southern Historical Society Papers* in 1905. By this time, he had resumed his career as an attorney and went on to become a judge and a board member at The College of William and Mary. He wrote and spoke about his war experience on numerous occasions and produced a volume on the Crocker family before his death in 1917 at age 89. He outlived his wife, Margaret, and a son.

Disappearance of a "Southern Brave"

The LaPrade cousins marched into Pickett's Charge not knowing that for one of them this would be their last fight.

Up to this point in the war, their military experiences had mirrored each other.

Back in the spring of 1861, Everett G. LaPrade (right) a 22-year-old carpenter, and 19-year-old farmer Cornelius B. LaPrade left their homes in Chesterfield County and joined the army. They enlisted as privates in a local company known as the "Chester Grays" or the "Southern Braves." The volunteers mustered into the Confederate army as Company I of the 14th Virginia Infantry.

The regiment became part of Brig. Gen. Lewis A. Armistead's brigade in Maj. Gen. George Pickett's Division. The Virginians faced first combat at Seven Pines and Malvern Hill during the Peninsula Campaign in 1862. Though the LaPrade boys emerged unscathed from these fights, both landed on the sick list before the end of the summer and missed the Battle of Antietam.

Back in action for Gettysburg, the LaPrades counted among the 422 troops that charged across open ground from Seminary Ridge toward massed Union troops beyond the Emmitsburg Road on the afternoon of July 3.

About three-quarters of the men in the 14th made it safely back to the main Confederate lines after Pickett's Charge disintegrated. They included Everett, who lived to fight another day.

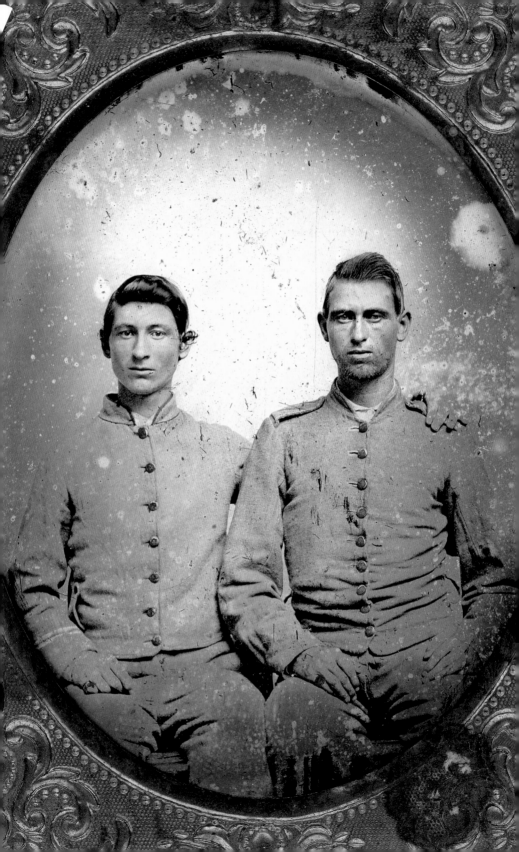

Cornelius numbered among those who did not return. An initial regimental report listed him as wounded and captured, but no federal records document him as a patient or prisoner. Unable to account for his whereabouts, the 14th dropped him from its rolls with the explanation that he was believed to have been killed.

Everett remained on the regimental rolls until the fall of 1864, when his name disappeared from company records. By this time, his home county of Chesterfield, located between the besieged cities of Richmond and Petersburg, had become part of the front lines. Everett was likely part of the exodus of desertions that depleted Gen. Robert E. Lee's Army of Northern Virginia during the chaotic final months of the war.

At some point he returned to his home and resumed life as a carpenter. He married a local woman, Jane, and started a family that grew to include five children. They named the first-born baby, a boy, Cornelius.

In 1900, 62-year-old Everett applied for a pension from Virginia for his Confederate military service. This is the last time his name appeared on a government record.

Sixth-plate ambrotype by an anonymous photographer. Charles T. Joyce Collection.

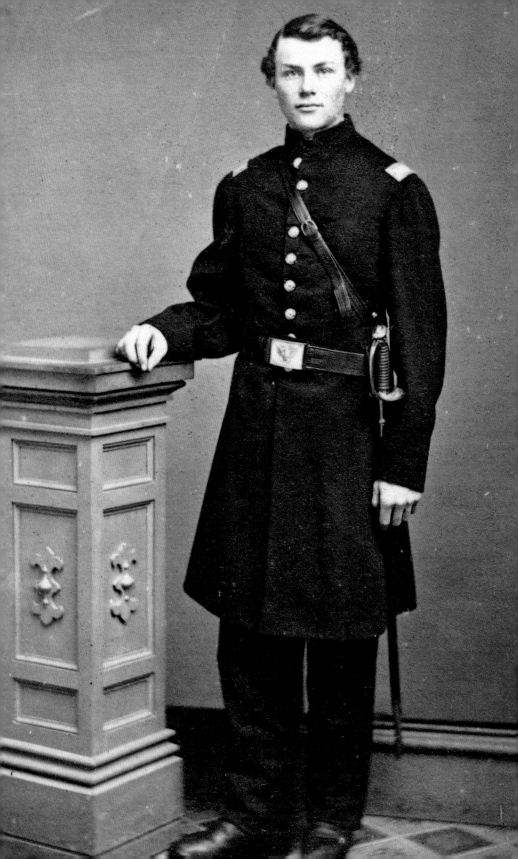

"Young Pohlman Was Everywhere"

The fighting in the vicinity of Cemetery Ridge on July 2 took a terrible toll on the 59th New York Infantry. Only one staff officer was left standing: 1st Lt. William Henry "Willie" Pohlman, the regiment's 21-year-old adjutant. According to a newspaper report, "Young Pohlman was everywhere cheering and inciting his men by his own example to deeds of noble daring."

Pohlman's path to Gettysburg began with his birth to Christian missionaries on the island of Borneo in 1842. A few years later in India, Pohlman's mother died in childbirth. His widowed father sent him and a sister home to America. The children arrived in Albany, N.Y., and were raised by their aunt, Elizabeth Pohlman McClure.

Pohlman grew up and entered Rutgers in 1859 to study the-ology with a goal of following his parents into missionary work. But the bombardment of Fort Sumter and a patriotic speech by the college's president, Theodore Frelinghuysen, inspired him to join the army.

Beginning in May 1861, Pohlman served stints in the 1st New Jersey Infantry and the U.S. Signal Corps before he accepted a second lieutenant's commission in the veteran 59th Infantry. He joined his new command in October 1862 and quickly gained the respect of his peers and trust of the enlisted men. In May 1863, he received a promotion to first lieutenant and adjutant.

Carte de visite by J.H. Abbott of Albany, N.Y. Rick Carlile Collection.

Pohlman served in this capacity less than two months later at Gettysburg, where command of the regiment fell to him after the wounding of other senior staff officers.

On July 3, he and the rest of the 59th joined other federal forces in the defense against Pickett's Charge. At some point during the assault, an artillery shell struck him and fractured his left shoulder. The same newspaper account that reported his ubiquitous presence noted that Pohlman's comrades "entreated him to withdraw to the camp, but he answered, 'Not while I have my sword arm left.' In about an hour afterwards his sword arm was disabled by a shot through the wrist, which severed one of the arteries, and faint and bleeding he was reluctantly compelled to retire from the field." According to another source, he left the 59th with words of encouragement: "Boys, stay in your places. Your country needs every man of you."

Pohlman received initial treatment at the 2nd Corps field hospital, and then was taken to the Swope Mansion in downtown Gettysburg to recuperate.

On July 4, he mustered the strength to scrawl a note to his sister, "I bear honorable wounds in my country's cause. The wounds are slight, but still forbid my using a pen at present. I shall soon write again concerning my whereabouts. Until then, farewell!" His wounds proved fatal, and he succumbed to his injuries on July 21. His remains were embalmed and sent home to Albany, N.Y., and buried in the Albany Rural Cemetery.

The sword Pohlman carried into Gettysburg, a gift from his Aunt Elizabeth, disappeared during the chaos and confusion of battle. But the scabbard, dented and blood-stained, made the trip home with him.

Remember for Whom You Fight

According to a participant in Pickett's Charge, Brig. Gen. Lewis
A. Armistead shouted his customary rallying cry as he and his
men advanced toward the Union defenses: "Men, remember
your wives, your mothers, your sisters, and your sweethearts."

Armistead intended these words to inject anyone within ear-
shot with an extra dose of courage. For one enlisted man in the
ranks of the 14th Virginia Infantry, the call to arms had immediacy
to it. Charles Henry Womack had just returned to his regiment
from being absent without leave to visit his family.

A farmer in his late twenties from Halifax County in south-
central Virginia, he had joined a local military company, the
Meadsville Grays, back in the spring of 1861. The Grays soon left
home and became Company H of the 14th. Womack, recently
widowed, left his two young children in the care of his in-laws in
neighboring Pittsylvania County.

Womack proved a good soldier, serving a stint as a corporal and
being present for duty with Armistead's Brigade in the battles of
the Seven Days, Second Bull Run, Antietam, and Fredericksburg.

In late May 1863, he disappeared from camp and trekked
to Pittsylvania County. His brother-in-law, William T. Boothe, a
private in the 38th Virginia Infantry, accompanied him. Womack
reunited with his children, who had remained in the care of
his in-laws. He also asked his father-in-law for permission to
marry his late wife's youngest sister, Martha. The father refused.
Womack and Martha eloped across the state border into North

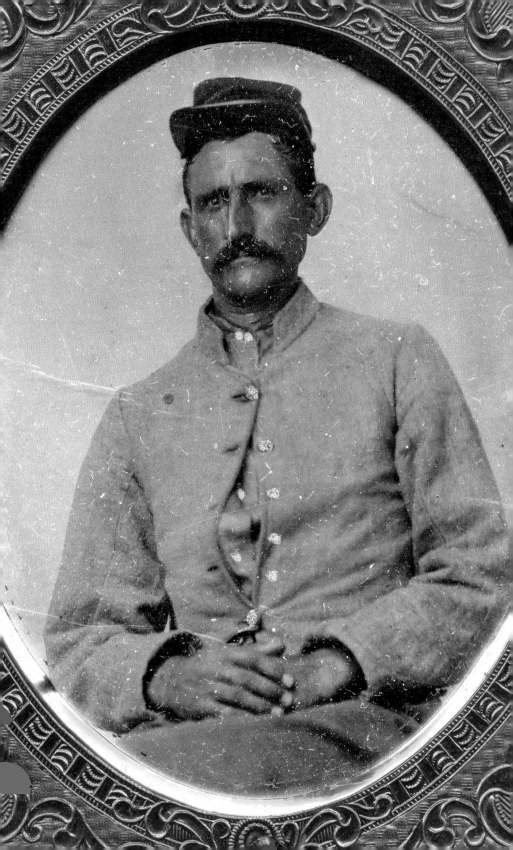

Carolina and wed. After a brief honeymoon, he rejoined his regiment and was back in the ranks by June 26, 1863. A day earlier, the 14th had crossed the Potomac River at Williamsport, Md., on its way to Pennsylvania.

A week after his return, Womack suffered gunshot wounds in the left side and thigh during Pickett's Charge. He succumbed to his injuries at Camp Letterman General Hospital on Aug. 16, 1863. Buried on the hospital grounds, his remains were later removed to Hollywood Cemetery in Richmond.

In February 1864, Martha gave birth to their daughter, Mary.

Sixth-plate tintype by an unidentified photographer. Faye and Ed Max Collection.

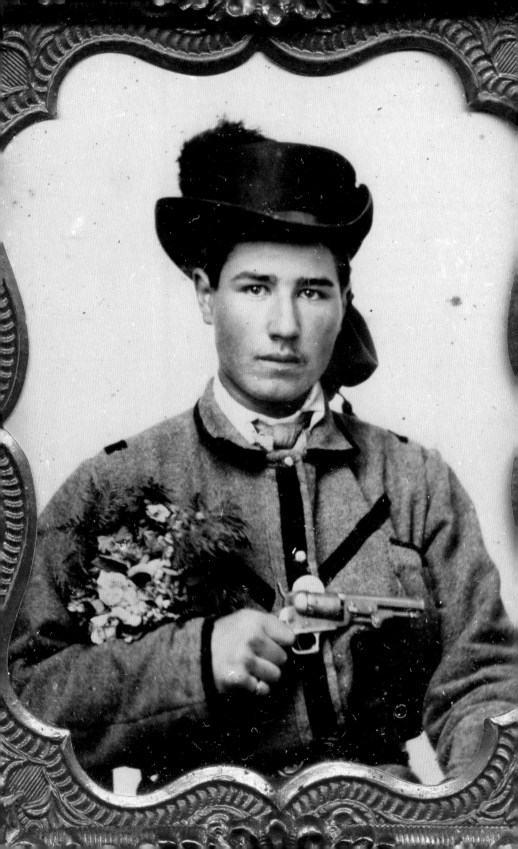

Second Wounding, First Capture

During the immediate aftermath of Pickett's Charge, details of
Union soldiers fanned out across the ground where so many
Confederates lay dead and wounded. One of the rebel soldiers
recovered, Cpl. John David Tanner of the 28th Virginia Infantry,
had been rendered immobile after he suffered a gunshot wound
in the left shoulder and injuries to both legs. His captors trans-
ported him to a field hospital for treatment.

Tanner, a farmer from Bedford County in the Piedmont
region of Virginia, had been on a casualty list once before. A
year earlier during the Peninsula Campaign's Battle of Gaines'
Mill, a bullet struck and passed through his body. His comrades
helped him to safety. Tanner spent the rest of 1862 recuperating
in a hospital before he returned to the 28th.

His hospital stay after Gettysburg was not as long. On July
21, 1863, his captors transported Tanner from Gettysburg to a
military hospital in Chester, Pa., for further treatment. Records
indicate he gained his parole and exchange within weeks and
returned to his home to complete his recovery.

Tanner rejoined his comrades before the end of 1863 and
participated in the final campaigns of the Army of Northern
Virginia. On April 6, 1865, just days before the surrender at
Appomattox, Union troops nabbed Tanner again during the
fighting at Sailor's Creek. This time, they took him to the federal

Ninth-plate ambrotype by an anonymous photographer. Seth McCormick-Goodhart Collection.

base at City Point, Va., where he signed the Oath of Allegiance to the U.S. government on June 21, 1865.

Tanner returned to Bedford County, where he married in 1868 and started a family. He went on to become a city councilman in Lynchburg, located in neighboring Campbell County. Tanner lived until 1924, dying at age 82. His wife and a daughter survived him.

He Bravely Served His Gun

The 1st New York Independent Battery pulled up on the far left of the Union line along Cemetery Ridge as rebel artillery blasted away. The Empire State men worked quickly to unlimber six cannon and roll them into position.

One of the men, Otis C. Billings, a brave and reliable soldier, did not feel well. He approached his captain and, pleading sickness, asked to go to the rear with the battery's caissons. The commander, Capt. Andrew Cowan, noted how ghastly pale Billings looked. In a different time and place, Cowan might have excused him. But in the heat of battle and the need for every man to be at his station, Cowan snapped, "No, Billings, this is no time to be sick."

Billings dutifully returned to his gun and braced for action.

A 22-year-old peacetime teacher, he had grown up the eldest of ten siblings in the Empire State. In September 1861, he left his family and schoolhouse and joined the army. He started his service with Battery E of the 1st New York Light Artillery. The following spring, he proved his courage along the Virginia Peninsula. During siege operations at Yorktown, federal infantry erected brush and rail barricades that obstructed the battery's fire. Billings, along with a lieutenant and an infantryman, crawled out into an exposed position in range of rebel sharpshooters. The marksmen shot and killed the infantry soldier almost immediately. Billings and the lieutenant accomplished the mission and returned safely.

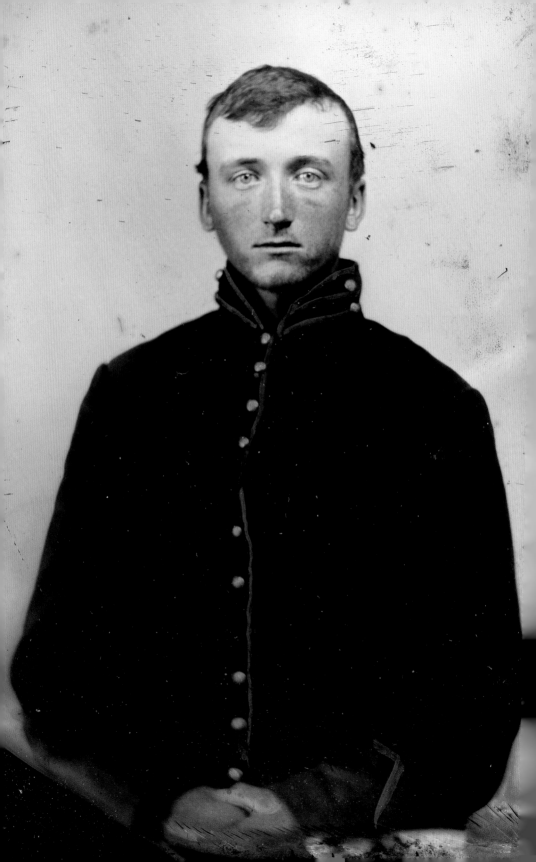

A few months later, Billings transferred to Cowan's Battery and fought at Antietam, Fredericksburg, and Chancellorsville.

The battery rolled into Gettysburg on July 2 and took up a position in the vicinity of the Copse of Trees the following morning, when the enemy artillery bombardment preceding Pickett's Charge erupted.

The scream of shells shattered the morning stillness and sent the artillerymen scrambling. Cowan barked, "Stand to horse! Cannoneers, to your posts," and his men obeyed. An aide from the staff of Maj. Gen. Abner Doubleday appeared and directed the battery up a hill.

About this time, Cowan denied Billings' request to be relieved. The battery relocated, unlimbered, and joined the chorus of guns trading shot and shell with its opposite number. Soon, Pickett's Division came into view, and the blue artillerymen switched to canister, ripping massive gaps in the gray ranks.

The Confederates surged forward and some of the Union infantry in support of the battery panicked, leaving Cowan's men exposed. The enemy closed to within ten yards of the battery when the last blasts of shot stopped the advance. Pickett's Charge was over.

The long casualty list included Billings, lying dead with a bullet through his head.

"He was killed, bravely serving his gun," observed Cowans. The Billings family recovered his remains and brought them home to Avoca, N.Y., for burial.

Sixth-plate tintype by an unidentified photographer. Charles T. Joyce Collection.

"The Brave May Fall but Cannot Yield"

One of the last orders Corp. James Parkman Chenery may have heard occurred during the culmination of Pickett's Charge. "Up, boys, they are coming!" shouted a general's aide. Chenery and his comrades in the 15th Massachusetts Infantry, who lay waiting beneath the broiling sun, rose to their feet as much by instinct than any order due to the intolerable heat and an impulse to stop the wave of Confederates descending on them.

Though only 20, Chenery had faced similar situations during his time in uniform. Almost two years earlier, he had left his job as a printer for the *Clinton Courant,* a newspaper in Worcester County, Mass., and, with other young men in his local militia, the Clinton Light Guard, enlisted in the army. Chenery joined Company C as a private in July 1861.

Three months later in Northern Virginia, the 15th fought in the Battle of Ball's Bluff and lost heavily when Confederate troops drove the Union forces to the edge of the Potomac River. Many jumped into the water and attempted to swim across to safety. Chenery numbered among the captured, and he spent the next year as a prisoner of war at camps in Richmond, Va., and Salisbury, N.C. He returned to his company before the end of the year and, in January 1863, received his corporal's chevrons.

At Gettysburg, he met his death during the climax of Pickett's Charge. According to his sergeant, William J. Coulter, "It was

Carte de visite by J.J. Boynton of Clinton, Mass. Mark Savolis Collection.

during the fight (at the stone-wall) that my tent-mate, James P. Chenery, was killed. He was shot through the neck and died immediately. He was buried right where he fell, and a board with his name written on it marks the spot."

His remains were likely removed to the Soldiers' National Cemetery.

A stone cenotaph at a cemetery in his hometown of Medford, Mass., is engraved with his name and that of his older brother, Frank, who served in the 36th Massachusetts Infantry and died in the 1864 Battle of Cold Harbor. An inscription arched along the top of the stone is a tribute to their sacrifice: "The brave may fall but cannot yield."

Cavalry Clash at Fairfield

James M. Sturgeon and his fellow troopers in the 6th U.S. Cavalry sped along a country road away from Gettysburg during the afternoon of the third day of battle. The regiment, about 400 sabers strong, headed to the village of Fairfield to investigate a report about a train of rebel supply wagons.

Confederates had occupied Fairfield, located about eight miles west of Gettysburg, four days earlier. The town and nearby Fairfield Pass were an important retreat route for the army—and soon to be needed in the wake of the failed charge by Pickett's Division.

Sturgeon, a Pennsylvania-born boatman in Erie, had enlisted in the regiment when it formed in July 1861. He began his service as a corporal in Company G and served in this capacity during the 1862 Peninsula Campaign, the Battle of Fredericksburg, and the cavalry fight at Brandy Station in June 1863. Sturgeon emerged from all these actions unharmed.

Less than a month later at Gettysburg, the 6th arrived in the vicinity of Fairfield and discovered the wagons trains parked along the Tract Road, protected by tall post-and-rail fences. The troopers encountered enemy pickets—and cavalry and artillery guarding the wagons.

The 6th dismounted and deployed along high ground in a field and an orchard and put its carbines to good effect to blunt a charge by the 7th Virginia Cavalry. At this critical moment, part of the 6th Virginia Cavalry entered the fray, and with its brother

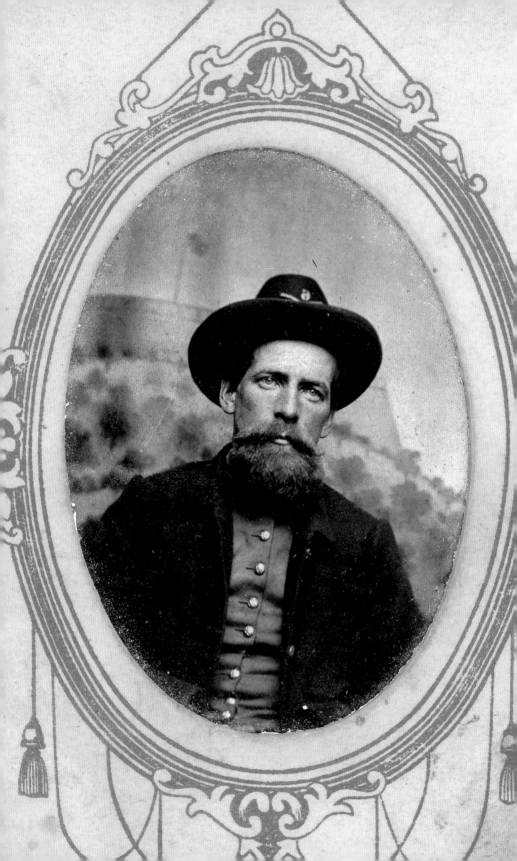

troopers in the 7th and artillery support saved the wagons and kept the retreat route open. The Union cavalrymen scattered as the Confederates overwhelmed them. Some managed to jump on their horses and flee to safety, while more the half of the regiment—242—were wounded or captured.

Sturgeon numbered among those who fell into enemy hands. How long he remained a prisoner of war is unclear, but he rejoined his regiment before it mustered out of the army at Petersburg, Va., in July 1864.

Following his discharge, Sturgeon made his way westward, perhaps inspired by wanderlust during his military service. He farmed in Wisconsin, mined for silver in Colorado, and by the turn of the century had settled in Riverside, Calif. By 1908, his physical and mental health failing, he entered a Soldiers' Home in Los Angeles. He died there on Memorial Day in 1911 at about age 76. His wife, Sarah, survived him. His remains are interred at the Los Angeles National Cemetery.

Ninth-plate tintype by James F. Gibson. Charles T. Joyce Collection.

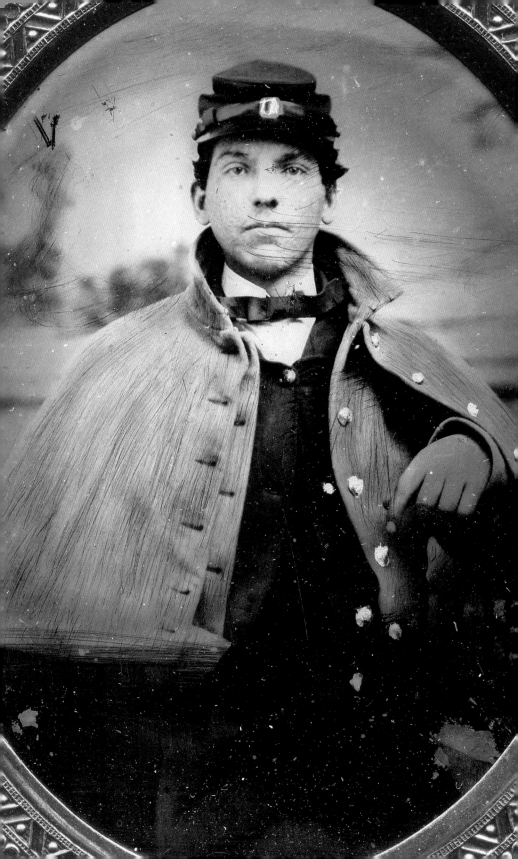

Cleanup Operations After the Fairfield Fight

In one of Gen. Robert E. Lee's acts to protect his retreat routes on July 3, he ordered his cavalry chief to guard wagon trains parked at Fairfield. Lt. Gen. JEB Stuart dispatched a brigade of Virginia troopers to the village, located about eight miles west of Gettysburg.

The brigade, commanded by Brig. Gen. William E. "Grumble" Jones, saddled its horses and rode off to execute orders. The Virginians made it to within two miles of the village when they encountered the 6th U.S. Cavalry. Jones deployed two of his regiments, the 6th and 7th, and held his third regiment, the 11th, in reserve.

The ranks of the 11th included Stephen Hannas, a Virginia native and farmer's son from the Hampshire County town of Romney. Located on the western edge of the Shenandoah Valley, Hampshire's populace had a significant share of Southern sympathizers. However, it joined other breakaway counties to form the new state of West Virginia. The government recognized its status on June 20, 1863.

By this time, Hannas had entered the second year of his Confederate army service. Back in October 1861, just a week after his eighteenth birthday, he enlisted in the 77th Virginia Militia. In March 1862, the 77th reorganized in Winchester, Va., and became

Sixth-plate ambrotype by an unidentified photographer. Chad Brabeck Carlson Collection.

part of Col. Turner Ashby's 7th Virginia Cavalry. Three months later, Ashby lost his life during Lt. Gen. Stonewall Jackson's Valley Campaign. Hannas and Ashby's other men became the 17th Battalion Virginia Cavalry. It combined with two other units to form the 11th in early 1863.

At Fairfield on July 3, Hannas and his comrades remained in reserve as their brother regiments soundly defeated the federal cavalrymen. Jones sent in the 11th for cleanup operations. It spent the rest of the day and the next on picket, gathering up prisoners scattered after the fight. At some point during the events at Fairfield, Hannas suffered a shoulder wound. The nature of his wound was not reported, but it kept him from returning to the ranks until the end of the August.

Five months later, in January 1864, he slipped out of camp with his saber, a pistol, and a Burnside carbine—and never returned to the regiment. A year later in Romney, he married and started a family that grew to include eleven children. A farmer during his working life, Hannas joined his local United Confederate Veterans camp and remained active until his death at age 69 in 1912. His wife, Sarah, and seven children survived him.

Magic Mail and a Silk Handkerchief at Farnsworth's Charge

Cavalrymen on both sides of the war were known for ornate dress, and Oliver Tucker Cushman was no exception. At Gettysburg, the knightly captain in the 1st Vermont Cavalry wore a flashy uniform of a tight-fitting white jacket trimmed with yellow braid and a silk handkerchief pinned to the visor of his cap.

When a fellow officer suggested he might present too conspicuous a target to the enemy, an admiring biographer noted the reply of the confident Cushman: "A lady sent this to me, and said it was made with her own hands, and no rebel bullet could pierce it. It may be a good day to try magic mail."

Cushman's daring dress and attitude to match rivaled that of the flamboyant George Armstrong Custer.

Cushman, 22, came by his zeal for making a grand entrance honestly. The son of a Vermont farm family, his parents, Clark and Abigail, sent him to preparatory school in New Hampshire and, in 1859. on to college at Dartmouth.

Had the war not happened, Cushman might have completed his course of study, graduated, and taken the world by storm. But it did, and he enlisted as a sergeant in Company E of his home state's first regiment of cavalry in the autumn of 1861. Here he rapidly rose through the ranks, earning the shoulder straps of a second lieutenant in early 1862 and advancing to captain a year later. Along the way, he led his troopers on various small-scale operations in Virginia. A fellow captain, William Wells, who

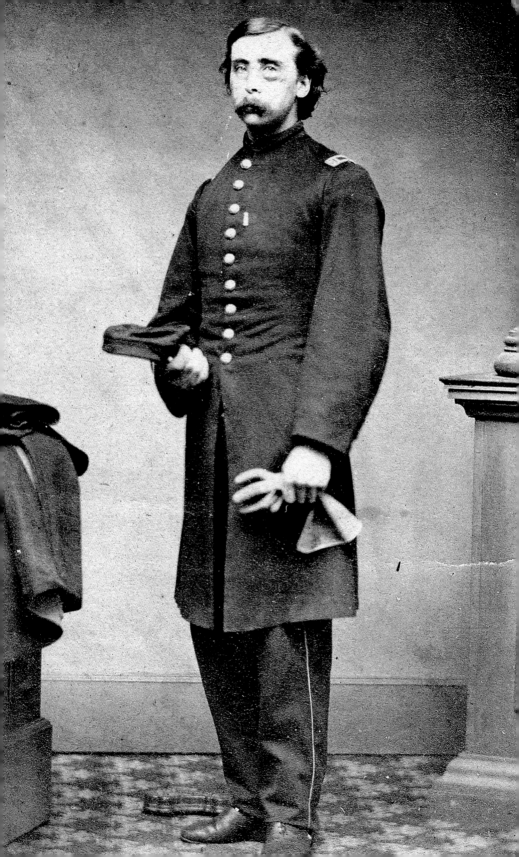

commanded Company C and went on to become a brigadier general and Medal of Honor recipient, praised Cushman: "His company was devotedly attached to him, and his superiors in command, as well as his associates, bear witness to his character as a soldier and a man."

At Gettysburg during the afternoon of July 3, newly minted Capt. Cushman, clad in magic mail and a handkerchief streaming from his cap, rode off with Brig. Gen. Elon J. Farnsworth into an ill-conceived charge that ended in complete failure. Cushman's magic mail did not get tested by rebel lead. But a bullet struck him in the face, knocking him off his mount and into the dust, where he attracted the attention of enemy horsemen who mistook him for a commanding general. According to one report, Cushman lay next to Farnsworth, who died after rebel troopers pumped five bullets into his chest.

At Gettysburg during the afternoon of July 3, newly minted Capt. Cushman, clad in magic mail and a handkerchief streaming from his cap, rode off with Brig. Gen. Elon J. Farnsworth into an ill-conceived charge that ended in complete failure.

Cushman, drifting in and out of consciousness, pulled out his revolver and fired until he fainted. According to one account, he lay on the battlefield until the next day, when he regained his senses and made his way to safety. Another version of the battle notes that the Confederates captured and paroled him.

Whatever the outcome, Cushman returned to Vermont to recuperate from his wound, which left his face swollen and scarred. The portrait here shows his condition.

In October 1863, Cushman returned to his command with renewed vigor and determination—and against the advice of

Carte de visite by Cushing of Woodstock, Vt. Francis Guber Collection.

friends. His biographer relayed the comment of a Dartmouth classmate, "Captain Cushman was perfectly fearless, and, in fact, seemed to court death on the battlefield, not caring to survive the war with such a disfigured face as he had."

On June 3, 1864, Cushman rode to his death in a skirmish during the Overland Campaign in Virginia. He was 23. Comrades recovered his remains and sent them to his family in Hartland, Vt., for burial. Family, friends, comrades, and college buddies from Dartmouth mourned his loss.

"To Do or to Die"

As Brig. Gen. Lewis A. Armistead and his nucleus of Confederate compatriots surged to the furthest advance of Pickett's Charge, a minor action occurred behind Union lines. A blue brigade positioned on the federal right flank hustled to its newly assigned position to the left and center of the line, near the point where Armistead struggled forward.

One of the regiments in the brigade, the 23rd Pennsylvania Infantry, moved quickly in obedience to orders. Conspicuously attired in natty Zouave-inspired uniforms, the men formed for battle with the guidance of its veteran officers. They included 1st Lt. Joshua Simister Garsed, 23, one of the regiment's most promising young leaders.

Born in Roxborough, located on the northwest edge of Philadelphia, he aspired to become an attorney before answering the call to military service. He joined the 23rd in the summer of 1861 as a corporal in Company B and steadily earned his way to first lieutenant. During the 1862 Maryland Campaign, Garsed led a detachment of about 35 men to investigate a report of weapons secreted in a barn near White's Ferry along the Potomac River. The assignment ended abruptly when rebels ambushed and captured the entire group. Garsed spent some weeks in Libby Prison before being formally exchanged and rejoining his regiment.

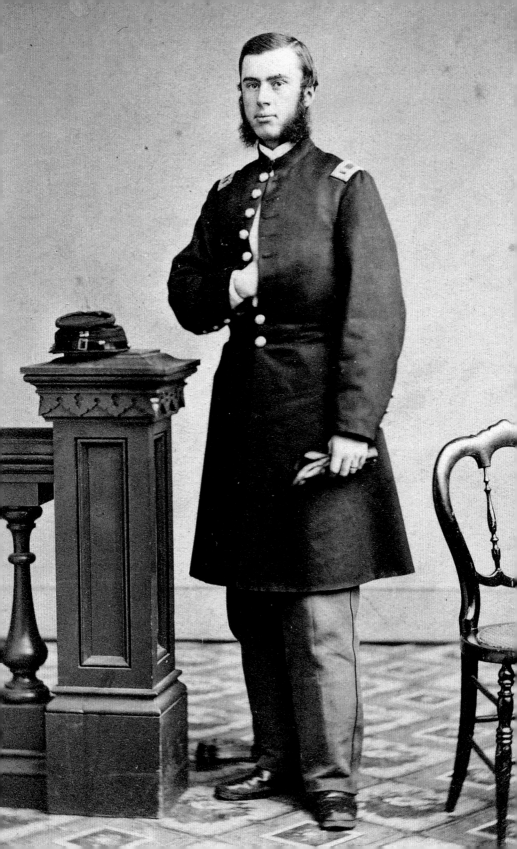

Months later at Gettysburg, Garsed and his fellow Pennsylvanians took up their new position and readied for new orders. Meanwhile, Pickett's Charge stalled as federal forces poured a murderous fire into the Confederate ranks. As the remnants of Pickett's Division fell back, rebel artillery lobbed occasional shots. One of them, a shell from a Whitworth gun fired near dusk, struck Garsed between the right shoulder and neck and literally tore him to pieces.

His remains were sent home to Philadelphia and buried with honors. On July 17, 1863, Garsed's company met and adopted a series of five resolutions to honor their fallen lieutenant. One of them noted, "That in the death of Lieutenant Garsed the Company has suffered an almost irreparable loss, and his comrades mourn the departure of a tried and cherished friend, one whose noble deeds and unswerving courage has ever nerved them with renewed efforts in the noble cause in which we are engaged, and whose only aim has been to do or to die."

Carte de visite by Frederick Gutekunst of Philadelphia, Pa. C. Paul Loane Collection.

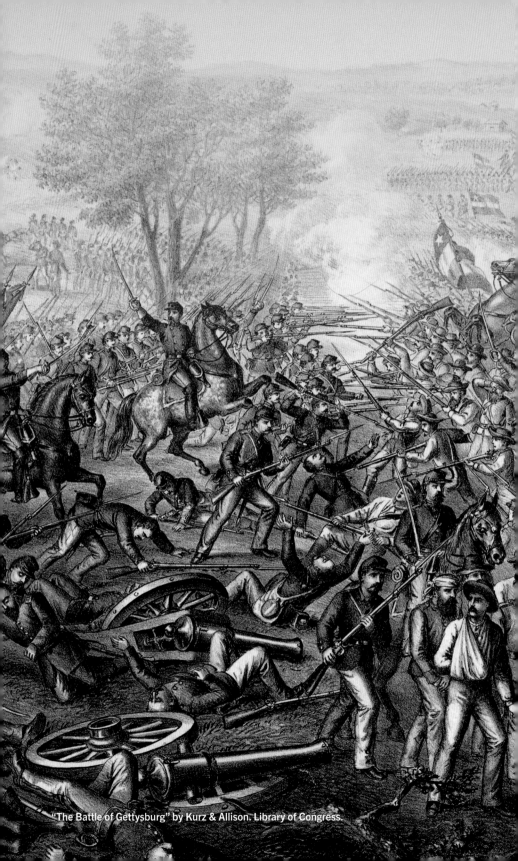

"The Battle of Gettysburg" by Kurz & Allison. Library of Congress.

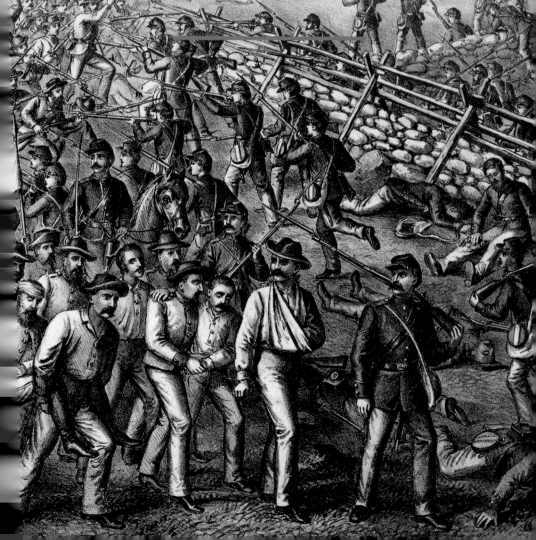

5

AFTER THE FIGHT

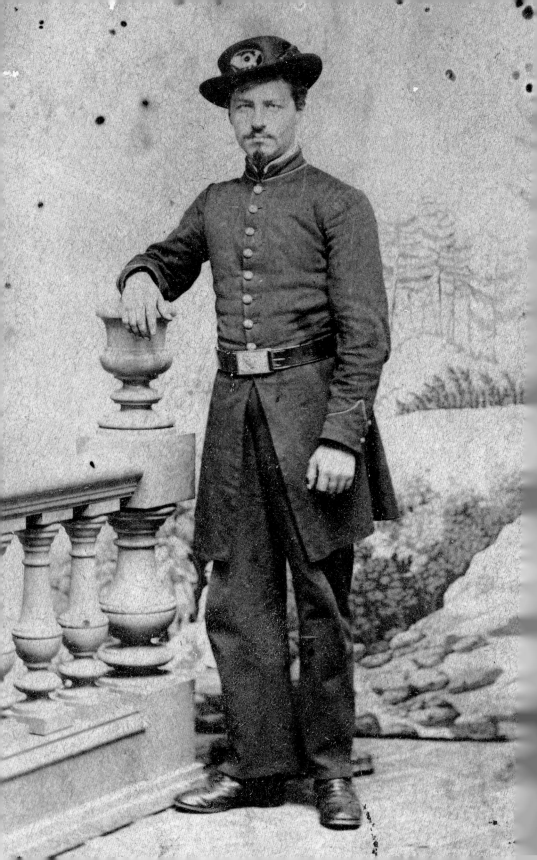

Love Found Amidst Death and Suffering

The exact moment Jacob Gundrum and Susie Herr first met has been lost in time. Surviving documents indicate they happened upon each other in downtown Gettysburg early during the battle or its immediate aftermath.

Jacob Friedrich Gundrum had emigrated from his native Germany in 1856. He made his way to Wisconsin, united with a sister who had already settled in America, and pursued his passion for teaching music. When the war came, the 24-year-old enlisted in the 2nd Wisconsin Infantry as a musician. After the army eliminated regimental bands due to the expense, Jacob lent his talents to the Iron Brigade Band. He and his fellow music makers entertained the troops in camp and on campaign. By 1863, he had grown tired of war and felt lonely.

Susanna "Susie" Herr, 19, the youngest of four sisters, grew up a few miles outside Gettysburg, where her father, Frederick, owned a tavern. In the mid-1850s, he sold the property to pay debts and relocated to a farm in nearby Cumberland Township. When agricultural life did not pan out, they moved to a new house on West Middle Street in Gettysburg. By this time her

At left and next page: The portraits exchanged between Susie and Jacob at the beginning of their romance in July 1863.

Cartes de visite by Fuller of Madison, Wis. Charles T. Joyce Collection.

sisters had married and established their own homes, leaving Susie to care for her elderly parents. Though she felt alone, Susie took solace in downtown living, which made it easy to trek to church in all kinds of weather.

The Herr home was close to the Adams County Court House—an easy two-block stroll. During the first day's battle, as the fighting quickly escalated and wounded Union soldiers poured into town, the courthouse became a makeshift hospital. Susie volunteered to help desperately injured men requiring treatment.

Though Jacob's whereabouts during this time are not precisely known, he might also have been helping the wounded—a traditional role for bandsmen during battle—while the Iron Brigade and other federal forces locked in combat with the rebel army.

If Susie and Jacob did not meet amidst the horribly mangled men holed up in and about the courthouse, they most certainly encountered each other after the fighting ended. Jacob and the rest of the Iron Brigade Band performed patriotic tunes outside the hospital every afternoon to keep everyone's spirits up. The musicians remained in town for several weeks.

Romance blossomed. Susie gave a handkerchief with her initials to a neighbor to deliver to Jacob. He presented Susie with this *carte de visite* portrait inscribed on the back, "Jacob Gundrum to his dear friend Susie Herr" before leaving Gettysburg on July 29. She sent him her likeness in return.

Jacob cherished her portrait. The pair kept up a lively correspondence through the rest of the war, and Jacob managed to visit her twice while on furloughs. During the second furlough, on Feb. 5, 1865, Susie and Jacob married at the Herr home on West Middle Street.

After he mustered out of the army later that year, Jacob reunited with his newlywed wife. They settled in Hanover, Pa., where Jacob resumed his life as a music teacher and Susie became mother to their three sons. She died in 1882 after an illness of about five or six months. She was 38. Jacob remained a widower until his passing in 1904. They are buried side by side at Mt. Olivet Cemetery in Hanover.

Cartes de visite by Tyson Brothers of Gettysburg, Pa. Charles T. Joyce Collection.

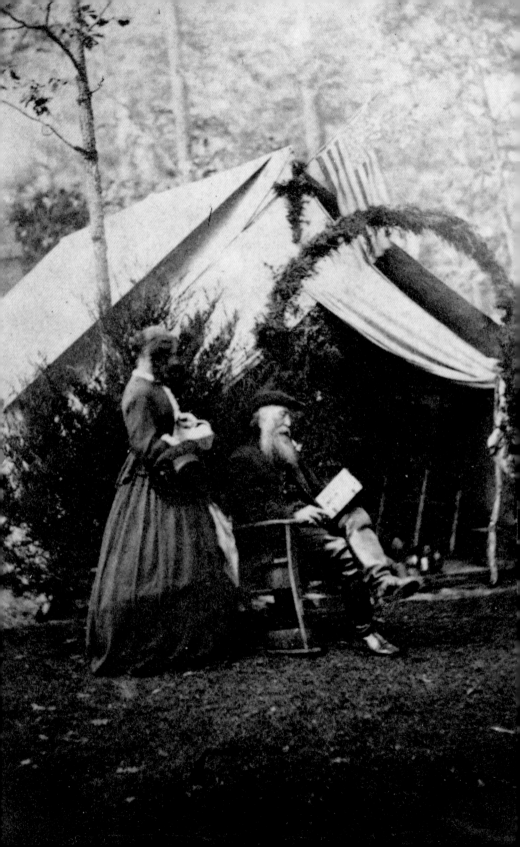

The Commission's Man in Gettysburg

After the fighting at Gettysburg ceased, mass casualties remained in crude field hospitals, private homes, and just about any shelter in the vicinity. This humanitarian crisis of epic proportions required a public and private response of equal proportion.

One of the philanthropic organizations that responded, the well-funded U.S. Sanitary Commission, sent desperately needed supplies and personnel to the scene. One of its top representatives, Rev. Gordon Winslow, the Commission's inspector for the Army of the Potomac, assisted in the operation.

Winslow, a veteran campaigner in his late 50s, brought a unique combination of spiritual and military experience to the job. A peacetime Episcopalian minister on Staten Island, N.Y., he started the war as chaplain of the 5th New York Infantry, popularly known as Duryée's Zouaves. His profile in the regiment's history reveals an indefatigable man: "He was a type of the old Revolutionary stock, possessing an iron constitution, capable of enduring any amount of hardship, with an active, untiring, energetic disposition."

When his flock of Zouaves went into battle, he went with them astride his favorite horse, Captive. "He was a man that knew no fear, and always was to be found on the advance line, sometimes even ahead of the skirmishers, and he never thought of danger or

Carte de visite by P.S. Weaver of Hanover, Pa. Author's collection.

spared himself when he could be of any benefit to the wounded," noted the historian.

Zouave commander Gouverneur K. Warren, who distinguished himself along the crest of Little Round Top at Gettysburg, confirmed Winslow's worth when he wrote in early 1863 that Winslow "has been constantly with me on the field, except when the claims of humanity and mercy called him to attend to the sufferings of his fallen comrades."

Winslow left the regiment in May 1863 when its original two-year term of enlistment expired. He joined the Sanitary Commission soon after and performed his duties well at Gettysburg. He's pictured here in the Commission's encampment.

In June 1864, less than a year after Gettysburg, he traveled aboard the Commission transport *Mary Rapley* with his injured son, Col. Cleveland Winslow, who commanded the veteran volunteers who reenlisted in the 5th. The young man had suffered a shoulder wound at Bethesda Church on June 2. As Chaplain Winslow attempted to draw a bucket of water from the Potomac River, he fell overboard and drowned. His body was never recovered. He was about 60 years old. His son succumbed to the effects of his wound on July 7, 1864.

Alone and Forgotten
on Independence Day

George L. Boss struggled from a knoll where he had taken refuge to a nearby fire as a drizzling rain fell over the battlefield during the evening of July 4. Suffering from a shell wound in his right hip, he wrapped himself in a blanket and tried to warm himself.

Two days earlier, Boss and his comrades in the 15th Massachusetts Infantry faced off against Confederates along the Emmitsburg Road near the Codori Farm. Here the Bay State boys fought hard and lost heavily. At some point during the engagement, Boss received his injury. Though the exact details of his wounding are lost, evidence suggests he may have been a victim of friendly fire. Grape and canister shot blasted from the barrels of Union field cannon fell short of the advancing enemy infantry and into the ranks of the 15th, injuring an undisclosed number of men.

The wound was the first Boss had received after two years in the army. Back in June 1861, then 19-year-old Boss had left his job as a mechanic in Fitchburg, Mass., and enlisted in Company B of the newly formed regiment. His military service record lists him as present for duty during early war actions that cost the regiment dearly in lives lost, including Ball's Bluff in late 1861 and the 1862 battles of Fair Oaks and Antietam.

Boss's character is revealed in an incident following the Union loss at Ball's Bluff, along the edge of the Potomac River in

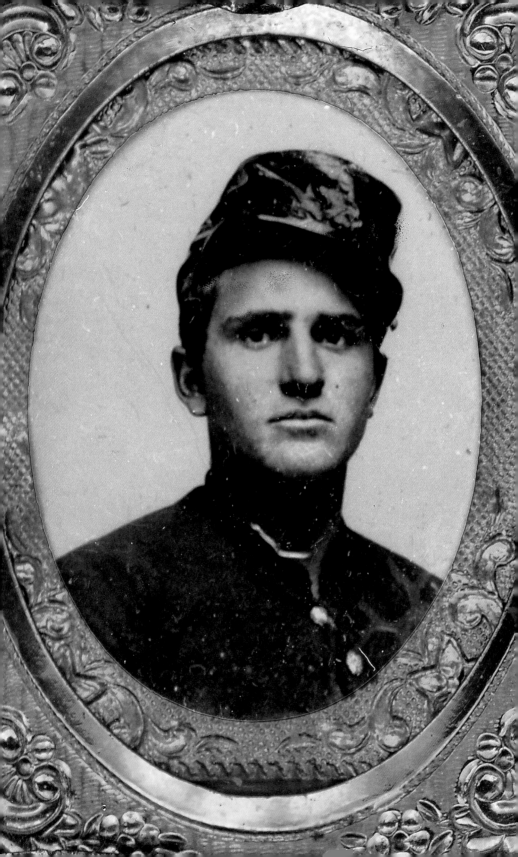

Northern Virginia. After Confederate forces drove the regiment down to the water's edge, the Massachusetts men had to cross the river to escape. Boss heard one soldier cry out that he could not swim and offered to help. Boss and others got the soldier safely across the Potomac.

At Gettysburg on July 2, Boss made his way to the makeshift field hospital at the Jacob Schwartz Farm in the vicinity of Rock Creek. He awaited treatment as critical hours passed and day turned into night, growing weaker by the minute. By the evening of July 4—more than 48 hours after his wounding—Boss had yet to receive medical attention.

Help never arrived. Boss died, huddled in his blanket by the fire in the rain.

His remains were buried on the Schwartz property and later removed to the Massachusetts section of the Soldiers' National Cemetery. His parents, Catherine and George, and a younger brother, Orlando, survived him. Orlando, who had followed Boss's lead when he enlisted in the 25th Massachusetts Infantry in September 1861, received the Medal of Honor for rescuing his mortally wounded lieutenant during the 1864 Battle of Cold Harbor.

Sixteenth-plate ambrotype by an unidentified photographer. Charles T. Joyce Collection.

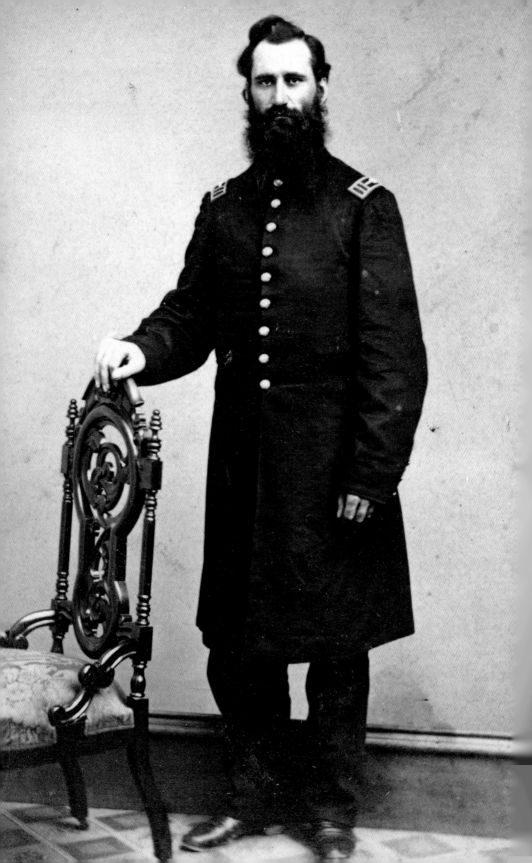

Captured Near Monterey Gap

The 5ᵗʰ New York Cavalry rode in the vanguard of Union troops pursuing the retreating Confederate army following its loss at Gettysburg. The Empire State troopers, part of a division commanded by Brig. Gen. Hugh Judson Kilpatrick, caught up with the fleeing rebels two days later.

On the morning of July 5, Kilpatrick's forces struck a wagon train near Monterey Gap, about 15 miles southwest of the battlefield. During the ensuing melee with Confederate cavalry, the chaplain of the 5ᵗʰ, Louis Napoléon Boudrye, fell into enemy hands.

Boudrye, a 29-year-old Vermont-born Methodist minister who had taken a leave from his church in Albany, N.Y., to join the 5ᵗʰ, described what happened in a letter written soon after the event. He explained how cavalry belonging to Brig. Gen. Albert G. Jenkins' brigade surrounded and captured him and others. "It was hard to say 'I surrender,'" Boudrye admitted.

His captors told him that he would be released and allowed to take his horse with him once they arrived at the headquarters of Maj. Gen. JEB Stuart. "True as the chivalry are able to be to their promises, on reaching the general, I was immediately released—of my horse and of all hopes of liberty," Boudrye quipped.

Carte de visite by Jordan H. Abbott of Albany, N.Y. Author's collection.

Not all the rebels were bad, he noted. The day after his capture, after an exhausting march with little food, the column of prisoners halted. Boudrye and his comrades made their way to soft grass to sleep. "I had just fallen into a doze, when I was roused up by a strange voice, calling 'Chaplain Fifth New York Cavalry.' Looking up, I beheld a Rebel lieutenant, with whom I had conversed a little during the day, who stepped up toward me with a cup of smoking hot coffee and a fine piece of warm bread. 'There, chaplain, I thought you might be hungry, and brought you this for your supper.' I was quite overcome with gratitude at an act so unexpected and so rare, and my heart leapt up for joy, as at the sight of the first flower of spring. That, I think, was a noble man, though he was a Rebel, and I have not found another among them like him."

Boudrye and his captive comrades continued into Virginia and on to Richmond's Libby Prison. Boudrye put his college education from New York's Troy University to work as a teacher to keep his fellow inmates spirits up. He also edited a handwritten weekly prison journal, the *Libby Chronicle*.

Boudrye spent about three and a half months in Libby before he received a parole. He returned to the regiment after his exchange and remained in uniform until July 1865 when the 5th mustered out of service. He returned to his life as a minister in New York, New England, and Canada. In 1891, his work brought him to Chicago, where he died of pneumonia a year later at age 58. He outlived his first wife, Celeste, who had died before the war. His second wife, Pearlie, and seven of their children survived him. Boudrye also left behind the *Historic Records of the Fifth New York Cavalry, The Libby Chronicle,* and religious writings.

Bayard

Soon after the guns at Gettysburg fell silent, Samuel Wilkeson stood in a dank room in the basement of the Adams County Alms House. It had been very recently filled with wounded and dying Union soldiers who left behind grisly reminders of their suffering.

Sam, a *New York Times* special correspondent attached to the Army of the Potomac, lingered at a particular spot, He described it to his daughter, Margaret, in a letter dated July 6: "I saw today a bloody mark about the size of a large man giving the outlines the human figure, that mark was made by Bayard as he lay six or eight hours dying from neglect and bleeding to death."

"Bayard" was 1st Lt. Bayard Wilkeson, 19 years old and the eldest of Sam's three sons. The young officer had arrived in Gettysburg just a few days earlier at the head of his Battery G in the 4th U.S. Light Artillery. He fell during the first day's action, as he and his gunners fought hard along Blocher's Knoll—renamed Barlow's Knoll in memory of Brig. Gen. Francis Barlow's Union forces that were hammered by advancing Confederates.

Sam sought answers about his son's death with a journalist's curiosity and the need of a grieving parent struggling to come to terms with the death of a child. He shared what he learned from interviews and personal observation with his daughter.

Sam explained that Bayard sat astride his horse giving directions to the right section of the battery when a shell struck the animal. The missile passed through the horse and smashed into Bayard's right leg below the knee. Conscious and aware of his

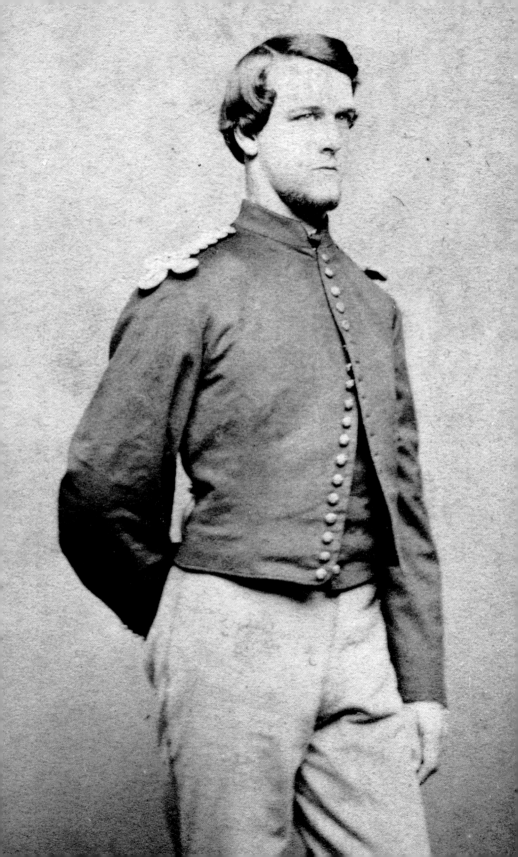

surroundings, Bayard passed command of the battery to his second lieutenant. The artillerymen limbered up and rode off in one direction as some of Bayard's men wrapped him in a blanket and carried him to safety in the Alms House crowded with other injured soldiers.

In a small room in the basement, Bayard lay by the door with the other wounded as the battle raged. Two women on the scene provided some comfort. An Irish lady wiped blood from Bayard's face and gave him water. A Black woman did what she could to help. Their efforts were not enough. He grew weaker from the loss of blood. During a period of six to eight hours, his life ebbed away as he writhed in pain, moaning loudly, and calling for his mother and father. He died about 10 p.m. without receiving medical attention.

How long Bayard's body lay in the room is not known. Eventually, the remains were wrapped in a blanket and hastily buried in a mass grave in a mud pit near a fence corner.

Sam found his son's body, but not before exhuming three other men. He found a makeshift tourniquet and bandages on and above the stump of Bayard's leg, the damaged remains of which he removed with his own knife.

The same day Sam wrote to his daughter, the *Times* published his account of the battle. It stands today as a masterpiece of American literature—and a tribute to a fallen son. It begins, "Who can write the history of a battle whose eyes are immovably fastened upon a central figure of transcendingly absorbing interest—the dead body of an oldest born, crushed by a shell in a position where a battery should never have been sent, and abandoned to death in a building where surgeons dared not to stay?"

The casket bearing Bayard's remains arrived by train in Buffalo, N.Y., on July 10. A military escort accompanied the flag-draped coffin in a solemn procession to a temporary church vault and buried Wilkeson in Forest Lawn Cemetery the next day. His stone memorial is a pedestal surmounted by an upright cannon barrel.

Easing an Epic Humanitarian Crisis

In the immediate aftermath of the Battle of Gettysburg, once bucolic fields and farms transformed from scenes of combat and bloodshed to a humanitarian crisis. As the armies withdrew, aid arrived from surrounding cities, including Baltimore, Philadelphia, and Washington, D.C.

One of the supply-laden ambulances that rolled through the streets of war-torn Gettysburg and into the Pennsylvania countryside on July 8, 1863, included Union army nurse Hattie Dada.

"The road was filled with army wagons, ambulances and wounded soldiers on their way to the railroad," Dada recalled. "All the way the houses, trees and thrown-down fences showed where shot and shell had sped on their mission of death and destruction." She added, "Nearly every house had the red hospital flag, and here and there were stacks of guns which had been gathered from the battlefield. Off at the left of the road, in the edge of the woods, could be seen the newly-made graves of those who had fallen."

Harriet Atwood Dada was no stranger to such scenes. Born in upstate New York to a cabinetmaker-minister and his wife, she answered a call to missionary work through the auspices of an influential Christian ministry, the American Board of Commissioners for Foreign Missions. She spent the years before

Ninth-plate tintype by an unidentified photographer. Chris Foard, The Foard Collection of Civil War Nursing, The Liljenquist Family Collection at The Library of Congress.

the war in Indian Territory teaching the Choctaw people and learning their language; it earned her the name "Imponna," or skillful.

As the clouds of war drew closer, polarizing politics stirred unrest in the territory and forced Dada and other Northern missionaries to flee in fear of their lives.

After the bombardment of Fort Sumter plunged the nation into civil war, Dada signed up to become an army nurse with the newly formed Women's Central Association of Relief in New York City and embarked on a crash course in caregiving at local hospitals.

Her first assignment followed the First Battle of Bull Run. Thus began an arduous journey of nursing soldiers at army hospitals. Dada came to prefer field work, finding in makeshift facilities the welfare of the soldier was the chief concern of caregivers, compared to more established hospitals, which all too often were tangled in the bureaucratic red tape.

Dada's assignment to Gettysburg was a perfect match of her skills and experience in the field. Her ambulance ride through the wrecked town and countryside ended at the George Bushman Farm. The main house, barn, and surrounding fields had been converted into a temporary tent hospital for the 12th Corps. Over the next three months, she and other nurses and medical personnel cared for hundreds of wounded and sick men here, and after July 21, at the more permanent general hospital closer to town.

Dada was colorblind when it came to treating patients. In addition to the many soldiers in blue she nursed, Hattie also cared for those in gray.

Dada was colorblind when it came to treating patients. In addition to the many soldiers in blue she nursed, Hattie also cared for those in gray. In response to one wounded Southern soldier who asked her if he would be treated, she replied, "We treat you just as we want our boys treated when they are taken prisoners."

The loneliness and homesickness that plagued many soldiers became a concern for Dada. Seeking ways to keep them from turning to alcohol, tobacco, and other vices to ease their pain, she turned to schoolchildren in New York to write letters, send newspapers, and make comfort bags filled with personal items and an encouraging note from the child who made it.

Dada left Gettysburg in October 1863 and went on to serve at army hospitals in Tennessee.

After the war, she earned a medical degree from the New York Medical College for Women in New York City and became a homeopathic doctor in Syracuse. She specialized in diseases of women and children. She wrote about her wartime experiences in a series of articles, "Ministering Angels," published in the *National Tribune* in 1884.

Dada practiced medicine well into her 60s. She died at age 74 in 1909, outliving her husband, Rev. Peter W. Emens, whom she had married in 1873.

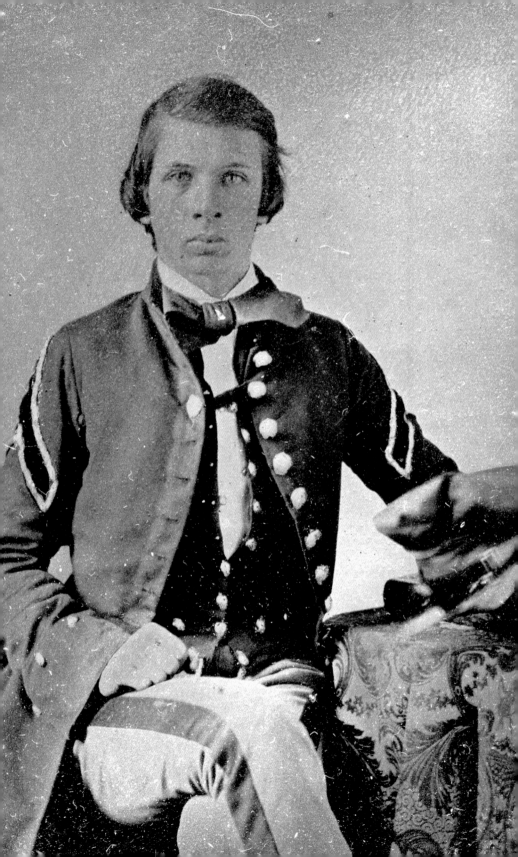

"The Solemn Change to Eternity"

The Union pursuit of retreating Confederates after the battle resulted in clashes large and small. One of them, outside Hagerstown, Md., at Funkstown, began on July 10 as a cavalry action that pitted blue and gray divisions against each other. Both sides called up reinforcements. When the fighting ended, the casualty list of about 500 included Augustine Leftwich, Jr. of Shoemaker's Battery, Virginia Horse Artillery. He suffered severe wounds in his lungs and in a shoulder.

The son and namesake of a tobacconist in Lynchburg, Va., Leftwich had joined the army more than two years earlier. In May 1861, at about age 18, he enlisted in an independent battery originally commanded by Capt. Marcellus N. Moorman and later by Capt. John J. Shoemaker. The artillerists fought in numerous engagements with the Army of Northern Virginia, notably the 1862 Peninsula Campaign. Along the way, Leftwich advanced from corporal to sergeant.

During the Gettysburg Campaign, Shoemaker's Battery rolled into Pennsylvania with the rest of the Confederate army but did not take part in the battle. According to one diarist, the artillerists heard the massive cannon duel that erupted prior to Pickett's Charge. Seven days later near Funkstown, the battery did engage

Sixth-plate tintype attributed to an unidentified photographer in Lynchburg, Va. Rusty Hicks Collection.

and fired until exhausting most of its ammunition and eventually withdrew with the rest of the Confederate forces.

Leftwich, too desperately wounded to make the trip to Virginia, was left behind. Carried to a nearby preparatory school, the College of St. James, he received treatment at the institution's hospital. He wrote to an unnamed friend in New York City, who visited him and made sure all his needs were met. Despite the friend's efforts, and the assistance of local women from Hagerstown, Leftwich succumbed to his injuries on July 29. A prominent Episcopal minister, Rev. John Barret Kerfoot, tended to his spiritual needs at the end. Leftwich's remains were placed in a walnut coffin and buried in St. John's Episcopal Church Cemetery in Hagerstown.

The clergyman wrote a letter to Leftwich's parents, informing them of his death and "the comforting assurance that their beloved son died in a state of hopeful preparation for the solemn change to eternity."

Meade's Parable

Nine days after the fighting at Gettysburg ended, the opposing armies poised for renewed combat along the Potomac River near Falling Waters, Md. On that Sunday, July 12, federal commander George G. Meade and his staff rode along the lines and took stock of the situation.

At one point, the entourage arrived near the position of the 118th Pennsylvania Infantry. Before long, three companies of Pennsylvanians received orders to support the picket line.

Battle appeared imminent.

These developments concerned the chaplain of the 118th, William J. O'Neill, who objected to fighting on the Sabbath. A son of Ireland and the younger brother of the regiment's major, Henry O'Neill, he had labored as a Methodist minister in Philadelphia prior to his enlistment.

Chaplain O'Neill strode solemnly with hat in hand to Meade and asked the general to postpone an attack until the next day. Eyewitnesses braced for Meade's reaction, for the general's irascible nature had earned him the nickname "Old Snapping Turtle."

The historian of the 118th recorded O'Neill's fate. "All who heard him expected he would meet a crushing rebuke, but instead of this General Meade received his interrogation most graciously and naively replied in parable, drawn to it doubtless by the scriptural calling of his interrogator." Meade revealed in his parable that he was like a man under contract to build a box.

Four sides and the bottom were complete. Now, it was time to put on the top and finish the job.

O'Neill bristled. The regimental historian continued, "'Then,' said the chaplain in tones as if he were administering Heaven's thundering anathemas, 'as God's agent and disciple, I solemnly protest, and will show you that the Almighty will not permit you to desecrate his sacred day with this exhibition of man's inhumanity to man. Look at the heavens; see the threatening storm approaching.' And the chaplain's prediction had scarce been made before it was fulfilled. The clouds that had been gathering all afternoon suddenly broke forth in copious showers, vivid lightning and pealing thunder followed and deep darkness."

The rain washed out any plan Meade might have had for an immediate advance in this sector. Meanwhile, Meade convened a council of war with his generals. Ten days earlier, on the second day at Gettysburg, he had held a similar meeting and decided to fight.

On this occasion, he decided to delay action—and the Confederates slipped across the Potomac to the safety of Virginia soil.

Chaplain O'Neill served with the 118th through the war's end. He went on to minister to Methodist faithful until his death in 1887 at about age 55. News of his passing traveled across the Atlantic to O'Neill's birthplace in Lisburn, Ireland, where townspeople mourned his loss.

Carte de visite by Theodore Evers of Philadelphia, Pa. Rick Carlile Collection.

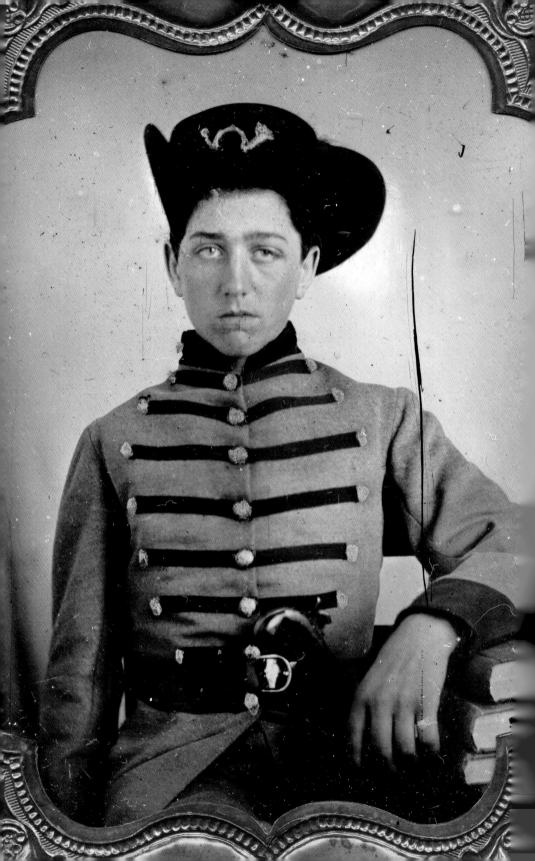

A River Crossing Too Far

In the ranks of the 11ᵗʰ Mississippi Infantry at Gettysburg
marched a Northern-born soldier and relative newcomer to the
South. John F. Brown, a native of Ohio, had celebrated his 18ᵗʰ
birthday just a few days before the battle began.

How Brown came to be a member of the regiment dates to
1861. A 16-year-old student at the University of Mississippi in
Oxford, he and his college buddies joined the Lamar Rifles,
a local militia unit, when the war began. It mustered into
Confederate service as Company G of the 11ᵗʰ and joined the
Army of Northern Virginia. Brown was present for duty in many
of the early war engagements in which the 11ᵗʰ participated,
including Malvern Hill and other actions during the Peninsula
Campaign and Second Bull Run. He missed the Battle of
Antietam, during which the regiment lost heavily, including its
flag bearer and the colors.

Brown had returned to action by Gettysburg and participated
in Pickett's Charge, which cost the Mississippians about half of
the estimated 400 men present.

Brown managed to escape injury but was not so lucky during
the long retreat to Virginia. On July 14 at Falling Waters, a
bucolic spot along the Potomac River about 50 miles south and
west of Gettysburg, Union forces attacked. Brown suffered a

Sixth-plate tintype by an unidentified photographer. Brian Boeve Collection.

minor wound and fell into enemy hands only a river crossing away from Confederate territory. His captors hustled him off to Washington, D.C., and held him as a prisoner of war in the Old Capitol Prison until early 1864, when he was exchanged and returned to the South.

Brown rejoined his regiment in time to participate in the Siege of Petersburg. Union forces captured him again during the April 2, 1865, assault that ended with the fall of the beleaguered city the next day. His captors carried him off to Fort Delaware, Del., where he remained until he signed the Oath of Allegiance to the federal government on June 11, 1865.

After leaving prison, Brown made his way back to Oxford, where he married twice. In 1906, he participated in dedication ceremonies for the Confederate monument at Oxford. He died 12 years later at age 72. He outlived two children and was survived by his wife, Katherine.

"He Had Been Where the Angels Were"

Some days after the conclusion of the battle, Abbie Louisa Ellis Babcock received the news of her soldier-husband's condition by telegraph at her home in Lowell, Mass. A bullet had mangled his left elbow and necessitated an amputation of his arm, which left him in a dying condition. She rushed to Gettysburg to be by his side.

Eight years earlier, Abbie had married Alonzo J. Babcock in her home state of New Hampshire. They were young. Abbie had yet to celebrate her 14th birthday. Alonzo had been born 19 years earlier in Norwich, Vt. They soon departed for Lowell, perhaps attracted by manufacturing jobs in the flourishing cotton industry.

Babcock found work in Lowell as a weaver. When war divided the country in 1861, he joined Company A of his adopted state's 2nd Infantry. He began his service as a corporal and earned his sergeant's stripes about two months after the Battle of Antietam.

Less than a year later, he received the crippling arm wound during the July 3 assault against Culp's Hill best remembered by the words of the regiment's lieutenant colonel, Charles R. Mudge. He responded to the order to attack, "Well it is murder, but it's the order." Babcock became one of about 135 killed and wounded in the regiment. The list of casualties also included

OBITUARY.

DIED AT THE GENERAL HOSPITAL, GETTYSBURG, PENNSYLVANIA,

July 17th, 1863,

FIRST SERGEANT ALONZO J. BABCOCK,

COMPANY H, MASSACHUSETTS SECOND REGIMENT,

AGED 27 YEARS AND 5 MONTHS.

THUS has another of our brave brothers fallen! Another home-circle is rendered desolate; another fond and trusting heart is draped with the sombre weeds of widowhood; another sacrifice is laid upon the altar of our country; and another victim to the fury of this God-accursed rebellion!

Mr. BABCOCK joined the Massachusetts Second Regiment, Company A, on the 11th day of May, 1861, and had hence been in the service of his country during two years, one month and twenty-six days. He participated in the battles of Cheat Mountain, Antietam, and Gettysburg, and all the battles in which the Second Regiment took part, and was at home but once during the entire time, and that for a period of only fifteen days.

On the third of July last, the eventful day of the late terrible battle of Gettysburg, he was struck by a minnie ball, which crashed through the elbow joint of his left elbow, rendering amputation necessary. Soon it became apparent that he must die, and at once his wife was telegraphed for, who hastened to his side, and during two weeks stood beside his bed, soothing his pain and ministering to his wants as only a wife can.

Some time before his death, Mr B. was enabled to cast his soul on Jesus by a saving faith, which wonderfully sustained him to his latest breath.

Just before he breathed his last, he called his weeping wife, and told her "he had been where the angels were, and they were with him;" that all was peace; that Christ was precious, and that he was ready to go, and with his dying breath he commended her to Jesus' care.

Many, many hearts in Lowell will mourn his loss, for "all who knew him loved him." He sleeps to-day with many sainted dead, in the Cemetery of Gettysburg, among whose cold and silent tombstones the battle raged so furiously only one short month ago. Four lonely mourners were all that stood beside his grave, when he was laid to rest, but angel watch the place; and when the trump of God shall sound the reveille which calls His Children home, our brother will come forth to inherit that mansion prepared for him on high.

J P LUDLOW,

Delegate of Christian Commission, Gettysburg, Pa.

Albumen print mounted to a memorial obituary notice. Paul Russinoff Collection.

Mudge, who suffered instant death when a bullet struck him just below his throat.

Babcock's case attracted the attention of James Peter Ludlow. A 30-year-old native of Charleston, S.C., he had taken a break from his studies at New York's Rochester Theological Seminary to minister to soldiers under the auspices of the influential U.S. Christian Commission. Ludlow ministered to Babcock as his life slowly ebbed away.

Ludlow recalled Abbie standing vigil over her dying husband over a two-week period. He also recounted Babcock's final words: "Just before he breathed his last, he called his weeping wife, and told her 'he had been where the angels were, and they were with him;' that all was peace; that Christ was precious, and that he was ready to go, and with his dying breath he commended her to Jesus' care." Babcock's remains are buried in the Massachusetts section of the Soldiers' National Cemetery.

Ludlow went on to become an ordained Baptist minister in 1864 and enjoyed a long career in service to his faith. He died at age 65 in 1898.

Abbie, widowed and without children, applied for and received a military pension before the end of 1863 to compensate her for the loss of her husband. This was the last time her name appeared on a federal government record.

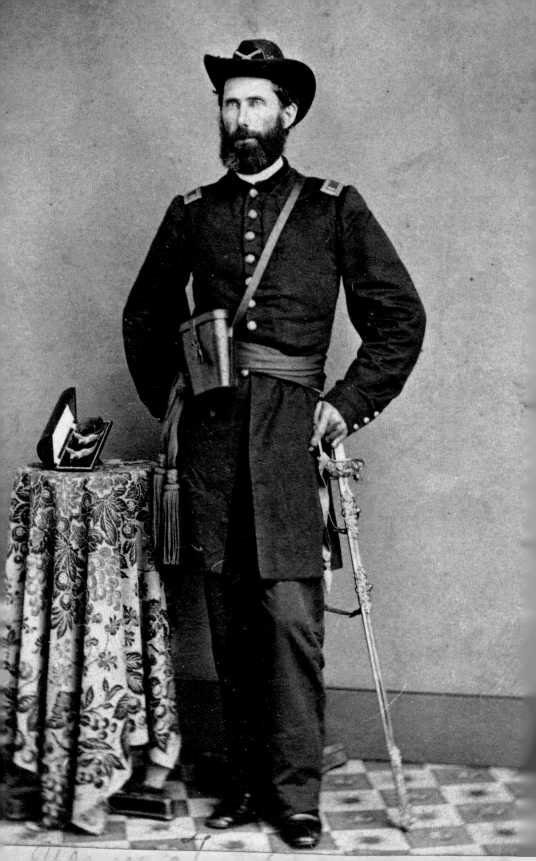

Gifts from Grateful Comrades

Following the battle, officers across the Army of the Potomac
filed official reports to detail the participation of their individual
commands. One of those leaders, 1st Lt. George Washington
Norton of the 1st Ohio Light Artillery, described the role of his
Battery H on the second and third days of the fight.

Norton could be justly proud of his gun crews. They manned
a half-dozen muzzle-loading rifled cannon with quiet confidence
gained on numerous battlefields, including Fredericksburg and
Chancellorsville. On July 2, the men lobbed shot and shell from
Cemetery Hill at enemy artillery during the afternoon and took
part in a sharp duel that evening. On July 3, they continued
to pump rounds into the enemy as Pickett's Charge unfolded.
Altogether, they fired 767 rounds and lost seven men, eight
horses, and a gun carriage.

The Buckeye State boys were equally proud of Norton. A
couple months after the battle, they presented him with an
expensive sword and eagle-headed spurs as a token of their
appreciation. Norton posed with them in this portrait, along
with his field glasses.

Norton's relationship with his comrades dated from the war's
beginning. A farmer in Toledo, Ohio, the New York-born Norton
played a key role in organizing the battery.

Carte de visite by Charles G. Crane of Philadelphia, Pa. Author's collection.

Norton went on to receive his captain's bars and continued in command of Battery H until he resigned in April 1864. His men continued into Virginia, fighting in the battles of the Overland Campaign and the Siege of Petersburg.

In June 1865, the survivors of Battery H reported to a camp in Cleveland, Ohio, to be mustered out of the army. One visitor identified as "Mc" described them in the *Cleveland Daily Leader:* "Their faces and bearing are so firmly associated with forts, breastworks, and Virginia surroundings that it was hard to realize that they really were in a land of peace, and were soon to become citizens." The writer added that if these veterans become as good citizens as they were soldiers, "no more need to be asked of them from this Republic."

Norton, who had already transitioned back to civilian life on his farm in Toledo, illustrated the writer's point. He lived a quiet life for the remainder of his days, dying in 1906 at age 87. Five of his children survived him.

Twice Absent Without Leave

On Sept. 15, 1863, a provost marshal arrested a deserter in the Massachusetts town of Marlborough. The accused had gone missing from an army hospital in Philadelphia, Pa., at the end of July. Military police transported him to headquarters in Boston, about 35 miles east, for processing.

The accused soldier, Pvt. Rufus K. Cooper, had received a serious wound during the recent Battle of Gettysburg. He and his comrades in the 15th Massachusetts Infantry suffered heavy losses in the fighting in and about the Codori Farm on the afternoon of July 2. During the engagement, a 12-pound artillery shell struck Cooper a glancing blow in the chest. According to one report, the round may have been friendly fire. Wherever it came from, it took him out of action.

Medical personnel forwarded Cooper to Mower General Hospital in the Chestnut Hill section of Philadelphia. In early August, a doctor detailed the nature and effects of the injury, "The shell struck the left chest, fractured the seventh and eight ribs and seriously injured the whole side. He spits blood every day and is troubled about breathing. He is barely able to walk and very much needs a few weeks of rest."

On July 31, 1863, Cooper left the hospital without permission and made his way to Massachusetts, from where he had labored as a painter prior to his enlistment two years earlier. He joined the ranks of Company C and fought his first battle at Ball's Bluff

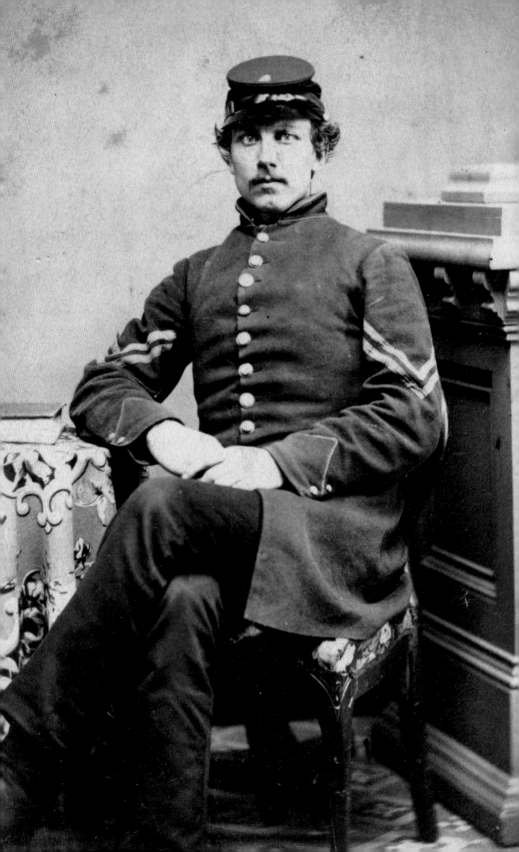

along the banks of the Potomac River in Northern Virginia in October 1861. Captured with many others in the regiment, he spent a year as a prisoner of war in the Confederate capital before military authorities exchanged him. On October 31, 1862, on his way to freedom aboard a car on a military railroad, he went absent without leave—his first stint as a deserter.

The army caught up with him in March 1863 and quietly returned him to duty.

A few months later he suffered the shell wound at Gettysburg that ultimately led to his second desertion. The provost marshal ultimately dropped formal charges that might have led to a court-martial and possible execution. Instead, they slapped him with a $20 fine and sent him back to the front lines. This time, he remained with his company until it and the rest of the regiment mustered out of service at the end of its three-year enlistment in July 1864.

The fact that the military chose not to make an example of him for his double desertion, and the presence of corporal's stripes in this portrait, suggests he was a good soldier who received favorable treatment—a relatively common occurrence in the nonprofessional volunteer armies during the war.

Cooper returned to Massachusetts and lived until 1905, dying at age 66 from a cerebral hemorrhage. His wife, Mary, whom he had married in 1862, survived him.

Carte de visite by J.J. Boynton of Clinton, Mass. Mark Savolis Collection.

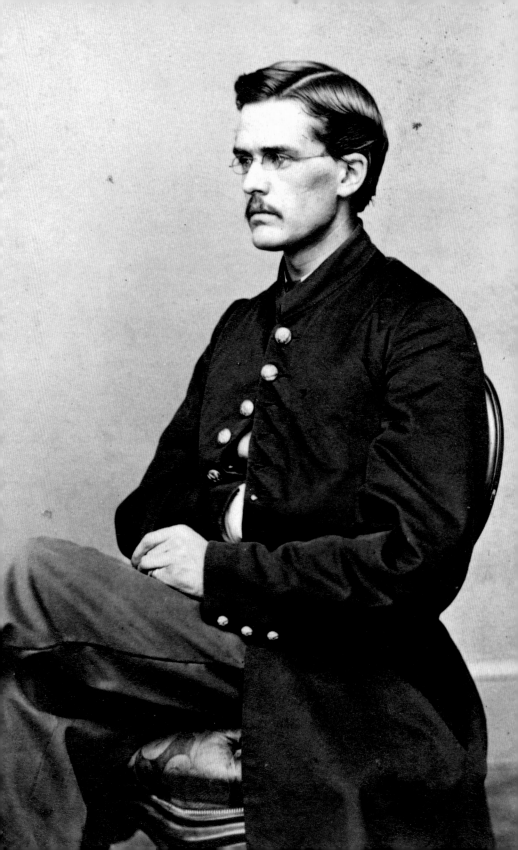

Pioneer Gettysburg Battlefield Guide

One day in the autumn of 1890 in Gettysburg, a group of
Marylanders set out for a tour led by Charles Austin Hale, a
popular battlefield guide. Hale, a lecturer and authority on Paul
Philippoteaux's Cyclorama painting, had firsthand knowledge of
the three-day fight.

More than a quarter-century earlier, then 2nd Lt. Hale and his
comrades in the 5th New Hampshire Infantry, 182 strong, led the
counterattack in The Wheatfield during the afternoon of July 2.
In two hours, it lost about 45 percent of its numbers. Hale sur-
vived without injury and received a promotion to first lieutenant.

The Maine-born son of a Baptist minister, Hale thrived in the
army. He joined the 5th as a corporal in Company C and proved
an able soldier in the 1862 Peninsula Campaign, during which
he suffered a minor wound during the engagement at Fair Oaks,
and the Battles of Antietam and Fredericksburg. Along the way,
he earned his sergeant's stripes.

At Fredericksburg, Hale composed part of the color guard.
During the intense fighting at Marye's Heights, six color bearers
suffered wounds, including Hale. Though the nature of his injury
went unreported, a comrade recalled overhearing Hale ask, "Who
will care for the flag?" as he was carried off the field of battle.

Carte de visite by George B. Billings and Albyron E. Hough of Lebanon, N.H. Dave Morin
Collection.

In early 1863, Hale advanced in rank to the regiment's sergeant major and then second lieutenant. He served in this capacity at Chancellorsville, where he suffered his third war wound, and at Gettysburg, where he tended to his mortally wounded colonel, Edward E. Cross.

The rigors of camp and campaign compromised Hale's health. He resigned a month after Gettysburg and found employment in Washington, D.C., as a War Department records copyist. He returned to the regiment in early 1865, received his captain's bars, and mustered out at the war's end. The 5th went down in history as having suffered the most battlefield deaths of any Union regiment.

Hale went on to marry and work as a machinist in New Jersey before becoming involved with the Gettysburg Cyclorama and, later, with tours of the battlefield. Though not the first professional guide at Gettysburg—this honor falls to Sgt. William David Holtzworth of the 87th Pennsylvania Infantry according to The Association of Licensed Battlefield Guides—Hale's pioneer work contributed to the high standards for which today's guides are recognized. He worked closely with the Tipton brothers, who held a photographic monopoly in Gettysburg throughout the late 19th and early 20th centuries.

In 1899, Hale died at age 58 after a brief illness.

A Unique Unveiling

Monuments honoring the heroes of the Union army and navy
popped up across the Northern states in the decades following
the war. One of the more unusual dedications occurred in New
Haven, Conn., on June 16, 1905.

On that day, throngs of aging veterans, their families, and
others from across Connecticut and New England braved unsea-
sonably warm weather to participate in the ceremony and witness
the unveiling of an imposing 30-foot tall monument. A granite
pedestal flanked by an infantryman and an artillerist supported
a column topped by a bronze eagle. It paid tribute to several reg-
iments and batteries organized in the state. Organizers draped a
huge flag over the monument, the crowd waiting with anticipa-
tion for the moment of its release to reveal the beauty beneath.

The moment came midway through the formal program. After
a patriotic song performed by a local boys' choir, an aging, arm-
less veteran gripped a string in his teeth and pulled on it. The
large flag slid down and revealed the full monument. The old
soldier, with a small flag attached to the end of the string, made
his way to the platform, and presented it to the head of the dedi-
cation committee.

The armless veteran, Pvt. George Washington Warner of the
20th Connecticut Infantry, needed no introduction to many in
attendance. A Connecticut native, he had left behind his Irish-
born wife, Catherine, five children, and his job as a millworker,

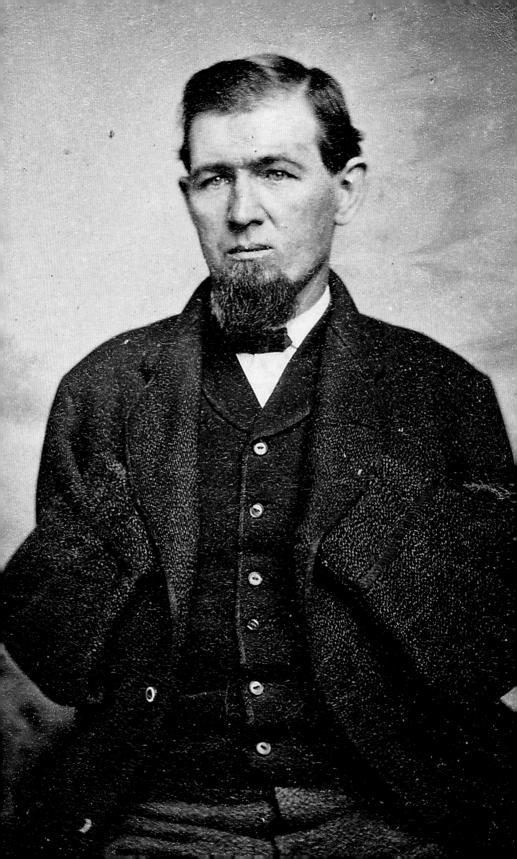

to enlist in the army in 1862. A year later at Gettysburg, on the morning of July 3, 1863, Warner and his comrades battled Confederates at Culp's Hill. During the clash, a shell fired from a Union cannon struck a tree above him and exploded. Fragments of iron tore off his right arm and severely damaged the other.

Less than an hour later at a field hospital, a surgeon sawed off his remaining arm. Medical personnel eventually cleared him to leave Gettysburg for a Philadelphia military hospital, where Catherine joined him to aid in his recuperation.

The couple returned to Connecticut, where Warner applied for and received a government pension. To supplement his income and feed his family, which grew to eight children, he sold books and traveled around the area selling his photograph and telling his story. The photograph included here, stenciled with his name, is among the dozen known portraits for which he sat between 1864 and 1887.

Warner returned to Gettysburg in 1885 and participated in the dedication of the monument to the 20th at Culp's Hill. He revealed the granite sentinel by means of a rope and pulley system connected from the draped flag to his waist. He went on to participate in two more unveilings, including the 1905 event in New Haven, where he and his family had settled.

Warner lived until age 91, dying in 1923. He outlived Catherine, five of his children, and many of his army comrades.

Carte de visite by an unidentified photographer. Buck Zaidel Collection.

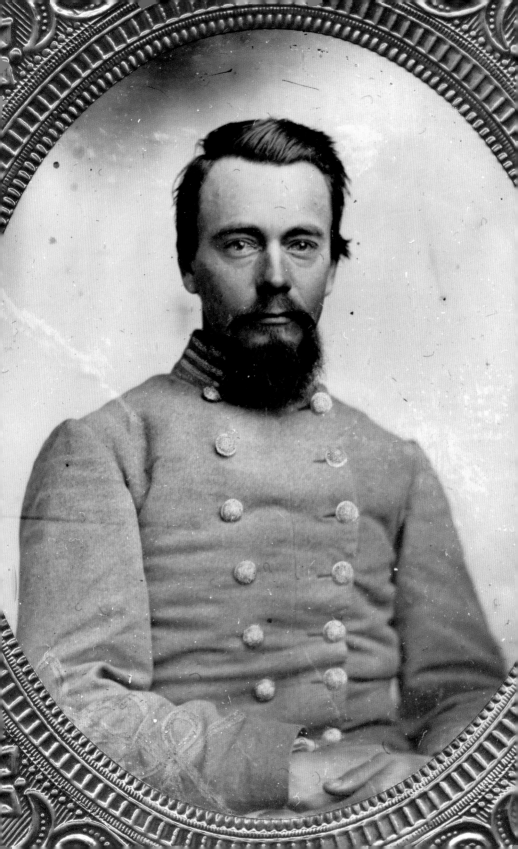

Final Charge

Benjamin James Hawthorne charged across an open field at Gettysburg on a summer's day in 1913. The old soldier and the veterans with him were full of fight and pride even though their youth had faded, like the Civil War, into the distant past.

Exactly 50 summers earlier, then Capt. Hawthorne had run across the same field into the bloody inferno that was Pickett's Charge. Just two weeks prior, he had been detached from his regiment, the 38th Virginia Infantry, for temporary duty on the staff of Brig. Gen. Lewis A. Armistead. They marched in the second line of battle. Armistead would not come back. He suffered a mortal wound as he held his sword aloft with his hat perched on the tip of the blade. Hawthorne received a gunshot wound in the left arm before he reached the stone wall behind which the enemy poured forth sheets of flame from musket and field cannon. Somehow, he managed to make his way back across the field littered with dead and dying men.

Hawthorne recovered from his injury, returned to command his company in the 38th, and surrendered at Appomattox on April 9, 1865.

A gifted student before the war who had graduated as valedictorian of the Randolph-Macon College class of 1861, Hawthorne went on to a 40-year career as a college professor. He spent much

Sixth-plate ambrotype by an anonymous photographer. Rusty Hicks Collection.

of his tenure at Oregon at Corvallis College (now Oregon State University) until 1884 and at the University of Oregon thereafter. An energetic and innovative educator, he established a formal curriculum of psychology at the University of Oregon.

According to one observer, he was a popular though eccentric professor who preferred to dress in gray hat, gloves, and suit. "Hawthorne was a tall man whose style of beard seemed to elongate him even more; he apparently had little expression in his eyes—sort of dreamy, and they would not seem to focus on anything…but they made a definite impression on his students."

Hawthorne was also remembered for his appearances at the annual Grand Army of the Republic parades. "He showed up in full Confederate dress and hollered rebel yells at the marching Union veterans," noted one writer.

After his retirement in 1910 he earned a law degree and became an attorney, and the G.A.R. was one of his clients.

Hawthorne died in 1928 at age 90. He outlived his wife, Emma, and four of his five children.

REFERENCES

The original research and writing of these profiles occurred between 2014 and early 2021 for *Military Images* magazine. In some cases, the image owner supplied notes or copies of documents, to which I added additional research and wrote capsule biographies. In others, I performed all the research and writing. A small number of profiles originally appeared in the magazine as feature-length stories researched and written by Senior Editors Charles T. Joyce and Paul Russinoff, sometimes in collaboration with others. A few were researched and written by volunteers Selden Hunnicutt, and August Marchetti. In my capacity as editor, I fact-checked and edited the writings produced by Joyce, Russinoff, Hunnicutt and Marchetti. The magazine's copy editor, Chuck Myers, edited all the capsule biographies and full-length feature stories. A team of proofers also reviewed the text prior to publication. The longest-serving member of the proofing team is Copy Editor Jack Hurov. The current active members are Copy Editor Chuck Myers, Executive Editor Rick Brown, Senior Editor Ron Field, and Contributing Editors Dan Binder, Michael R. Cunningham, PhD, and Ron Maness. Other proofers include Peter Horkitz, Linda Horkitz, Phyllis Sukys, Sue Evanko, and Anne Coddington.

In July 2021, I selected 100 profiles from the magazine and embarked on a 114-day project to produce the manuscript that became this book. I dedicated one day to review and write expanded versions of the original 100 capsules and/or full-length biographies. I had kept all the original research, related documents, and communications, which proved invaluable in meeting

my daily goal. I budgeted an additional 14 days to prepare the front and back matter. I completed the manuscript on Oct. 31, 2021.

This book, and my other writings about the Civil War and photography, would not have happened without the support of Anne Coddington, my wife. She has supported my need to collect and chronicle for as long as I can remember. My mother, Carol Coddington, who is also the advertising director of *Military Images*, nurtured my interest in history and art, and continues to be actively involved at the Civil War shows in Gettysburg and Franklin, Tenn.

My daily routine for the first 100 days began with a review of the original research and searching for any new sources of information that might have come to light since first publication in *Military Images*.

Basic research included The American Civil War Research Database by Historical Data Systems, Inc., and three Ancestry .com LLC products: Ancestry.com, Find a Grave, and Fold3. From these sources I collected biographical information about the individual, including life dates, genealogical details, and military service and pension records. Every profile includes information gleaned from these sources.

I also collected articles from Newspapers.com, owned by Ancestry.com LLC, and performed unique keyword searches on Google for digitized books, magazines, pamphlets, and other publications, as well as personal accounts in the form of letters, diaries, and other writings by the individuals profiled and others. These sources are not reflected in every profile. When they were used, I noted them in the following collection of references.

CHAPTER 1

Klinefelter: Russinoff, Paul. "Return and Retreat at Gettysburg: A Seminarian Is Called to Arms to Defend His College Town." *Military Images* (Summer 2016).

Saunders: Jordan, Cornelia J. *Echoes from the Cannon.* Buffalo, N.Y.: Charles Wells Moulton, 1899; Trout, Robert J. *Memoirs of the Stuart Horse Artillery Battalion, Moorman's and Hart's Batteries.* Knoxville, Tenn.: University of Tennessee Press, 2008; *Chattanooga Daily Gazette,* Chattanooga, Tenn., July 2, 1863.

Paxton: Russinoff, Paul. "President Lincoln's Bodyguard for a Day: Sgt. H. Paxton Bigham's Gettysburg Experience." *Military Images* (Summer 2019); *Richmond Dispatch,* Richmond, Va., April 5, 1896; Horner, John B. *Sgt. Hugh Paxton Bigham: Lincoln's guard at Gettysburg.* Gettysburg, Pa.: Horner Enterprises, 1994; *Altoona Tribune,* Altoona, Pa., March 10, 1926.

Cheney: *Specifications and Drawings of Patents Issues from the United States Patent Office for October, 1880.* Washington, D.C.: Government Printing Office, 1880; *York Daily,* York, Pennsylvania, Dec. 3, 1903.

Harris: *Milwaukee Sunday Telegraph,* Dec. 20, 1884, and Feb. 15, 1885.

Clark: Kimball, George. "A Young Hero of Gettysburg." *The Century Magazine* (November 1886); *The Times-Democrat,* New Orleans, La., July 20, 1867.

CHAPTER 2

Severs: Isenberg, Britt C. "Early Encounter in Familiar Territory." *Military Images* (Summer 2020); Moyer, Henry P. *History of the Seventeenth Regiment Pennsylvania Volunteer Cavalry.* Lebanon, Pa.: Sowers Printing Company, 1911.

Bahn: Gibson, John, ed. *History of York County, Biographical Sketches.* Chicago, Ill.: F.A. Battey Publishing Co., 1886.

Gordon: *Detroit Free Press,* Aug. 31, 1878; Farmer, Silas. *History of Detroit and Wayne County and Early Michigan.* Detroit, Mich.: Silas Farmer and Co., 1890.

Green: Marchetti, August. "A Traded Rifle and a Horrible Hole." *Military Images* (Summer 2020); Green, Wharton J. *Recollections and Reflections: An Auto of Half a Century and More.* Raleigh, N.C.: Edwards and Broughton Printing Company, 1906.

Webb: Fisher, George E. *Catalogue of the Delta Kappa Epsilon Fraternity.* New York, N.Y.: Council Publishing Company, 1890.

Mall: *The Union Army,* Volume I. Madison, Wis.: Federal Publishing Company, 1908.

Thayer: Cook, Benjamin F. *History of the Twelfth Massachusetts Volunteers.* Boston, Mass.: Franklin Press, 1882; *Biographical Sketches of Representative Citizens of the Commonwealth of Massachusetts.* Boston, Mass.: Graves & Steinberger, 1901; *The Boston Globe,* July 22, 1905.

Cady: Michael Kirley, Company K, 97th New York Infantry, to Daniel Cady, Sept. 7, 1863. Rush P. Cady Papers, American Civil War Collection, Hamilton College, Clinton, N.Y.; 97th New York Infantry Regiment's Civil War Newspaper Clippings, New York State Military Museum and Veterans Research Center, Saratoga Springs, N.Y.

McMahon: *War Talks in Kansas.* Kansas City, Mo.: Press of the Franklin Hudson Publishing Company, 1906.

Link: *The Scranton Republican,* Scranton, Pa., July 14, 1899.

Atlee: Dreese, Michael A. *The 151st Pennsylvania at Gettysburg, Like Ripe Apples in a Storm.* Jefferson, N.C.: McFarland & Company, Inc., Publishers, 2000; Charles L. Atlee to Col. George McFarland, 151st Pennsylvania Infantry, March 21, 1866. J. Horace McFarland Papers, Pennsylvania State Archives, Harrisburg, Pa.

Reisinger: Chamberlin, Thomas. *History of the One Hundred and Fiftieth Regiment Pennsylvania Volunteers, Second Regiment, Bucktail Brigade.* Philadelphia, Pa.: F. McManus, Jr., & Co., 1905; *The News-Herald,* Franklin, Pa., May 26, 1925.

Beck: *The Southern Recorder,* Milledgeville, Ga., Sept. 15, 1863; Freeman, Valerie J., ed. "James W. Beck." Pike-Wilkes-Meriwether County Ga Archives Biographies. files.usgwarchives.net/ga/wilkes/bios/bs33.txt

Murphy: Hall, Isaac. *History of the Ninety-Seventh Regiment New York Volunteers ("Conkling Rifles") in the War for the Union.* Utica, N.Y.: L.C. Childs & Son, 1890; Abbott, Allen O. *Prison Life in the South During the Years 1864 and 1865.* New York, N.Y.: Harper & Brothers, 1865; Wesley, Zachary. "A Slaughter Forgotten: A Reflection on the Wayside on Iverson's Assault." The Gettysburg Compiler. gettysburgcompiler.org/2018/05/11/a-slaughter -forgotten-a-reflection-on-the-wayside-on-iversons-assault/

Knaggs: *Detroit Free Press,* Sept. 27, 1862; Ross, Robert B., ed. *History of the Knaggs Family of Ohio and Michigan.* Detroit, Mich.: Clarence M. Burton, 1902; Libby Prison War Museum Association. *Libby Prison War Museum Catalogue and Program.* Chicago, Ill.: Foster Roe and Crone, 1889.

Seas: *The Marion Star,* Marion, Ohio, April 4, 1961.

Vaughan: Marchetti, August. "Georgians in Gray: Images from the David W. Vaughan Collection." *Military Images* (Spring 2020).

Burgwyn: Batalo, Dave, Rusty Hicks, and Ronald S. Coddington. "Cadet to Boy Colonel: The Life and Service of North Carolina's Henry King Burgwyn, Jr." *Military Images* (Summer 2019).

Payne: Jones. J. William. *Southern Historical Society Papers,* Vol. 28. Richmond, Va.: Richmond Historical Society, 1900; Sgt. Charles A. Cameron, 17th Mississippi Infantry, to William C. Payne, March 16, 1864. Jeff Kowalis Collection.

Smith: Dunkelman, Mark H. "'Hard Luck Regiment': The Life and Times of the 154th Infantry." *Military Images* (Spring 2015).

CHAPTER 3

Johnston: Smith, Karlton D. "To Consider Every Contingency." Papers of the 2006 Gettysburg National Military Park Seminar, Gettysburg National Military Park, Gettysburg, Pa.; Coddington, Ronald S., and Dave Batalo. "Fallout from the Johnston Reconnaissance: A late-war letter by Robert E. Lee sheds light on an enduring Gettysburg controversy." *Military Images* (Summer 2018).

Leach: *The Medical and Surgical History of the War of the Rebellion,* Part II, Vol. II. Washington, D.C.: Government Printing Office, 1876.

McDowell: *The Pittsburgh Daily Commercial,* Pittsburgh, Pa., March 5, 1864.

Hooks: Mulholland, St. Clair A. *Story of the 116th Regiment, Pennsylvania Infantry.* Philadelphia, Pa.: F. McManus Jr., 1899; *National Tribune,* Washington, D.C., Oct. 7, 1897; Brockett, Linus P., and Mary C. Vaughan. *Woman's Work in the Civil War: A Record of Heroism, Patriotism, and Patience.* Philadelphia, Pa.: Zeigler, McCurdy, 1867; Hunnicutt, Selden. "Ministering Angels." *Military Images* (Spring 2015); Coddington, Ronald S. *Faces of Civil War Nurses.* Baltimore, Md.: Johns Hopkins University Press, 2020.

De la Mesa: Rodriquez, Amanda, "Essay on The Collection and De La Mesa." New York State Military Museum and Veterans Research Center. museum.dmna.ny.gov/unit-history/ infantry/39th-infantry-regiment/captain-carlos-alvarez-de -la-mesa-collection/essay-collection-and-de-la-mesa; 39th New York Infantry Regiment's Civil War Newspaper Clippings,

New York State Military Museum and Veterans Research Center, Saratoga Springs, N.Y.; *Times Union*, Albany, N.Y., Oct. 8, 2011; Smith, John D. "'The Work It Did Not Do Because It Could Not': Georgia and the 'New' Freedmen's Bureau Historiography." *The Georgia Historical Quarterly* (Summer 1998).

Chew: *Final Report of the Gettysburg Battle-field Commission.* Trenton, N.J.: The John L. Murphy Publishing Company, 1891; Bowen, George A. "The Diary of Captain George A. Bowen 12th Regiment New Jersey Volunteers," *The Valley Forge Journal* (1985); Coddington, Ronald S. "Defending Bliss Barn." *Civil War News* (July 2013).

Dudley: Barrett, Orvey S. *Reminiscences, Incidents, Battles, Marches and Camp Life of the Old 4th Michigan Infantry in War of Rebellion, 1861 to 1864.* Detroit, Mich.: W.S. Ostler, 1888; *The Sunday State Journal*, Lincoln, Neb., Dec. 8, 1912; *The Plattsmouth Journal*, Plattsmouth, Neb., Dec. 9, 1912.

Jordan: Blake, Mortimer. *A History of the Town of Franklin, Mass.* Providence, R.I.: J.A. & R.A. Reid, 1879.

Rutter: *Reading Times*, Reading, Pa., June 16, 1879; *The Mercury*, Pottstown, Pa., July 7, 2003; Smith, James M., II. *Storming the Wheatfield: John Caldwell's Union Division in the Gettysburg Campaign.* Trumbull, Conn: Gettysburg Publishing LLC, 2019.

Taylor: Bartlett, Asa W. *History of the Twelfth Regiment, New Hampshire Volunteers in the War of the Rebellion.* Concord, N.H.: Ira C. Evans, 1897.

Whittier: Bartlett, Asa W. *History of the Twelfth Regiment New Hampshire Volunteers in the War of the Rebellion.* Concord, N.H.: Ira C. Evans, 1897.

Foss: Joyce, Charles. "Unfading Be Their Laurels." The Charles T. Joyce Collection of Gettysburg Casualty Images. charlesjoyceimages.wordpress.com/2018/11/20/charles-augustus-foss/; Brown, Henri L. *History of the Third Regiment Excelsior Brigade*

72d New York Volunteer Infantry 1861-1865. Jamestown, N.Y.: Journal Printing Co., 1902.

Maxcy: *Maine at Gettysburg: Report of Maine Commissioners.* Portland, Maine: The Lakeside Press, 1898; Towers, Bruce. "Complete List of Recipients of the Kearny Cross." USGenWeb, http://files.usgwarchives.net/me/civilwar/kearny/kcross.txt

Hugo: Ivanoff, Carolyn B. "Wounded in the Peach Orchard." *Military Images* (Autumn 2020); *Reports of Committees of the Senate of the United States for the Second Session of the Fifty-Third Congress. 1893-'94.* Washington, D.C.: Government Printing Office, 1895.

Osman: Muffly, Joseph W., ed. *The Story of Our Regiment: A History of the 148th Pennsylvania Vols.* Des Moines, Iowa: The Kenyon Printing & Mfg. Co., 1904

Banta: Joyce, Charles. "Action With Zook's Brigade." *Military Images* (Summer 2020); "Proceedings of the N.Y. Medico-Legal Society. March 26, 1874." *The Sanitarian* (July 1874).

Marvin: Joyce, Charles. "Buying Time With Blood." *Military Images* (Summer 2020); Marvin, Matthew. Papers. Minnesota Historical Society, St. Paul, Minn.; Fox, William F. *Regimental Losses in the American Civil War 1861-1865.* Albany, N.Y.: Albany Publishing Company, 1889; *The Winona Daily Republican and Herald,* Winona, Minn., July 27, 1903.

Miller: Lang, Wendell W., Jr. "The 1st Minnesota: 'So Grand a Body of Men'", *North South Trader's Civil War* (July-August 1997).

Campbell: Dean, Miranda. "For Life and Lone Star Honor: A Texan at Gettysburg." *Military Images* (Summer 2017); Harris, Andrew. "Echoes of Glory: Local Civil War Soldier Rediscovered after 150 Years." *The John H. Reagan Camp News* (April 2016); Pfanz, Harry W. *Gettysburg: The Second Day.* Chapel Hill, N.C.: The University of North Carolina Press, 1987.

Hatchett: Statement of war service by Pinkney G. Hatchett, undated. Brian Boeve Collection; Cushman, Russell. "Jeff Milton: An Odoriferous Legend." Russell Cushman Blog. russellcushman.blogspot.com/2013/12/jeff-milton-from-in -law-to-outlaw-to-law.html

Burton: Marchetti, August. "Georgians in Gray: Images from the David W. Vaughan Collection." *Military Images* (Spring 2020); Vaughan, David W. "Civil War Portraits from the David W. Vaughan Collection." *Georgia Backroads* (Summer 2012); Harper, F. Mikell. *The Second Georgia Infantry Regiment, 1861-1865*. Macon, Ga.: Henchard Press, 2005.

Ramsdell: Weygant, Charles H. *History of the One Hundred and Twenty-Fourth Regiment NYSV*. Newburgh, N.Y.: Journal Printing House, 1877; 124th New York Infantry Regiment's Civil War Newspaper Clippings, New York State Military Museum and Veterans Research Center, Saratoga Springs, N.Y.; Ruttenber, Edward M., and Lewis H. Clark. *History of Orange County, New York*. Philadelphia, Pa.: J.B. Lippincott, 1881; *Middletown Times Herald,* Middletown, N.Y., Jan. 11, 1934.

Jones: Brainard, Mary G.G. *Campaigns of the One Hundred and Forty-Sixth Regiment New York State Volunteers*. New York, N.Y.: The Knickerbocker Press, 1915.

Larrabee: Nash, Eugene A. *A History of the Forty-Fourth Regiment New York Volunteer Infantry in the Civil War, 1861-1865*. Chicago, Ill.: R.R. Donnelley & Sons Company, 1911; *Chicago Tribune,* July 10, 1863.

Storm: *Buffalo Courier,* Buffalo, N.Y., March 19, 1899.

Wolcott: Clark, Rufus W. *Heroes of Albany: A Memorial of the Patriot-Martyrs of the City and County of Albany*. Albany, N.Y.: S.R. Gray, 1866.

Thompson: *Houston Daily Post,* Nov. 12, 1909.

Billings: Russinoff, Paul. "America's "'Good Death': Capt. Charles W. Billings of the 20th Maine Infantry at Little Round Top." *Military Images* (Summer 2020); Parvin, Robert J. "Incident After Gettysburg." *The Northern Monthly: A Magazine of Original Literature and Military Affairs* (May 1864).

Thompson: *Buffalo Morning Express and Illustrated Buffalo Express,* Buffalo, N.Y., July 4, 1884; *The Gibbon Reporter,* Gibbon, Neb., Dec. 19, 1907.

Dunn: Griffing, William J., and Charles T. Joyce. "The Civil War Letters of Will Dunn." dunnletters.wordpress.com; William Dunn to his parents, July 26, 1862, and Jan. 30, 1863. William H. Dunn pension record, National Archives, Washington, D.C.; Sgt. James J. Ricketts, Company G, 62nd Pennsylvania Infantry, to Arthur Dunn, July 24, 1863. William H. Dunn pension record, National Archives, Washington, D.C.

Coon: Joyce, Charles T., and Paul D. Mehney. "Dwelling in Peace in the Land of the Spirits: Pvt. Admiral Coon's portraits reveal a family's pain and sorrow." *Military Images* (Summer 2019).

Chase: Joyce, Charles T., "'Lost an Arm in Freedom's Fray': Union Amputees after Gettysburg." *Military Images* (Summer 2021); *St. Louis Post-Dispatch,* June 29, 1886; *Tampa Bay Times,* St. Petersburg, Fla., Nov. 29, 1914.

Veazey: Beyer, Walter F., and Oscar F. Keydel. *Deeds of Valor: How America's Heroes Won the Medal of Honor.* Detroit, Mich.: The Perrien-Keydel Company, 1903.

CHAPTER 4

Hancock: Figg, Royal W. *"Where Men Only Dare to Go!" Or the Story of a Boy Company.* Richmond, Va.: Whittet & Shepperson, 1885.

Archibald: 137th New York Infantry Regiment's Civil War Newspaper Clippings, New York State Military Museum and Veterans Research Center, Saratoga Springs, N.Y.; Joyce, Charles T. "Unfading Be Their Laurels." The Charles T. Joyce Collection of Gettysburg Casualty Images. charlesjoyceimages .wordpress.com/2018/11/12/frederick-a-archibald/

Bellis: *Evening Star,* Washington, D.C., July 25, 1917.

Doran: 122nd New York Infantry Regiment's Civil War Newspaper Clippings, New York State Military Museum and Veterans Research Center, Saratoga Springs, N.Y.; Brother of James E. Doran to an unknown recipient, April 1865. Collections of Pamplin Historical Park and the National Museum of the Civil War Soldier; *Syracuse Daily Record and Union,* Syracuse, N.Y., May 5 and 9, 1865.

Castle: *The Evening Star,* Washington, D.C., March 8, 1886; *The Critic and Record,* Washington, D.C., March 10, 1886.

Newhall: *Walter S. Newhall. A Memoir.* Philadelphia, Pa.: C. Sherman, Son & Co., 1864; *New York Times,* Nov. 5, 1861.

References: Porter, John W.H. *A Record of Accounts in Norfolk County, Virginia.* Portsmouth, Va.: W.A. Fiske, 1862; *The Virginian-Pilot,* Norfolk, Va., Sept. 5, 1911.

References: Lewis, Virgil A., and Dr. Robert A. Brock. *Virginia and Virginians.* Richmond, Va.: H.H. Hardesty, 1888; *Farmville Herald,* Farmville, Va., Nov. 25 and Dec. 2, 1893.

Crocker: Crocker, James F. *Gettysburg—Pickett's Charge and Other War Addresses.* Portsmouth, Va.: W.A. Fiske, 1915; Crocker, James F. "Prison Reminiscences." *Southern Historical Society Papers,* Vol. XXXIV (1906); Tyler, Lyon G. *Men of Mark in Virginia,* Volume IV. Washington, D.C.: Men of Mark Publishing Company, 1908.

LaPrade: E.G. LaPrade pension application, Library of Virginia, Richmond, Va.

Pohlman: Clark, Rufus W. *Heroes of Albany: A Memorial of the Patriot-Martyrs of the City and County of Albany.* Albany, N.Y.: S.R. Gray, 1866; 59th New York Infantry Regiment's Civil War Newspaper Clippings, New York State Military Museum and Veterans Research Center, Saratoga Springs, N.Y.

Womack: *Southern Historical Society Papers,* Vol. XXXI (1903); "Womack v. Tankersley, 78 Va. 242 (1883)." Caselaw Access Project, Harvard Law School. cite.case.law/va/78/242.

Tanner: *The Times Dispatch,* Richmond, Va., June 16, 1924.

Billings: *The Washington Post,* July 2, 1911; New York Monuments Commission for the Battlefields of Gettysburg and Chattanooga. *Final Report on the Battlefield of Gettysburg,* Vol. III. Albany, N.Y.: J.B. Lyon Company, 1900; Joyce, Charles T. "Reluctant Hero: Otis C. Billings and Cowan's 1st New York Independent Battery at Gettysburg." *Military Images* (Summer 2018).

Chenery: Ford, Andrew E. *The Story of the Fifteenth Regiment Massachusetts Volunteer Infantry in the Civil War 1861-1864.* Clinton, Mass.: Press of W.J. Coulter, 1898; Ford, Andrew E. *History of the Origin of the Town of Clinton, Massachusetts 1653-1865.* Clinton, Mass.: Press of W.J. Coulter, 1896.

Sturgeon: Joyce, Charles T. "Misadventure and Missed Opportunity." *Military Images* (Summer 2020); *The Gettysburg Times,* Sept. 10, 1934.

Hannas: *Confederate Veteran Magazine,* June 1913.

Cushman: Scales. John, ed. *Biographical Sketches of the Class of 1863 Dartmouth College.* Hanover, N.H.: Privately published, 1903; Quint, Wilder D. *The Story of Dartmouth.* Boston, Mass.: Little, Brown, and Company, 1914.

Chandler: *Sandusky Daily Star,* Sandusky, Ohio, Feb. 20, 1902.

Garsed: Marrone, Frank, contributor. "Joshua Simister Garsed." Pennsylvania Civil War. pa-roots.com/pacw/infantry/23rd/ joshuagarsedobit.html; *Philadelphia Inquirer,* Aug. 8, 1863.

CHAPTER 5

Gundrum: Joyce, Charles T. "A Romance Fueled by Photographs: At Gettysburg, an Iron Brigade Bandsman and a Former Tavern Keeper's Daughter Find Love and Likeness." *Military Images* (Summer 2020).

Winslow: Davenport, Alfred. *Camp and Field Life of the Fifth New York Volunteer Infantry.* New York, N.Y.: Dick and Fitzgerald, 1879; Holton, David P., and Frances K. Holton *Winslow Memorial,* Vol. II. New York, N.Y.: Mrs. Frances K. Holton, 1888; *The Sanitary Commission Bulletin,* New York City, June 15, 1864.

Boss: Ford, Andrew. *The Story of the Fifteenth Regiment Massachusetts Infantry in the Civil War.* Clinton, Mass.: Press of W.J. Coulter, 1898; Joyce, Charles T. "Unfading Be Their Laurels." The Charles T. Joyce Collection of Gettysburg Casualty Images. charlesjoyceimages.wordpress.com/2018/12/09/ george-l-boss/

Boudrye: Boudrye, Louis N. *Historic Records of the Fifth New York Cavalry.* Albany, N.Y.: S.R. Gray, 1865; Boudrye, Louis N. *The Libby Chronicle: Devoted to Facts and Fun.* Albany, N.Y.: privately published, 1889; *The Inter Ocean,* Chicago, Ill., Jan. 6, 1892.

Wilkeson: *The New York Times,* July 6, 1863; "Gettysburg: The Correspondence From the Famous Story of Lieutenant Bayard Wilkeson, Killed at Gettysburg." Raab Collection. raabcollection.com/civil-war-autograph/civil-war-signed -gettysburg-correspondence-famous-story-lieutenant-ba- yard; *Evening Courier & Republic,* Buffalo, N.Y., July 11, 1863.

Minnigh, Luther E. Gettysburg: What They Did Here. Gettysburg, Pa.: Tipton & Blocher, 1924.

Dada: Brockett, Linus P., and Mary C. Vaughan. *Woman's Work in the Civil War: A Record of Heroism, Patriotism, and Patience.* Philadelphia, Pa.: Zeigler, McCurdy, 1867; Raus, Edmund J. ed. *Ministering Angel: The Reminiscences of Harriet A. Dada, a Union Army Nurse in the Civil War.* Gettysburg, Pa.: Thomas Publications, 2004; Hunnicutt, Selden. "Ministering Angels." *Military Images* (Spring 2015); Coddington, Ronald S. *Faces of Civil War Nurses.* Baltimore, Md.: Johns Hopkins University Press, 2020.

Leftwich: Trout, Robert J. *Memoirs of the Stuart Horse Artillery Battalion.* Knoxville, Tenn.: The University of Tennessee Press, 2008; *The Camden Confederate,* Camden, S.C., Sept. 18, 1863.

O'Neill: Survivors' Association. *History of the 188th Pennsylvania Volunteers.* Philadelphia, Pa.: J.L. Smith, 1905; *Belfast News-Letter,* Belfast Ireland, March 28, 1887.

Brown: *Confederate Veteran,* July 1906.

Norton: *History of Washington County, Ohio, with Illustrations and Biographical Sketches.* Cleveland, Ohio: H.Z. Williams & Bro., 1881; *Cleveland Daily Leader,* Cleveland, Ohio, June 13, 1865.

Hale: *Report of the State of Maryland Gettysburg Monument Commission.* Baltimore, Md.: William K. Boyle & Son, 1891; Child, William, M.D. *A History of the Fifth Regiment New Hampshire Volunteers in the American Civil War, 1861-1865.* Bristol, N.H.: R.W. Musgrove, Printer, 1893; The National Tribune, Washington, D.C., Sept. 28, 1899.

Warner: Leisenring, Richard Jr. "Philanthropic Photos: Fundraising during and after the Civil War." *Military Images* (Spring 2018); Joyce, Charles T., "'Lost an Arm in Freedom's Fray': Union Amputees after Gettysburg." *Military Images* (Summer 2021); *The Daily Morning Journal and Courier,* New

Haven, Conn., June 17, 1905; *Program of Exercises at the Dedication of a Soldiers Monument Erected by the First Connecticut Light Battery the Sixth, Seventh and Tenth Connecticut Volunteers Monument Association at the Broadway Park New Haven, June 16, 1905.* New Haven, Conn.: Press of The Price, Lee & Adkins Co., 1905.

Hawthorne: *Charleston Gazette-Mail,* Charleston, W.Va., June 2, 2011; Stone, Teresa. "Benjamin James Hawthorne." Otterburn Antiques. otterburnantiques.com/Hawthorne2.htm.

INDEX

Newhall, Walter Symonds: 247, *248*, 249

Norton, George Washington: *326*, 327–328

O'Neill, William J.: 317, *318*, 319

Oak Ridge: 23, 47, 48, 51, 73

Ohio troops: 1st Light Artillery, 327; 82nd Infantry, 81; Dilger's Battery, 53

Osman, George: *158*, 159–160

Payne, William R.: 93, *94*, 95

Peach Orchard: 141, 151, 153, 155

Peninsula Campaign: 15, 58, 93, 107, 109, 114, 129, 133, 143, 155, 165, 169, 193, 211, 245, 249, 251, 261, 271, 273, 279, 315, 321, 333

Pennsylvania troops: 3rd Cavalry, 247, 249; 13th Cavalry, 23; 16th Infantry, 3; 17th Cavalry, 27; 21st Infantry, 11; 23rd Infantry, 289; 26th Emergency Infantry, 4; 42nd Infantry, 43; 53rd Infantry, 133; 62nd Infantry, 109; 74th Infantry, 53; 83rd Infantry, 199; 87th Infantry, 334; 114th Infantry, 114; 118th Infantry, 317; 121st Infantry, 63; 148th Infantry, 159; 149th Infantry, 43; 150th Infantry, 67; 151st Infantry, 61; Bell's Adans County Cavalry, 9

Petersburg Campaign: ix, 16, 65, 105, 122, 201, 229, 240, 263, 281, 322, 328

Pickett's Charge: viii, 41, 72, 73, 223, 229, 245, 251–252, 253, 257, 261, 266, 267, 269, 271, 275, 277, 279, 289, 291, 315, 321, 327, 339

Pitzer's Woods: 107–108

Pohlman, William Henry: *264*, 265–266

Prisoner of war camps: Belle Isle, Va.: 98, 123; Charleston, S.C.: 243; Columbia, S.C.: 34, 75, 241; Danville, Va.: 241; Fort Delaware, Del., 39, 143, 252, 322; Johnson's Island, Ohio: 39, 252, 255, 259; Macon, Ga.: 34, 241; Point Lookout, Md.: 93; Richmond, Va.: 34, 53, 75, 79, 241, 277, 289, 306, 331; Salisbury, N.C.: 34, 277; Washington, D.C.: 322

Ragon, Newton J.: 141, *142*, 143

Railroad Cut: 38, 41, 83

Ramsdell, Henry Powell: 183, *184*, 185–186

Rector's Crossroads: 7

Reisinger, James Monroe: *66*, 67–69

Rutter, Samuel Hockley: *132*, 133–134

Saunders, Charles D.: *6*, 7–8

Schwartz Farm: 303

Seas, Henry: *80*, 81–82

Seminary Ridge: 57, 61, 63, 175, 261

Severs, Wilson S., *26*, 27–28

Sherman, Adelbert Clinton: 129, *130*, 131

Sickles, Daniel E.: 139, 153, 165

Smart, Richard Baxter: *164*, 165–166

Smith, Horace: *96*, 97–99

Soldiers' National Cemetery: 11, 45, 83, 149, 160, 198, 213, 221, 233, 278, 303, 325

Spangler's Woods: 255